SCOTLAND
ON THE
FRONTLINE

SCOTLAND
ON THE
FRONTLINE

A Photographic History of
Scottish Forces 1939–45

CHRIS BROWN

First published 2012

The History Press
The Mill, Brimscombe Port
Stroud, Gloucestershire, GL5 2QG
www.thehistorypress.co.uk

British Library Cataloguing in Publication Data.
A catalogue record for this book is available from the British Library.

ISBN 978 0 7524 6478 7

Typesetting and origination by The History Press
Printed in Malta by Melita Press

CONTENTS

ACKNOWLEDGEMENTS

A short book – or even a very long one for that matter – cannot possibly touch on every aspect of Scotland in the Second World War. It can do no more than touch on a handful of operations, units and individuals. If this book can raise a little money for the Erskine Hospital and raise a little bit of awareness of Scotland's experience of the greatest conflict in history it will have served its purpose and, hopefully, have justified the trouble that many institutions and individuals have gone to in the provision of the memoirs, photographs and artwork that appear here. I am indebted to a great many people and associations including Tony Banham and Steven Foster of the Far East Prisoners of War Association; Jack Burgess of the Scottish Saltire Aircrew Association; the Museums of the Royal Scots; Major Robin MacLean of the Royal Scots Dragoon Guards Museum; the Black Watch; Rod MacKenzie at the Argyll and Sutherland Highlanders; Ian Martin at the King's Own Scottish Borderers; the Royal Army Chaplains' Department; Jonathan Moffat of the Malayan Volunteers Group; John Pollock; Heather Johnson; Martin Langford of the Royal Armoured Corps (Bovington Tank Museum); Tempus Archive; Jo de Vries at The History Press; Sutton Publishing; Sarah McMahon at the Random House Group; Louise Miller; Kevin Turner and Elaine Jeffrey of the *Glasgow Herald* and *Evening Times*; Alex Hewitt of *The Scotsman* and *Writer Pictures*; 'Trond' of NF Stamps; the *Daily Telegraph*; Jenny Murray of the Shetland Museum; Krystyna Kennedy of the Erskine Hospital; the two soldiers who wished to remain anonymous (but you know who you are); Sir Simpson Stevenson; the 'on-line museum' of 51st Highland Division; Brid Hetherington of Cualann Press; Bill Simpson; Squadron Leader Bruce Blanche; David Ross; Marcus Geddes; Keith Chalmers-Watson; Professor Dugald Cameron; Roddy Macgregor and the 602 (City of Glasgow) Museum Association for the photographs of 602 and 603 Squadrons, RAF; Jack Amo of the Regimental Museum of the Canadian Scottish Regiment; Andy Leishman of the Royal Highland Fusiliers;

Rab Hailstones; Sergeant Gorman of the Scots Guards; Pete Rogers; Geoff Murray and Peter Copland of the Commando Veterans Association; 'Jon' of the Paradata team at the Airborne Assault Museum; Anne MacGregor; my son Robert who provided me with a scanner, laptop and the solution to several computer problems.

If I have missed anybody out (and there are so many people who have helped that I almost certainly have) and for those who contributed material that has not been used, please accept my heartfelt apologies as well as my gratitude. My thanks are also due to the members of my family who, yet again, have borne with fortitude my end-less wittering about war and history: Charis and Alex; Chris and Mariola; Colin and Juliet; my late father-in-law Robert Smith; my parents Peter and Margaret Brown; my brother Peter; and most of all my wife Pat; and, of course, the sounding board for all my thoughts, my Irish Terrier, Sam.

I have made a lot of use of the work of Colonel J. Kemp, who published a history of the Royal Scots Fusiliers, and of a website dedicated to 15th Scottish Reconnaissance Regiment. Colonel Kemp's work is more than just a collection of anecdotes and diary entries from members of the battalions; it includes mate-rial from the official war diaries of the different battalions and from several units and individuals that served with or beside fusilier battalions and is therefore a very full picture of the life of the regiment. The various battalions of the fusiliers served in many theatres – Africa, Burma, Italy, northern Europe and in the little-known, though important, Madagascar campaign against the Vichy French colonial army. The variety of stations and tasks allocated fusiliers were fairly typical of Scottish regiments generally and I have chosen them as a sort of 'control sample' to show the experience of one regiment over the years from 1939 to 1945. In a sense, I have used Colonel Kemp's book as a prose equivalent of a photograph album, using images from this or that theatre to illustrate the process of the war, not from the point of view of one individual, but from that of the thousands of men who served in the Royal Scots Fusiliers. I have used the web-published account of 15th Scottish Reconnaissance Regiment as a second 'control sample' to try to give an impression of the experience of one unit over a relatively short period in one theatre of the war – the campaign through northern Europe. The publishers of Colonel Kemp's history have been defunct for some decades, and efforts to locate a copyright holder have proven unsuccessful. I have no doubt at all that the colonel would have been pleased to see his material get another airing more than half a century after pub-lication and that he would have been more than happy to know that his work was being used to support a cause like the Erskine Hospital. I have made several equally unsuccessful attempts to make contact with the owners or administrators of www.15threcce.org and the excellent online 'Virtual Museum' of the 51st Division. I hope both the colonel and Captains Kemsley and Riesco (the original compilers of the 15th Reconnaissance Regiment material) and the compilers of www.51HD. co.uk would approve the extracts I have chosen.

INTRODUCTION

Given the very large number of Second World War books that appear in our book-shops every year, one might be forgiven for wondering if there was any possible avenue that had yet to be explored and therefore what possible point there could be in publishing yet another volume on the conflict of 1939–45.

An important part of the rationale for writing this book has been to raise money for the Erskine Hospital for disabled veterans and at the same time raise awareness of the valuable work that has been carried out there since its foundation in 1916. One of the tragedies of both the First and Second World War was the failure of successive governments to honour their obligations to those who sustained physical and emotional wounds. That failure continues to have an impact on men and women who served in the Second World War. The Erskine Hospital has been doing what it can to redress the balance for nearly a century. If this book does a little to help then the effort involved will have been well worthwhile. The Erskine Hospital exists to help those who have served their country on the battlefield; the rights and wrongs of going to war are not the issue. This is not really a question of charity, more a question of fair play. By purchasing this book you will have made a contribution to the Erskine project; if you feel moved to do something more to help our veterans I shall be personally very grateful.

The other major motivation for writing this book has been to raise awareness of Scottish service in the Second World War. Ever since the war ended, and increasingly over the past forty years or so, there has been something of a tendency to see the 1939–45 war as the triumph of the men of the English army. It is a phenomenon that can even be identified in the genre of popular songs. It is now nearly forty years since Lennon and McCartney penned the lyrics to *A Day in the Life*, which includes the lines: 'I saw a film today, Oh Boy/ The English army had just won the war …'

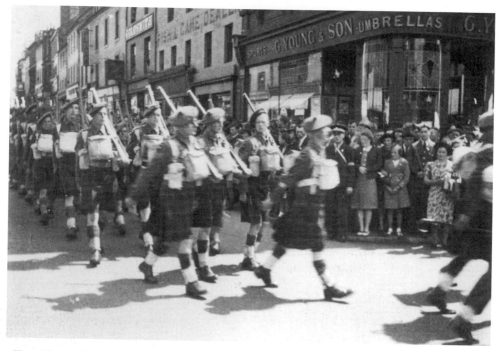

5 Troop, No 2 Commando march to war, Dumfries. (Collection of Pete Rogers/Courtesy of the Commando Veterans Association)

Clearly, no one would look to the Beatles as a historical source or to justify a particular view of the events of the past, but the words of the song are not far removed from the perception of the Second World War held by a significant proportion of the book-reading public, not only in England, but all over the world – or at least in those places where there is no clear distinction between the terms 'British' and 'English'. The perception that the men of the 'English army' won the war does a disservice to the hundreds of thousands of men who served in the RAF and the Royal Navy, not to mention the many women who served in uniform.

It might also be less than warmly received by the other countries that spent blood and money to bring down Nazi Germany, Fascist Italy and Imperialist Japan. It is rather disparaging not only to the Scots, Welsh and Irish, but to the many Canadians, Indians, East, West and South Africans, Australians, New Zealanders, Americans, Poles, Czechs, Fijians, West Indians, Nepalese, Malaysians and others who served in British and Commonwealth units.

Even among those who are aware of Scotland's participation in the war there is often very little idea of the breadth or scale of Scottish involvement, which is remarkable given that something like 40,000 Scottish people lost their lives and many, many thousands more were wounded, both physically and emotionally. There is, for example, a relatively common perception that Scots served in the Highland Division alone, even though, in fact, there were other Scottish

formations in the British Army – the 9th, 15th and 52nd divisions. Many Scottish infantry and armoured units served in other formations; battalions of the Scots Guards served with the Guards Armoured Division and 7th Battalion King's Own Scottish Borderers in the 1st Airborne Division to cite just two examples. Many Scots served in the Royal Artillery, the Royal Engineers, the Royal Army Ordnance Corps, the Commandos – No 2 Commando was largely Scottish – the Royal Army Service Corps and, indeed, in every corps and department of the Army. Naturally, large numbers of Scots also served in the Royal Navy, the Royal Marines and the RAF. They did not do so, by and large, in specifically Scottish units, but they did constitute a disproportionately large number of personnel serving in the regular military units in existence at the start of the war.

It is my hope that this book will also serve a useful function for Scottish school-teachers. Although some study of the Second World War is virtually compulsory in Primary 6 and/or Primary 7, there is a singular lack of suitably focused material

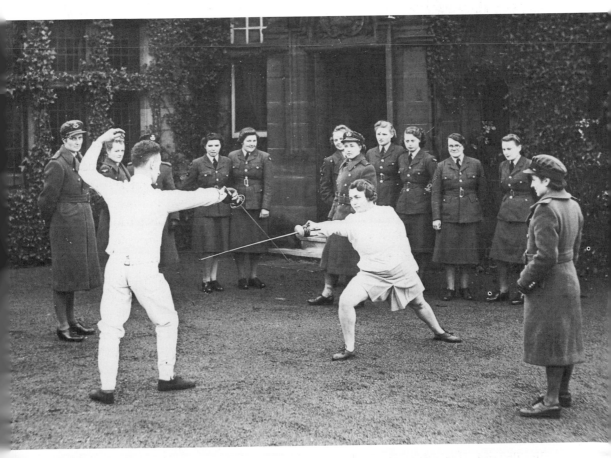

The women who served in the Armed Forces are often overlooked, despite their making an invaluable contribution to intelligence, aerial photographic interpretation, medical services and many other functions. (Daily Mail)

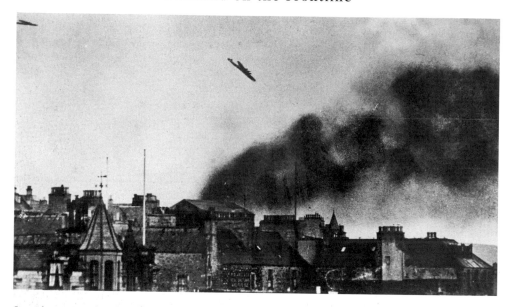

Lerwick experienced its first air raid when six Heinkel IIIs attacked the harbour on 22 November 1939. (Courtesy of the Shetland Museum)

for the purpose and the approach that has developed in most schools is to look exclusively at the Home Front. Children look at rationing and evacuation, though in reality not that many Scottish children were evacuated at all and few of them stayed away from home for very long. One has to question the validity of getting Scottish children to go through the motions of being 'evacuees' as a useful learning experience. Even the Home Front is seldom really explored; most Scottish children are aware of the Blitz, but only as something that happened in London or, in a few cases, in Birmingham and Coventry. Bombing raids on Aberdeen, Dundee, Glasgow and Edinburgh, and the wholesale destruction of Greenock and Clydebank do not generally make it to the classroom. Few people anywhere are aware that the first bombs that fell on Britain fell in Shetland. Scottish children are, as a rule, quite unaware that the Battle of Britain was not fought exclusively over London and the Home Counties.

The first German aircraft destroyed in the Second World War was a Junkers 88 fighter-bomber; it was shot down by Flight Lieutenant George Pinkerton over the River Forth. In one of those ridiculous situations that arise from petty policy decisions and book-keeping procedures, one of the greatest 'aces' of RAF history, Archie McKellar, does not appear on the Battle of Britain Memorial since he was killed eight hours after the official end of the battle. Few Scottish children know that the many great convoys of warships, troopships and supply vessels that took part in the Battle of the Atlantic started or ended their journey at Glasgow or Greenock rather than Liverpool or Manchester, or that many of the aircraft that flew missions to protect those convoys operated from Scottish airfields.

Right *Flight Lieutenant Cardell, 603 Squadron. (Courtesy of 603 Sqn RAFVR)*

Below *Flight Lieutenant Patrick Gifford of 603 Squadron and 'Red Section' turn to attack a Ju88 attempting its escape after dive bombing Royal Navy ships near the Forth Bridge on 16 October 1939. This was the first enemy aircraft to be shot down in British airspace during the Second World War. (Painting reproduced by kind permission of Prof. Dugald Cameron)*

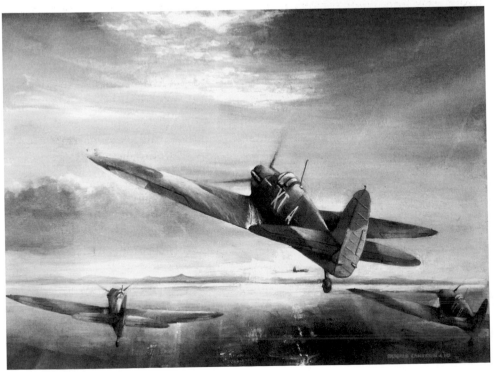

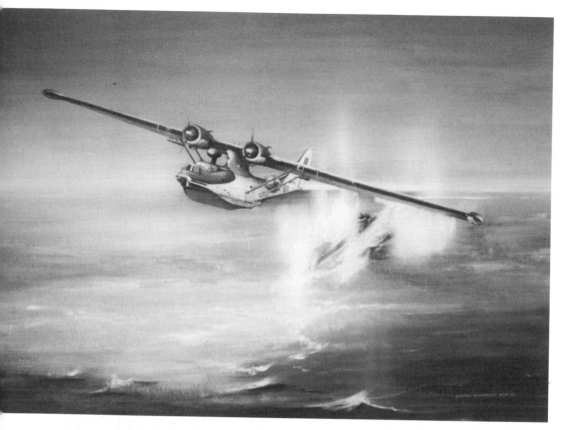

Flight Lieutenant John Cruickshank attacks a German U-boat on 17 July 1944. Although the Catalina of 210 Squadron sank the enemy submarine, it was damaged by return fire which killed one crew member and injured the others. Cruickshank, born in Aberdeen, was extensively and badly wounded but continued to fly the machine until he was satisfied that it was on the right heading for its base at Sullom Voe. The trip back took over 5 hours. He was awarded the Victoria Cross for his courage. (Painting reproduced by kind permission of Prof. Dugald Cameron)

There can be no denying that there is a real value to studying the effects of the war at home. It is desirable that children should have some understanding of the war as it affected the communities in which they live, but it does rather lead to a study of the war in which – to use a phrase that will be familiar to some readers – 'nobody mentions the war', or more accurately no one mentions that the war involved fighting. Even if they do, discussion of the actual combat seldom strays beyond northern Europe. Perhaps this is an inevitable cultural consequence. Our political, economic and social focus is centred more on European affairs than was the case in the past.

This Eurocentric view may or may not be inevitable, but it is surely not altogether desirable, and certainly not to the extent of marginalising the global nature of the conflict. Conversations with both teachers and pupils have provoked surprised reactions that Scottish soldiers, sailors and airmen fought in Italy, Egypt, Libya, Greece, Madagascar, Germany, Belgium, France, the Netherlands, Iraq, Syria, Lebanon, India,

An anti-aircraft gun from the Second World War in Shetland. (Courtesy of the Shetland Museum)

Tunisia, Burma, Malaysia, Singapore, Yugoslavia, Hong Kong and in the Atlantic, Pacific and Indian Oceans. They are even more surprised to learn that Scots took part in the occupation of Iceland in May 1940 – probably the only really successful operation in Europe that year – or that they served in what we now call Indonesia and Vietnam when the war had finished. The same conversations have also provoked considerable surprise that Scottish women served in all of these locations and that they served in a wide variety of roles, not just as nurses, but as communications staff, drivers, administrators, in anti-aircraft units and, in the UK at least, as pilots, ferrying newly built aircraft to operational stations.

The lack of knowledge of the war years among children is mirrored in their parents. Thirty or forty years ago almost anyone who was too young to remember the war was aware of it from the conversations that they had overheard among those of their parents' generation. Naturally this is no longer the case; beyond service reunions and care homes very few conversations nowadays begin with 'remember when you couldn't get such-and-such a thing because of the war ...' or 'When I was in the Army in Burma ...' or 'in the Navy in India' or 'in the Air Force in Iraq'.

1

THE SCOTTISH SOLDIER

Scots have had a long relationship with soldiering. From the late thirteenth century until the Union of the Crowns under James VI there was always the danger of war with England, war that was not always restricted to the British Isles. Many Scots served in English and French forces during the Hundred Years War and for some years in the 1420s an entire Scottish army served the French Crown. Many Scots found employment in other European wars, so much so that when the Bishops' Wars of 1639 and 1640 broke out the Scottish Government was able to raise substantial armies with a strong cadre of experienced officers and non-commissioned officers in a very short space of time, which were more than capable of dealing with King Charles' Scottish supporters in 1639 and a projected English invasion in 1640. Scots served in large numbers in the Irish, English and Scottish conflicts that comprise the War of the Three Kingdoms. The wars brought about Scotland's first regular army, named, like its counterpart in England, the New Model Army. The first regular army unit had, however, been raised some time before. In 1633 Charles I issued a warrant authorising Sir John Hepburn to raise a regiment from Scotland for service in France. Hepburn's regiment included a number of men from a unit of Scots that he had led in Swedish service, and in a sense the regiment became the Royal Scots – the oldest and most senior formation in the British Army until its amalgamation with the King's Own Scottish Borderers in 2006 to form a single battalion in the new Royal Regiment of Scotland.

Scots served in foreign armies for a variety of reasons. Some joined up because of the possibility of economic gain and social advancement, some for sheer adventure, some to avoid the consequences of criminal activity. Some prospered and some did not, but soldiering has long been seen as a perfectly honourable career in Scotland.

Scots take their Scottishness with them wherever they go, and even within the context of British formations overseas, a considerable number of distinctively Scottish

When the Home Guard was first formed there were neither uniforms nor rifles to issue to the volunteers; men drilled with broom handles and in their own clothing for some months before equipment became available. (Scotsman Publications).

units were raised. This was particularly strongly developed in Canada, due largely to the very large number of Scottish immigrants in the late eighteenth and nineteenth centuries. Over the years there have been a total of fifteen Canadian Scottish infantry regiments and one air defence regiment. At different times Australia has had six Scottish regiments, including no less than two associated with the Cameron Highlanders – the 16th and 61st battalions. At least four battalions in the South African Army have adopted Scottish traditions at one time or another and New Zealand had the 1st Armoured Regiment, also known as the New Zealand Scottish.

Scottish units, or discrete Scottish elements within units, could, at one time, be found among British colonial volunteer formations as far apart as South Africa and Hong Kong. This was not limited to army units in the Empire and Commonwealth; Liverpool, Tyneside and London have all had Territorial Army Scottish regiments at different times.

Even within the English line regiments there has often been a surprisingly large contingent of Scots. In the eighteenth and nineteenth centuries English regiments often found it hard to attract an adequate supply of men from their home areas and made good the shortfall by sending recruiting parties to Scotland and Ireland. Ireland tended to be more fruitful in terms of numbers, but the early advent of

near-universal literacy in Scotland compared to any other country in the world made Scottish recruits desirable in a period when only a minority of working-class men could read or write.

Scottishness could even make its way beyond the boundaries of the British Army. In June 1859 a unit called the 79th or Cameron Highlanders came into being. They adopted Cameron of Erracht tartan trews or kilts and wore diced Glengarry caps. What is curious about the 79th is that they were raised not in Scotland, but in New York, and were a volunteer unit of the United States Army. They had no connection with the Cameron Highlanders of the British Army other than the fact that they liked the name and doubtless admired the reputation. It is not clear that the trews and caps lasted long once the American Civil War started in 1861, but more than 2,000 men of the 79th saw action at many of the great battles of the eastern theatre, including Bull Run, Antietam and Fredericksburg. The regiment was eventually disbanded in 1876.

A number of Gurkha and Indian regiments have in the past adopted certain Scottish attributes, most notably pipe bands, of which there are a number in both India and Pakistan to this day. The first Indian unit with a clear Scottish connection may have been the 45th (or Rattray's) Sikhs, which was an infantry regiment of the British Indian Army. The 45th were originally known as the 1st Bengal Military Police Battalion, which was raised in April 1856 in Lahore by Captain Thomas Rattray. The regiment originally comprised a troop of 100 light cavalry and 500 infantry, half Sikhs and half Muslims, and saw service in Bihar and Assam.

Although the Scottish divisions did not come into being until the twentieth century, highland brigades were formed on a number of occasions, including the Crimean War, where the formation consisted of the 42nd Foot (the Black Watch), 79th Foot (Queen's Own Cameron Highlanders) and the 93rd Foot (the Sutherland Highlanders). The latter was commanded by Sir Colin Campbell and served with distinction at several engagements, such as when the Sutherlands famously repelled an attack by Russian cavalry at the Battle of Balaclava, and the regiment became the original 'thin red line'. Campbell – who became Lord Clyde in 1858 in recognition of his exceptional leadership during the Indian Mutiny – was the son of a Glasgow carpenter, an illustration of the opportunities for social mobility afforded by the Victorian army.

The Egyptian Rebellion of 1882–85 saw the formation of another highland brigade from battalions of the Black Watch, Highland Light Infantry, the Camerons and the Gordon Highlanders. The brigade performed well despite heavy casualties at the Battle of Tel-el-Kebir.

A highland brigade was formed from the 2nd Seaforths, 2nd Black Watch, 1st Argyll and Sutherland Highlanders and the 1st Highland Light Infantry for service in the Second Boer War, 1899–1902. The brigade suffered heavy casualties at Magersfontein and Paardeberg. The Boer War led to the foundation of one of Scotland's more unusual military institutions. Concerned that while the family of officers killed in action

would probably still be able to afford to see to the education of their sons, but that the families of other ranks may not, Queen Victoria felt that some provision should be made for the education of the sons of 'ORs' (other ranks – privates, corporals, sergeants in the army, seamen and petty officers in the Royal Navy) and was instrumental in setting up a free boarding school for the sons of Scottish soldiers and sailors killed in action. Queen Victoria School opened at Dunblane in 1908 and continues to fulfil the function for which it was intended.

The years after the Boer War brought a wave of reform to the armed services, particularly the Army. The war in South Africa had shown that the British Army was not really equipped or structured to provide an army for any operations beyond the requirements of intervention in such conflicts as might arise within the Empire. In addition to reforming the reserve forces so that they could act as an effective supplement to the Regular Army in time of need, Haldane, with the considerable assistance of Douglas Haig, set about reorganising the Army so that a major force could be deployed as a single, coherent entity in a reasonably short space of time. One of the factors that propelled this initiative (though in reality it was long overdue anyway) was the Tangier Crisis of 1905–6.

The crisis had nearly brought France and Germany to war, essentially over the question of Germany's growing imperial ambitions in Africa. The British Foreign Secretary, Sir Edward Grey, had agreed to support France militarily in the event of war, but Haldane recognised that the British Army was in no position to provide a force of the scale required to make a worthwhile contribution to a European war. The Haldane Reforms led to the creation of a revamped 'Expeditionary Force'. The force was not an army kept in being for immediate deployment, but was a system for committing the existing units of an army to battle in a rational manner. The new system would have a permanent general staff (the Imperial General Staff) with a suitable body of technical and administrative personnel. The General Staff would have responsibility for ensuring that colonial, imperial and dominion forces would, by and large, have a common structure, as well as common offensive and defensive policies, and armament. They would be capable of an integrated strategic and tactical doctrine which would simplify the defence needs of the British Empire as a whole. The training of the British Army, and consequently the armies of India, Canada, Australia and New Zealand, would now be based firmly on the precepts and objectives laid down in Douglas Haig's Field Service Pocket Book.

The structure that Haldane put in place was the one that governed the British Army in 1914 when the British Expeditionary Force (BEF) was sent to the continent to face the Germans. Within weeks it had become apparent that the two corps of the BEF would need to be heavily reinforced by new recruits as well as by the reserve formations. It is not the practice in the British Army to raise new infantry battalions, but rather to raise second, third, fourth and subsequent battalions of existing regiments, and over the next four years each of the Scottish regiments would raise

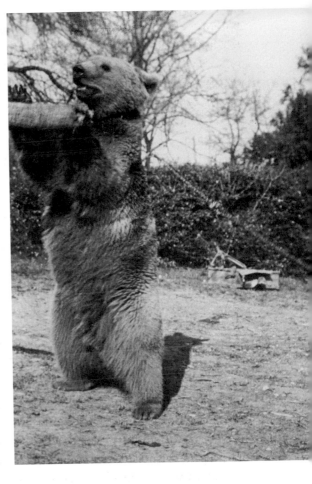

Wojtek, a Syrian brown bear who was adopted as mascot of the Polish Army. Wojtek was presented to Edinburgh Zoo in 1947. (Scotsman Publications)

several battalions for war service, chiefly in France and Flanders, but also on other fronts. The First World War saw the creation and deployment of three Scottish divisions, the 9th, 15th and 51st, though many Scottish battalions saw service with other divisions and several English battalions served in Scottish divisions.

The end of the war in 1918 led to wholesale demobilisation for the majority of the soldiers, sailors and airmen who had volunteered or been drafted for the duration. Despite the horrors of the trenches and a strong wave of pacifist feeling, soldiering continued to be a popular career choice for young Scots. Pay and conditions were not good, but unemployment was high and the prospect of foreign travel and adventure was attractive compared to poverty at home.

Overseas commitments were part of the problem when the war broke out in 1939. British ships, squadrons and regiments were scattered across the globe from China to the West Indies and could not simply be withdrawn to Europe. The Royal Navy was much larger and more powerful than the German Kriegsmarine, but had a much greater burden in the way of commerce protection and also had to contend with the threat of the Imperial Japanese Navy in the Pacific and the Italian Navy in the Mediterranean. The RAF and the British Army had worldwide commitments and although the RAF did have two high-quality aircraft in the Hurricane and Spitfire fighters, a great deal of the army's equipment was old-fashioned to the point of obsolescence. Worse still, despite the training and conscription measures taken in 1938–39, with a combat strength of only nine divisions, the Army was desperately small in comparison with the seventy-eight divisions of the German Army. Worst of all, the strategic policies and tactical doctrines were a generation behind the times.

2

BEFORE THE WAR

On the eve of the Second World War the Scottish element in the regular forces remained relatively distinct in the Army, due to the traditional regimental structure of the infantry and cavalry regiments; famous names like the Black Watch and the Scots Greys. This was not the case for the Royal Navy or the RAF, nor for branches of the Army such as the Royal Engineers or the Ordnance Corps. The Scottish dimension was more apparent in the reserve element of the RAF in the form of local units, such as the City of Edinburgh and City of Glasgow squadrons, and the various regional divisions of the Royal Naval Volunteer Reserve and the Royal Naval Volunteer Supplementary Reserve. Since the reservists had civilian occupations to conduct, they naturally did most of their training in their home area with a number of days per year spent at sea, in training elsewhere or on exercises. The Scottish reserve units of the different Army departments tended to retain their Scottish nature after the outbreak of the war, but were not necessarily deployed as components of Scottish formations.

Before the First World War, and again in the 1920s, some thought had been given to the possibility that all Scottish Regular and Territorial units would, in time of war, be organised as an essentially Scottish army within the British Army, and that this would facilitate peacetime training on a grander level than simply within the battalion. Such a structure would have been utterly impractical in the event of another huge and protracted worldwide conflict, but in the early 1900s and the 1920s very few people envisaged such a situation.

The demands of the First World War had forced the British Government to introduce compulsory military service – conscription – for the first time in 1916. Compulsory service had been widely enforced in other European countries for some time, and was retained in France after 1918. However, this was almost immediately abandoned in Britain, partly because of the long British tradition of having

The war diary of 7th Battalion Royal Scots Fusilers. (Royal Scots Museum)

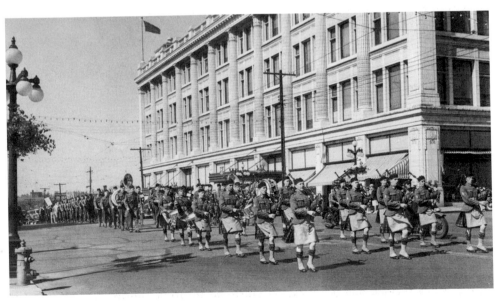

A Recruiting parade in Victoria, 1939. (Museum of the Black Watch, Royal Highland Regiment of Canada)

an all-volunteer military establishment and partly on the grounds of cost. Although Britain had a very much larger imperial and colonial commitment than other powers, there was also a stronger tradition of raising forces to protect overseas territories from the local population, thus reducing the proportion of British units stationed abroad. Even so, overseas commitments were extensive and between the wars Scottish battalions could be found in British colonies all around the world.

The pre-war British Army amounted to something in the region of 200,000 men, but this was clearly not going to be an adequate force to wage a war in Europe as well as maintain garrisons overseas, and in April 1939 the Military Training Act came into being. The act was not very ambitious. Men of 20 and 21 years of age were obliged to register for a period of training to last no more than six months, after which they would return to civilian life but be liable for military service as required. The Military Training Act was the first attempt at peacetime conscription in Britain and did not last for long. The situation clearly called for a much more far-reaching approach. Despite a considerable rise in the number of men volunteering for both the regular and reserve services, less than 900,000 men were registered for service and a great many of those were far from being trained soldiers. It was clear that a much more radical measure was called for and in 1939 Parliament passed the National Service (Armed Forces) Act, requiring military service from all men between the ages of 18 and 41.

Reserve soldiering had been quite popular in Scotland before 1939, a tradition that dated back to the Militia Yeomanry institutions of the Napoleonic era, which had been amalgamated under the 1907 Haldane Reforms. The increased likelihood of war with Germany led to a proposal, announced on 29 March 1939, to double the size of

ANTI-ITALIAN FEELING

Orgy of Window-Breaking and Looting in Edinburgh

CROWDS DEMONSTRATE IN OTHER CITIES

Big Round-Up of New Enemy Aliens Throughout Britain

At the outbreak of war civil unrest and disturbances were not uncommon throughout Britain, this newspaper article attests to the anti-Fascist feeling that was present in Edinburgh. Such feelings played their part in inspiring men to volunteer for the Armed Forces.

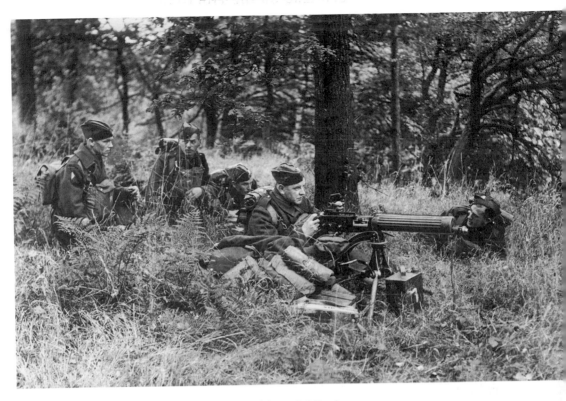

A Scottish Home Guard machine-gun team. (Courtesy of the Daily Mirror)

the Territorial force to 440,000 men. The Territorial Army battalions were recruited on a regional basis and were part of the wider family of the different Scottish regular regiments. The battalions were activated and posted to locations around the world as required, several seeing service in France in 1939–40. Following the campaign of 1940 it became apparent that the troops would not be 'home for Christmas' and a substantial number of men who had been in occupations critical for a sustained war effort were obliged to leave the Army and return to their peacetime occupations in coal mining, shipbuilding, steelmaking, agriculture, railway industries, water, electricity, gas, science and the merchant marine. A large proportion of these men would still serve in uniform as Air Raid Precaution wardens or in the Home Guard.

The Home Guard consisted of men who were too young or too old for conscription into the armed services and of those whose civilian occupation was vital to the war effort. It was also an option for those who were not British subjects but wished to serve in some capacity. There had already been some degree of official interest in such a project before the war, but no steps had been taken towards achieving it. There was some concern, even in the very early stages of the war, that Germany might mount an invasion of the British Isles and that a volunteer force might help to disrupt enemy plans and free trained units for offensive action.

The Commander-in-Chief Home Forces, General Sir Walter Kirke, had grave doubts about the likelihood of a German landing and about the value of a volunteer force, but as early as October 1939 Winston Churchill, then First Lord of the Admiralty, was proposing the raising of a force of half a million men above military age who could be trained to arms for deployment in an emergency. This was not so wild a scheme as it might at first appear. There were a great many men who had served in the First World War who were still capable of fighting and whose experience of battle meant that they could be trained relatively easy. The idea of a Home Guard force gathered support from a number of prominent individuals and from the press, though there were also concerns that the initiative might lead to bodies of armed men operating outside the control of the Army and that such forces might, in the event of an invasion, be treated not as soldiers, but as *francs tireurs*, or what would be called 'unauthorised combatants' today, and would run the risk of summary execution if captured. Around the time of the German offensive of 10 May 1940, the

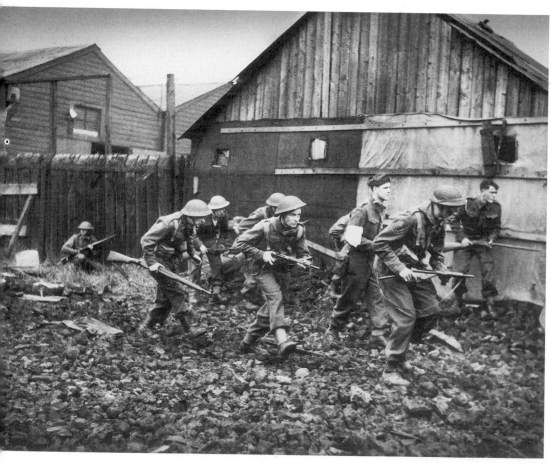

As weapons and uniforms became available, the Home Guard evolved into a more viable force. Men of this Glasgow unit carry Sten sub-machine guns and Canadian Ross rifles. (Courtesy of the Daily Mirror)

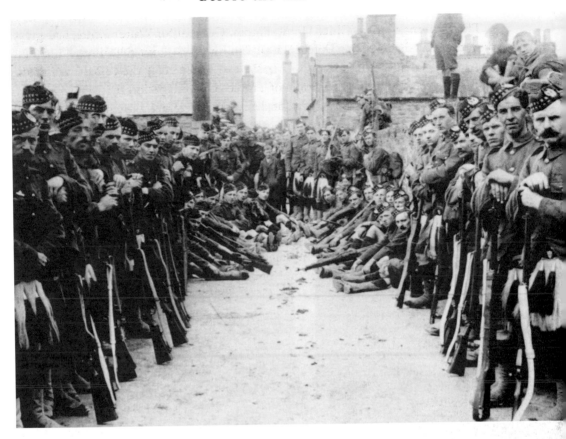

Scottish soldiers of the First World War. (Author's collection)

government came up with a plan for a force that would be able to guard significant installations, thus freeing manpower for the Army, and an appeal for men to join the Local Defence Volunteers was made on 14 May.

By the end of the year nearly 2 million men had registered, but the name was never popular – the acronym 'LDV' lending itself all too well to 'Look, Duck, Vanish' – so the title was changed to 'Home Guard' on 22 July 1940, which was what Churchill and others had preferred in the first place. There were all sorts of administrative issues about who would have command responsibility for what, but the first and greatest problem in 1940 was the shortage of equipment.

There were substantial numbers of pistols, shotguns and sporting rifles in private hands and a good many 'souvenir' weapons from the First World War, but demands for an adequate supply of the wide variety of small arms ammunition needed for these weapons was an administrative and industrial impossibility. The standard–issue small arms of the Army were in very short supply, partly because of the enormous expansion of the Army to war establishment in 1939 and partly because of the heavy loss of materiel in the campaign of 1940. The shortfall was made up by the

purchase of large numbers of surplus rifles from Canada and the United States, but Home Guard units had to wait a long time for uniforms, helmets and any kind of support or light automatic weapons, and longer still for adequate supplies of ammunition for training.

Despite the problems of acquiring weapons and uniforms, most of the Home Guard units became reasonably efficient and some became extremely competent, though by that time the threat of invasion had passed. The Home Guard continued to operate until December 1944 and was formally disbanded at the end of 1945. Although never called upon to fight, the Home Guard provided many thousands of its younger members with a solid basic training before they were drafted.

Although the strength of Home Guard units varied enormously from one area to another due to density of population, the theoretical structure of each unit was essentially the same as that of the infantry in general, and it is worth having a brief look at the theoretical organisation and equipment of an infantry battalion. Precise strengths did vary a little from time to time and from place to place, but in principle unit organisation remained fairly constant throughout the war.

Of all the 400,000 or so Scots who served in uniform in the Second World War, less than half would come into direct contact with the enemy on a regular basis, and the majority of these would be infantrymen. The basic tactical building block was the rifle section, a group of ten men under the command of a corporal or lance corporal. As a rule, eight men would carry the Lee-Enfield rifle, a bolt-action

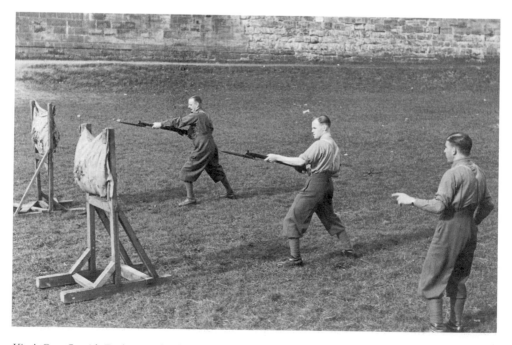

King's Own Scottish Borderers undertake bayonet training. (KOSB Museum)

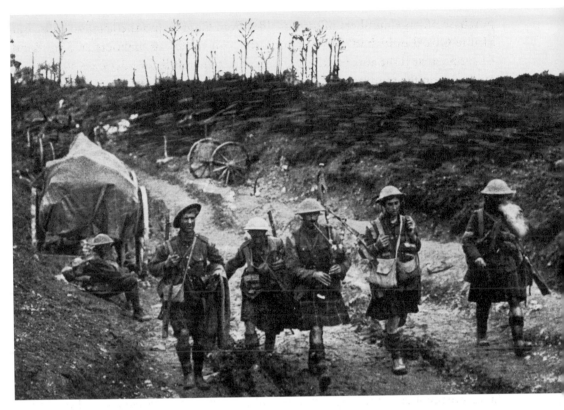

Here soldiers make their way back from the Western Front during the First World War. (Author's collection)

weapon with a magazine that took ten rounds. The Lee-Enfield was a remarkably reliable and accurate weapon. A skilled soldier could hit an enemy at 700m or more, though in practice he would very seldom see an enemy soldier at any distance beyond 200–300m. It was not uncommon for soldiers to load ten rounds into the magazine, then depress the topmost round and place another round into the breech of the weapon. This was a dangerous practice since it meant that there was a round in the breech all the time, increasing the chances of firing off a round accidentally. Additionally, this practice put an unnecessary strain on the magazine spring and could lead to damage to the weapon and jamming. The two remaining members of the section would carry a sub-machine gun (a Sten or Thompson) and the section Bren gun. The Sten gun was designed in 1940 when it was realised that the basic rifle section lacked firepower compared to their German equivalents. It was cheap to produce – almost 4 million were made in the war years – but was unreliable unless maintained very carefully and was never a popular weapon.

The Bren gun, on the other hand, was a remarkably good piece of equipment. For decades there was a persistent, though completely false, tale related through the Army that the Bren had been designed by a private soldier by the name of Bryan,

Breen or O'Brian. In fact, it had been designed at the Czech armaments establishment in Brno and was first manufactured at the Enfield Lock Royal Ordnance Factory, hence the name 'Bren' from the first two letters of Brno and the first two letters of Enfield. In theory every man in the section carried two magazines for the Bren gun, but this was found to be impractical and it soon became common practice for the man who acted as the assistant to the Bren gunner (the 'number two' of the Bren team) to carry a box or satchel with as many magazines as he could manage.

Three of these rifle sections, with a small headquarters element, constituted a platoon. The 'Platoon HQ' would generally consist of the platoon commander – notionally a lieutenant, but due to the high attrition rate in junior officers the role would often be filled by a sergeant – a wireless operator and possibly a man to operated a 2in mortar and/or a PIAT anti-tank weapon. The PIAT did not come into service until the Sicily campaign of 1943. In a sense it was a replacement for the Boyes anti-tank rifle, though in practice the Boyes had been abandoned some time previously since it had proved to be almost completely ineffective against all but the very lightest of armoured vehicles.

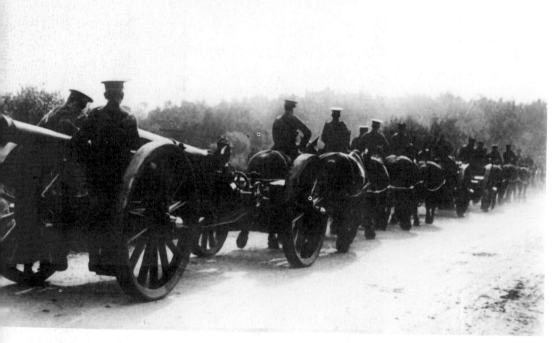

Medium artillery pieces on the move. (Author's collection)

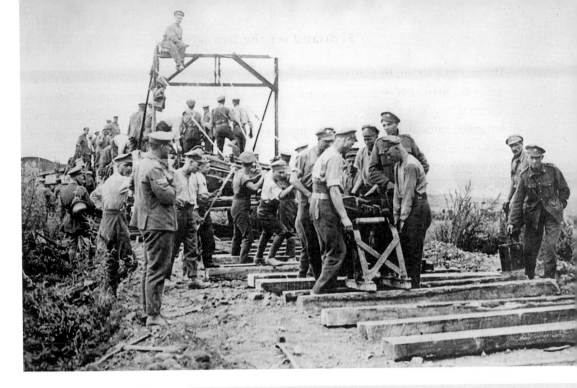

Above *Royal Engineers in the First World War. Many Scots served in every corps of the Army. (Author's collection)*

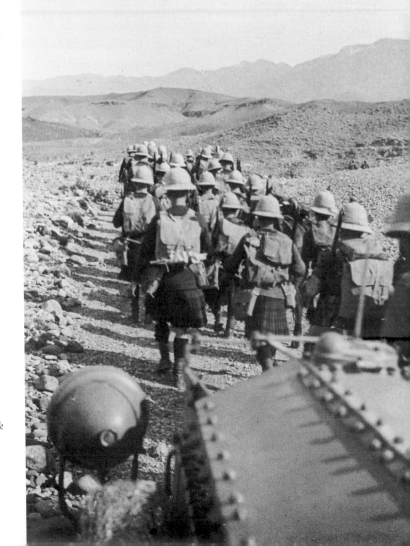

Right *Men on the move in the desert before the outbreak of war. Note the desert helmets and kilts – Scottish soldiers were known for customising and personalising their uniforms and kit. (The Tank Museum, Bovington)*

Four platoons, or sometimes only three due to manpower shortages, would form a rifle company under the command of a major, and four rifle companies would constitute the rank and file of a battalion under a lieutenant colonel. The battalion would have a number of other supporting assets, including a 3in mortar platoon for integral close support, an anti-tank platoon armed with 2 pounder guns in the early stages of the war, but upgraded to the more effective 6 pounder, which was introduced in 1942. The battalion would also have a machine-gun platoon armed with Vickers guns and a Bren carrier platoon with eleven lightly armoured tracked vehicles, machine-guns and mortars. The role of the carrier platoon was to carry out reconnaissance and provide rapid intervention as required, but the battalion would also have carriers for other functions, including transporting the mortar platoon and towing the anti-tank guns. The carrier was useful for any number of roles and by the latter stages of the war an infantry battalion might have a total of about fifty of them.

In peacetime, each regiment would have two regular battalions, though they would virtually never be stationed together, and a number of territorial battalions, which is why we find titles such as '6th Royal Scots Fusiliers' or '4th Black Watch'. From time to time two battalions might be amalgamated to make one, hence terms such as '5th/7th Battalion'.

Three rifle battalions would be grouped together to form a brigade and, for the most part, a brigade would serve as one of three in a division commanded by a major general. However, some brigades were 'independent', meaning that they were available to the army commander as discrete assets to be committed directly to the battle as required rather than being given instructions through a divisional headquarters.

In much the same way that the battalion had integral artillery support in the shape of the mortar platoon, the division would have a strong artillery element. In most cases this would consist of three regiments of field guns, each equipped with three batteries of eight 25 pounder guns. The other combat asset of the division was the reconnaissance regiment, whose role, as the title implies, was to identify where the enemy was and, just as importantly, where he was not. The reconnaissance regiment was divided, not into companies and platoons, but into squadrons and troops. The equipment of the unit varied a great deal depending on the theatre of war and the availability of material, but generally consisted of armoured cars, scout cars and half-tracks. The half-tracks would carry infantry elements that could be dismounted to carry out reconnaissance on foot or to secure a particular objective until relieved by a rifle battalion.

A large part of the infantry division was not infantrymen at all, but members of the many different branches of the service that were required to ensure that the troops in the frontline were properly supplied with food, water and ammunition, that their vehicles were properly maintained and a hundred other tasks that had to be dealt with if the division was going to be an effective fighting force.

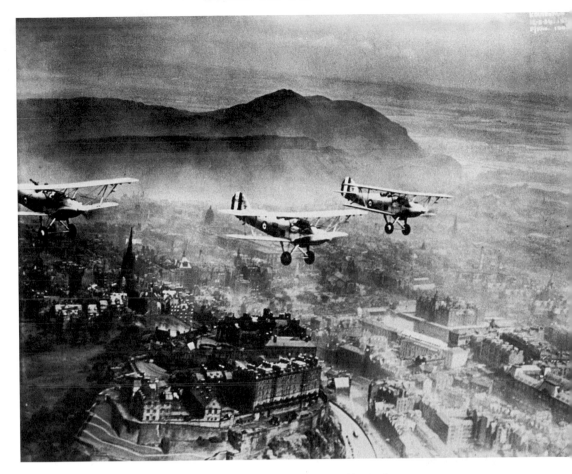

A spectacular image of the RAF flying over Edinburgh Castle. (Scotsman Publications)

Like the reconnaissance regiment of an infantry division, armoured units were subdivided into squadrons and troops. Armoured units are almost invariably described as regiments rather than battalions. The number of men and the number of tanks varied considerably through the war years, partly due to the differing needs of the wide variety of vehicles used; the Sherman – by far the most widely used Allied tank in the Second World War – needed a crew of four, but the Grant needed six or seven men. Until late 1944 there were generally three tanks to a troop, commanded by a lieutenant, and four troops to a squadron, commanded by a major. The regiment, commanded by a lieutenant colonel, would also generally include a reconnaissance squadron of light tanks and an anti-aircraft squadron of tanks mounting multiple machine-guns, though these tended to disappear in the later stages of the war as the Luftwaffe lost control of the air. As a rule, an armoured regiment might have anything from fifty-five to seventy-eight tanks in its theoretical strength, but would seldom be able to put that number into the field due to

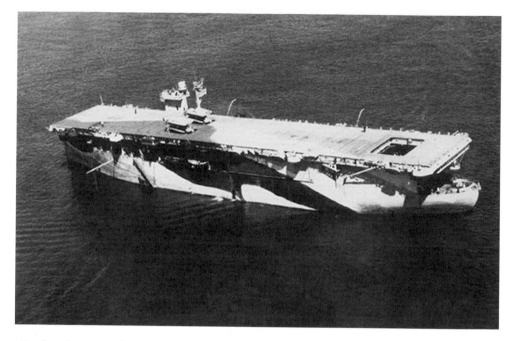

Aircraft carriers were to play a vital role in mobilising troops all over the world. HMS Dasher, pictured above, exploded in the Firth of Clyde in March 1943. (Scotsman Publications)

battle losses and mechanical breakdowns. Broadly speaking, there were two kinds of tank units in the later stages of the war. Some units were designed to combat the armoured divisions of the enemy, others to support infantry battalions, but in either case the number of men required to make the unit function was very much greater than the number of men required to crew the tanks.

The disparity in numbers between the actual combatants and the men and women required to make a unit function was even greater in the RAF. A fighter squadron would generally have a complement of twelve aircraft divided into two flights and each flight divided into two or three sections, but keeping the dozen or so Spitfires, Hurricanes or Typhoons in the air required the skills of several hundred mechanics, fitters, engineers, armament specialists and others, not to mention the radar staff and plotters who would direct the aircraft into battle.

The same principle applied to the Royal Navy. From minesweepers and motor launches to battleships and aircraft carriers, the number of men actively engaged in firing weapons was a relatively small proportion of the complement of the ship, but every man on board was vital to the well-being and effectiveness of the vessel in battle.

3

THE PHONEY WAR

Hitler's invasion of Poland prompted Britain and France to declare war on Germany on 3 September 1939. Army and RAF units were deployed to the Franco-Belgian border and Royal Navy ships were committed to a blockade of German ports. Over the next few months a large proportion of the Regular Army – and by 1940 many territorial units – had been committed and the BEF grew into an army of more than 150,000 men in three corps. The planning process for sending an army to France had started in earnest after the Nazi annexation of Austria in 1938 and the movement of troops and equipment was carried out in a fairly efficient manner. By the end of October 1940 something in the region of 160,000 servicemen, 25,000 vehicles and a considerable proportion of the fighter and light bomber squadrons of the RAF had already been sent across the Channel. By the end of January they had been joined by 51st Highland Division.

Despite the deployment of such large forces on land and in the air, very little actually happened in the autumn and winter of 1939/40. The French Government had put its faith in the Maginot Line and both they and the British adopted something of a 'wait and see' policy in the hope that a political solution could be arranged that would prevent the war from turning into a real conflict. There were two major flaws with this approach. The Maginot Line had not been completed and, in any case, did not extend to the Franco-Belgian border area and was therefore vulnerable to a flanking manoeuvre through the Netherlands and Belgium into northern France. However strong the Maginot fortifications might be, the Germans could avoid attacking them altogether and thus render them utterly redundant.

The failure of the British and the French to pursue the war actively through the autumn and winter of 1939 was a catastrophic error of judgement. It was driven by a number of political factors, but probably the most significant issue was the desire to avoid another prolonged bloodbath on the model of the 1914–18 war. The belief

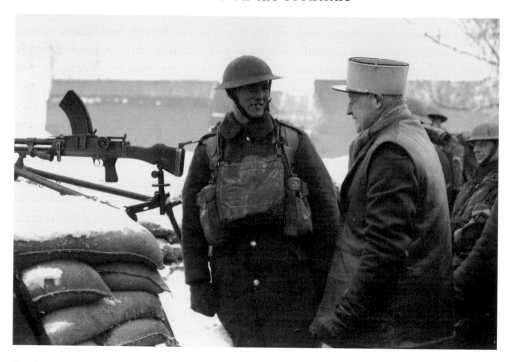

Royal Scots Bren gunner with a French officer near Lecelles, 26 January 1940. (Royal Scots Museum)

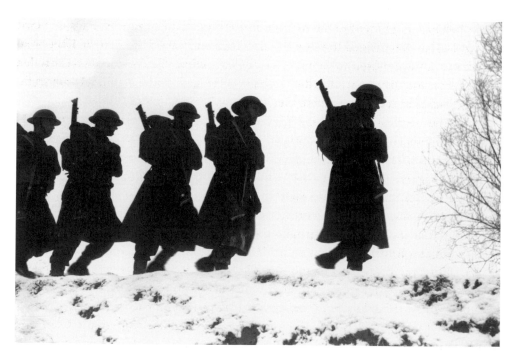

Men of 1st Battalion the Royal Scots going forward to an advanced post near Lecelles, 26 January 1940. (Royal Scots Museum)

that the Maginot Line and the scale of the power of the French and British armies, navies and air forces would be sufficient to deter a German attack smacked strongly of wishful thinking. The French and British forces took virtually no offensive action for nine months. There were a number of relatively minor bombing raids and several operations which consisted of dropping propaganda materials, but the general policy was to build up the Army in Flanders against a possible German attack to the north of the Maginot Line.

All this came to an abrupt end on 10 May 1940, when the German Army mounted an offensive through the forests of the Ardennes – an area that the Allied leadership had decided was impenetrable to a modern, mechanised army. The end of the 'phoney war' in France led to the resignation of Neville Chamberlain and his replacement by Winston Churchill, who had always favoured a more aggressive policy toward the Germans, but the damage was already done. The focus on conducting a purely defensive campaign meant that there was no means of assembling a mobile reserve that could halt the German advance and within a few weeks the Battle of France had been decided.

Most of the BEF was obliged to withdraw to the Channel and was successfully evacuated at Dunkirk, between 26 May and 3 June. The two Scottish divisions were too far away to be withdrawn in that process.

The 51st Division had initially been deployed to relieve the French 21st Division between Bailleul and Armentiéres, where the troops could prepare for battle, work on defences and generally adjust to being in France. The division remained there for some weeks before being moved to the Moselle region. The division repelled a major attack on 13 May, but was obliged to retire to maintain contact with the French. They were withdrawn from the front to Varennes on 20 May, where the divisional commander, General Fortune, discovered that the German Army had made a stunningly successful advance and had managed to divide the French and British forces.

When the Germans invaded, the division was thus separated from the main body of the BEF by a considerable distance as it retired to Dunkirk. Since the Germans had outflanked the Maginot Line, the fortifications had become redundant and the division was ordered to retire to the Somme, where it would join the French Tenth Army under General Robert Altmayer.

The Tenth Army, and consequently the 51st Division, were committed to an unfeasibly long front and when the Germans mounted a major attack on 5 June they were able to inflict a heavy defeat on 154th Brigade, which consisted of one battalion of the Black Watch and two battalions of the Argyll and Sutherland Highlanders. Separated from the rest of the division, 154th Brigade made its way westward and became the basis of 'Arkforce', an ad hoc formation committed to forming a defensive line to the east of Le Havre which would allow the withdrawal of the balance of 51st Division and various French formations. The crowded roads, the intervention of the Luftwaffe and the swift movement of the German 7th Panzer Division prevented

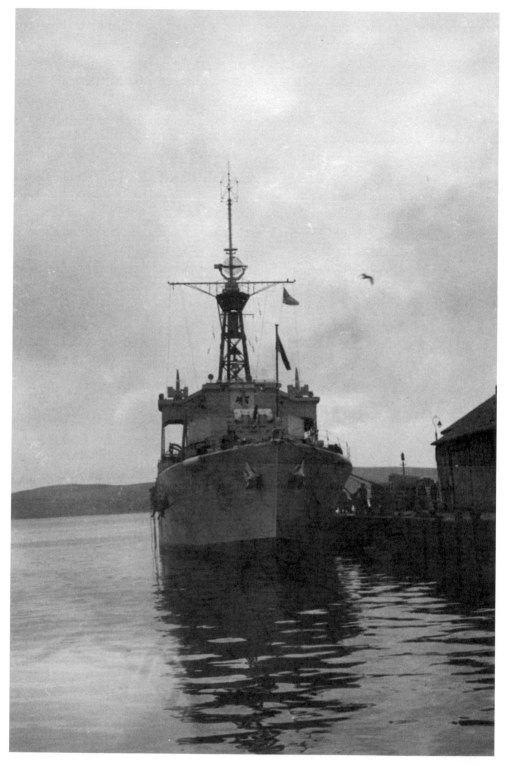

Fishing trawlers such as this were used as part of the evacuation at Dunkirk. (Courtesy of the Shetland Museum)

the units committed to Arkforce from concentrating, let alone fulfilling their task, and the unit was eventually evacuated from Le Havre on 13 June.

The other two brigades of the 51st Division (152nd and 153rd) were less fortunate. Encircled by the Germans at Saint-Valéry-en-Caux, they were forced to surrender on 12 June.

The battalions of 51st Division were not the only Scots in France in 1940. In addition to the many Scottish RAF personnel and those in the Royal Artillery, Engineers and other armed services, the 1st and 6th Royal Scots, 2nd Cameronians, 6th Seaforths, 6th Argylls, 4th and 6th Gordons, 1st Queen's Own Cameron Highlanders, 1st King's Own Scottish Borderers, 6th Black Watch and 1st Highland Light Infantry were all serving with divisions of I, II or III Corps. Additionally, a second wave of the BEF, operating under the title 'Normanforce' and including 52nd Lowland Division and elements of 1st Canadian Division, arrived in France in May 1940 to be commanded by General Sir Alan Brooke. By the time General Brooke arrived it was abundantly clear that there was nothing that his force could do which would materially affect the course of the battle. There was a French plan to continue the campaign in the northwest, but it was not based on sound strategic or tactical principles and was bound for failure. Even if the necessary forces could be saved from the disasters that had occurred over the preceding month, the morale of the French Army was shattered. On 14 June Brooke managed to persuade Churchill that there was no future in carrying on the fight in France and that the only sensible course of action was to withdraw all the remaining elements of the BEF – chiefly the 52nd Division, elements of the 1st Canadian Division and the remaining units of the 1st Armoured Division – as quickly as possible. Accordingly, Brooke concentrated his command at Cherbourg and St Malo, where they were evacuated between 15 and 17 June.

There were, of course, Scottish battalions elsewhere in France. One battalion from the Seaforths and 2nd Battalion Royal Scots Fusiliers served in 17th Brigade of the 5th Division. The day after the German attack commenced 17th Brigade left their base at St Pol and started their journey to the front on foot. It is unclear whether this was because of transport shortages or for fear of German air strikes, though the former seems more likely. One officer recorded the experience:

> There followed three days of marching in very hot weather along dusty country roads and at the end we found ourselves at Monchy Gayeux, 40 miles nearer the enemy than when we set off. There we rested for a day and from then on things began to happen more rapidly. On the afternoon of the 15th the Battalion embussed in troop-carrying transport and moved off heading for Ninove in Belgium.
>
> This journey, like all others that followed during the next ten days, was slow and tedious, for not only were the roads overburdened with Army vehicles moving into Belgium but there was also a steady stream of civilian traffic moving back in the opposite direction. This consisted of every form of vehicle – lorries, private cars, horse-drawn carts and

wagons and even perambulators. In addition, there were thousands of pedestrian refugees leaving their homes in search of safety. As we approached the battle area the roads became more densely congested. The inhabitants had for the most part forsaken their homes, taking with them such of their valuables as they could carry and leaving behind them a state of confusion and chaos which can only be described as appalling. [History of the Royal Scots Fusiliers, 1919-59, Lt Col J. Kemp, hereafter 'Hist. RSF']

The problems encountered in getting to the front were compounded by the nature of the front itself. The Maginot Line was a remarkable piece of military science and engineering, but the fact that no part of it was actually 100 per cent completed was as nothing to the fact that it was conceptually obsolete. For all the vast amount of money poured into it, it was more of a burden than an asset. Firstly, the sums spent would have been better used in developing an army structure suitable for mechanised warfare – as advocated by several French generals and virtually all serious military thinkers of the day. Secondly, the fortifications bred a positional mentality. Since they had been so expensive to build they must surely be of value and must therefore be strongly manned even if that meant depriving the field units of manpower, transport and supplies. Essentially, the French Government had done what most governments do, spent lavish sums on a highly visible project of the kind that might have been useful in the preceding war; they had just done it on an unusually grand scale. Failure to complete the installations did not help; Colonel Kemp does not specifically comment on the uselessness of an 'anti-tank ditch a foot deep', but he was clearly unimpressed with the Maginot Line installations:

> … with their impenetrable wire defences and minefields, big guns, underground passages, and elaborate fire plans covering every inch of wire and the minefields, were immensely impressive. Their power and the careful planning of their construction were subsequently proved by the way they held out after being completely surrounded. There was, however, no gun of larger calibre than 75 millimetres in the line itself. In front of the fortified line was the *Ligne de Contacte*, a series of scattered independent posts on the eastern edge of the Forêt de Bouzonville. Behind was the *Ligne de Soutiens*, almost non-existent, and supposedly a support line; behind this again lay the *Ligne de Recueil*, with an anti-tank ditch a foot deep and slit trenches, situated on a forward slope giving an almost uninterrupted view over several miles. The Maginot posts were in telephonic communication with forward artillery observation officers, who by means of a code could ensure that any 100 metre square on the map received 100 shells within 60 seconds after a call for fire.

This was all very impressive in its own way (though it is hard to envisage any useful function for an anti-tank ditch that was only a foot deep), but if the Maginot Line was to be of any value at all, the Germans had to choose to attack it. By adopting a purely defensive posture, the British and French armies were already halfway

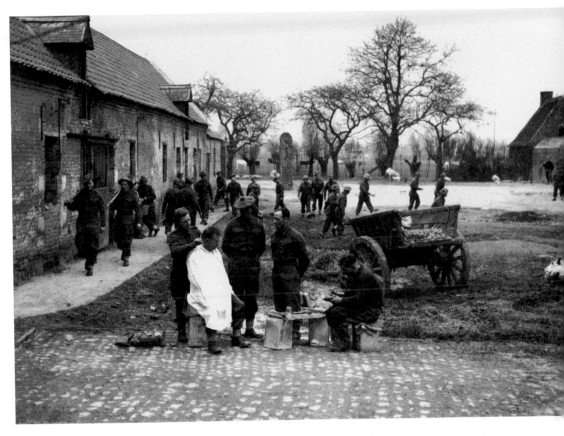

Regimental barber at work, 18 April 1940. (Royal Scots Museum)

to defeat. There were German forces nearby, but the French (and therefore the British) adopted a very passive policy:

On taking over, the 51st Division found that the enemy had hardly been disturbed by the French. A flag flew at the German Battalion headquarters on Hitler's birthday, and the comings and goings at an enemy regimental headquarters could be clearly observed through field glasses. 'No man's land' was from half a mile to a mile wide at Dampont Farm. Hedges, ditches, woods, copses and undulating pasture gave good cover and the enemy made full use of it; their forest wardens patrolled with dogs and moved almost as and where they liked. The wardens, local men, knew every inch of the ground and had friends, probably relations too, on the French side of the border. Every evening after dark 'A' Company laid a network of black threads, each about three yards long and tied at one end, the loose end stretched on top of the grass in gateways and gaps in the hedges. In the morning the enemy's movements were easily read, and a detailed picture of patrol routes could have been built up had the Germans not carefully changed them nightly to avoid ambush. Nevertheless much useful information was obtained. [Hist. RSF]

To all practical intents and purposes, the Royal Scots Fusiliers, along with every other battalion in France, had been committed to a sort of 'watching brief'. No serious action was to be undertaken, not even, it would seem, offensive patrolling to take prisoners. As a regular battalion, the fusiliers were men who had trained for battle throughout their working lives; they were professional soldiers. Now three out of four of the riflemen were being tasked with digging trenches and erecting wire around existing fortifications of very doubtful value:

> … 'A' Company was preparing for the first contact with the enemy, the rest of the Battalion was kept occupied on pioneer duties. Eric Linklater records in *The Highland Division* that the 51st Division's two pioneer battalions, the Fusiliers and the Norfolks, 'did some strenuous work. Forward of the Maginot Line they used mules to carry their building material, the only form of transport that could be taken right into the outpost line.'[ibid]

The 'phoney war' period came to an end in the late spring of 1940. Although the French and British armies had been in the same positions for months on end, there seems to have been no valid planning at any level for the possibility that there might, eventually, be some fighting or that the Germans might not be so obliging as to attack in areas that would be convenient for the Allies. The fusiliers moved off toward the anticipated battle area:

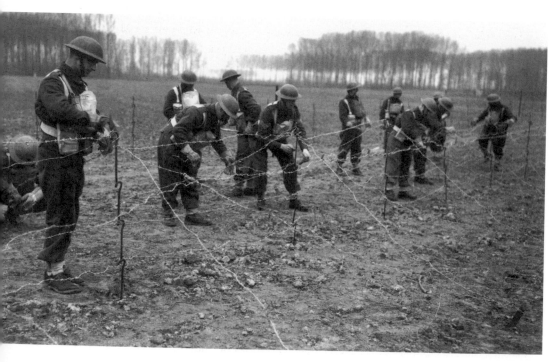

Men of the 1st Royal Scots fitting up barbed wire entrapments, 18 April 1940. (Royal Scots Museum)

On May 10, the day Hitler invaded the Low Countries, the Fusiliers were ordered to move out to St. François and dig in on the *Ligne de Recueil* on a front of 3,000 yards which had been allotted to them there. About 100 anti-tank mines and a few coils of wire were available; also one 2-pounder anti-tank gun and one platoon of medium machine guns which was not under command of the Battalion. On the evening of May 12 the Fusiliers' official orders arrived, but there was no reference in them to the relief of 'C' Company, which was still in the Maginot Line. The Fusiliers were to hold their front on the *Ligne de Recueil* until the 154th Infantry Brigade of the 51st Division passed through, and for a further five hours thereafter. Moreover the 154th Brigade took the medium machine guns and the anti-tank guns with them as they withdrew, leaving the Fusiliers, 300 strong, strung out on a front of 3,000 yards on a forward slope, with only 100 anti-tank mines and seven Bren guns. The situation appeared so likely to result in an unnecessary waste of lives that Lord Rowallan protested to the Divisional Commander, Major-General Fortune, who accepted the protest.

The battalion war diary makes for depressing though somehow unsurprising reading. Less than three weeks after the opening of the German offensive, the situation was dire. Communications were poor at best and non-existent at worst. Vast amounts of material had been discarded by retreating units and consequently there were local shortages of all the crucial sinews of war – food, petrol, medical supplies and ammunition:

May 27. Arrived Rouvray. No hot coffee for the men, but the rest camp not far away – four mile march. Enormous quantities of food and stores of all kinds thrown about in odd corners. Impossible to get any information as to whereabouts of the 51st Division. Lord Rowallan with the commanding officers of the 4th Camerons, 4th Seaforth, 4th Black Watch, 5th Gordons and 7th Norfolks, decided to go to Rouen Sub-Area in a body. Discovered that 51st Division is at Gisors. Four rifle Battalions ordered to move at 6 p.m. Do not know what will happen to us.

May 28. Still awaiting news of our advanced party and road party. No orders from 51st Division. At 10 p.m. Captain Gluckstein told us not to move except on orders from Division. Norfolks received operation order for one destination but do not know if it has been altered since issued.

May 29. Buses waiting for us from French General Headquarters. Still no word from 51st Division nor is it possible to get in touch with them. Finally decide to go to Neufchatel ahead of buses to see Divisional Headquarters and warn them of our move. See Colonel Roney-Dougal and find destination is as stated in Operation Order. Go on to billeting area and learn that our transport has arrived and all safe. Whole Battalion arrives about 2 p.m. to have hot meal provided on our cookers by our own cooks. So ends the most extraordinary move – 400 miles across France. [ibid]

A soldier on duty keeps watch through a periscope. (Scotsman Newspaper)

The contributors to Colonel Kemp's history were able to give a vivid picture of the retreat across France and, incidentally, give the reader occasional glimpses of other units and formations. This serves to remind us that the individual battalions, however self-contained they might seem, were always part of a much larger picture, dependent on the efforts of other units and departments of the Army. The squadron of the Lothians and Border Horse referred to in this episode were part of a divisional reconnaissance regiment:

The road to 'A' Company's position at Eu was blocked by fallen trees and telegraph poles and was under constant fire. The dispatch rider could not get through with the order to withdraw, but Fusilier Parsons, who took over the task, managed to find a way after pioneers had cleared the road. However, there was an hour's delay in getting the message to 'A' Company. The operation of bringing out the two forward companies along heavily shelled roads now began. For 'C' Company, the rearward route had not suffered much damage and

the move was comparatively easy; but Lieutenant Gow, who had been left in charge of 'A' Company, had great difficulty in disengaging, collecting the men together, and withdrawing. A squadron of the Lothians and Border Horse were covering the withdrawal, but they could not be committed to the valley and had to remain on the high ground to carry out their role; also they could wait for only a limited time, although the squadron leader agreed to stay in position for half an hour longer than was scheduled.

The new positions at Belleville were strong; the Norfolks and Royal Engineers had worked very hard to prepare them. However, the general situation was confused and there was little information of how the battle further south had gone. To add to the confusion a military policeman arrived at 'B' Company's position with orders for transmission to Battalion Headquarters that the battalion group must at once take up a line facing south, as they were already outflanked by the enemy. When a search was made for this policeman to have the orders confirmed he could not be found. Fifth Column activity was widespread. Even the French liaison officer attached to the Scots Fusiliers had been sent back to Divisional Headquarters under arrest. He had acted in a suspicious manner, and when with Battalion Headquarters in Flocques had shouted loudly across the village street: 'When is the battalion withdrawing tonight?' The question did not even need to be answered; as long as it

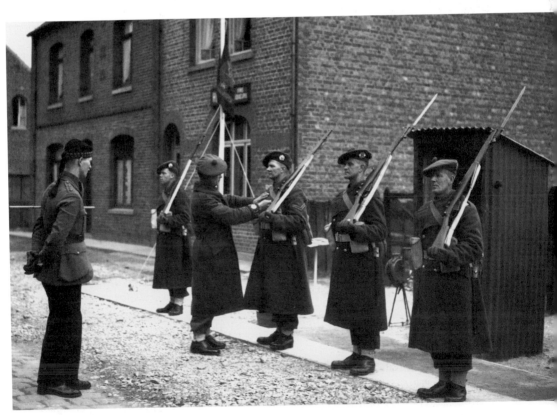

Men of the Royal Scots on guard duty, 18 April 1940, during the Phoney War period. (Royal Scots Museum)

was heard and understood by the enemy, sensitive information had already been given away – the fact that the battalion was going to withdraw at all would have been a useful addition to the enemy's intelligence picture [ibid].

France was not the only theatre of war in 1940. Concerned that Norway, under pressure from Britain and France, might disrupt the supply of Swedish iron, Germany invaded on 9 April 1940. Britain's contribution to the defence of Norway included elements of the Cameronians and 1st Battalion, the Scots Guards, who landed at Harsad on 16–18 May. As part of 24th Guards Brigade, the battalion was deployed to defend harbours from the German advance, but there was no real prospect of preventing the Germans from conquering all of Norway, and the British and French forces were withdrawn by the end of the first week in June. This operation was also the first active service deployment for elements of the Liverpool Scottish. Both the Liverpool Scottish battalions would remain in Britain for the duration of the war, providing recruits for other regiments, mostly, though not exclusively, for the Cameron Highlanders. The 2nd Battalion was turned into an anti-tank regiment in 1942. However, as this excerpt from the regimental history shows, some Liverpool Scottish men served in Norway:

> The Liverpool Scottish contributed a troop to the composite No. 4 Independent Company, which also contained troops from the King's Regiment and South Lancashires, collectively under the command of Major J.R. Paterson – an officer from the Scottish. Formed on 21 April 1940, at Sizewell, the company soon after embarked aboard the Ulster Prince, bound for Norway to join the Allied campaign against Germany. After landing in early May, No. 4 Company relieved a French force and occupied positions near Mosjoen. The company, in conjunction with others, operated under the aegis of Scisserforce, commanded by Brigadier Colin Gubbins. When a German landing cut off Mosjoen from the north on 11 May, No. 4 Company had to be evacuated by a Norwegian steamer and transported to Sandnessjøen, then to Bodø with No. 5 Company.

The Norway campaign, like the campaign in France, was an utter failure, but at least in Norway there was the mitigating factor that the whole operation had been put together at the last minute and at a time when there was very little in the way of manpower or equipment available. The French campaign was obviously the biggest drain on the resources of the armed services, but the Army, Navy and Air Force were under huge pressure to provide a presence in many other locations. The Italians – and in due course the Germans – threatened the Suez Canal and were competing for control of the Mediterranean. After the fall of France the Vichy Government had control of forces in Syria, Lebanon, Algeria, Madagascar and Indo-China, and although the threat of Japan was largely ignored until it was too late, British garrisons in Malaya, Burma and Hong Kong represented a significant part of the British

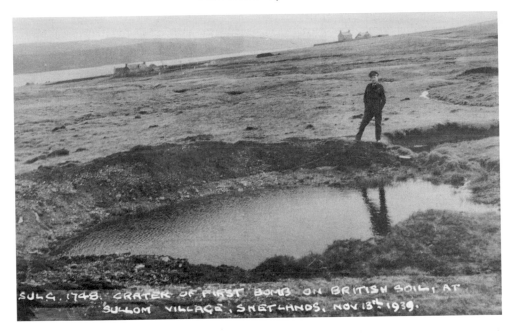

The first bomb to land on British soil, Shetlands 1940. (Shetland Museum)

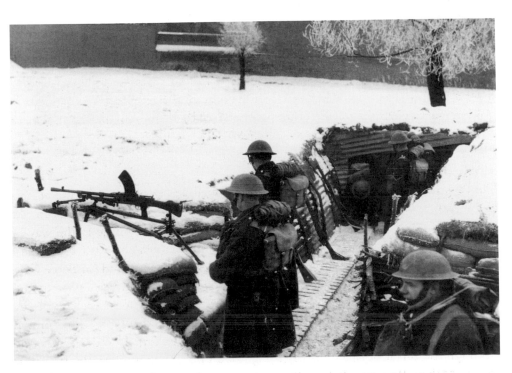

A trench manned by 1st Battalion the Royal Scots in Belgium, winter 1940. (Royal Scots Museum)

military establishment. The demand for men and machines was worldwide and could not possibly have been met whatever actions Churchill's government had taken; the loss of thousands of men and vast quantities of transport, armour, artillery and stores of all kinds in France simply made a bad situation worse.

The campaign of 1940 was a severe blow to Britain as a whole and to Scottish society in particular. There was a degree of suspicion – not perhaps entirely unfounded – that the 51st Division had been sacrificed to save other formations. A more realistic suggestion is that Churchill kept the 51st Division in battle in an effort to persuade the French to keep fighting from their many colonies around the world. Captain Ian Campbell of General Fortune's intelligence staff was convinced that this was the case. More than thirty years after the event he declared:

> It has always been abundantly clear to me that no division has ever been more uselessly sacrificed. It could have been got away a week before but the powers that be – owing I think to very faulty information – had come to the conclusion that there was a capacity for resistance in France which was not actually there. [www.51HD.co.uk]

There had, of course, been losses among the Air Force and Navy personnel, as well as in the 52nd Division and the twelve Scottish infantry battalions assigned to I, II and III Corps of the BEF, but the loss of the 51st Division has loomed large in Scotland ever since and is the subject of several folk and rock and roll songs; the dance 'Reel of the 51st Division' was composed at Laufen POW camp and was the first contemporary piece to be published by the Royal Scottish Country Dance Society.

The surrender at St Valéry was not the end of the 51st Division, which was reformed from the survivors of 154th Brigade and the transfer of two brigades from the 9th Highland Division. The 9th Division continued to exist as a training formation, preparing recruits for the other Scottish divisions and conducting trials and training for specialist armoured vehicle developments until the end of the war. For the next two years the 51st Division was committed to home defence until it was deployed to North Africa in June 1942.

4

THE DESERT

To a great extent the war in Africa is identified with the exploits of the Eighth Army and with the generalship of Field Marshal Montgomery in the campaigns through Egypt, Libya, Tunisia and Algeria. However, there were also extensive campaigns in north-west Africa, in which the 2nd Battalion Queen's Own Cameron Highlanders, 2nd Battalion Highland Light Infantry, 2nd Battalion Black Watch, and 1st and 3rd battalions Transvaal Scottish all saw service alongside African and Indian troops. The East Africa campaign raged through the Sudan, Somalia, Eritrea, Ethiopia and Kenya. Despite being fought with very limited resources, very little air support and only a handful of tanks and armoured cars, the campaign was a major victory for Commonwealth forces and resulted in the comprehensive defeat of a substantial Italian force. However, a number of Italian troops, possibly as many as 7,000, continued a guerrilla campaign for some time, including a highly successful attack on the Commonwealth ordnance stores at Addis Ababa. Elsewhere in the region, the British had developed considerable interests, largely a product of the destruction of the Ottoman Empire at the end of the First World War. These interests included a considerable commitment to Iraq. Under the terms of a series of British–Iraqi treaties made between 1922 and 1930, the British Government took effective control of the military and economic structures of the country, the latter becoming especially significant after the discovery of oil in the late 1920s. The treaties allowed the British to maintain several large sovereign bases and to raise troops to maintain order, and for over a decade Iraq became something of a second home to the RAF, though the number of bases was eventually reduced under the terms of the 1937 treaty to just two, RAF Habbaniyeh near Baghdad and RAF Shaiba near Basra. Naturally a good many Scots spent time in pre-war Iraq in the Army and RAF. In March 1941 the 'Golden Square' movement in Iraq staged a *coup d'état* and formed a government which, if not especially sympathetic to the Axis, was certainly opposed to the Allies. The British

A personalised greeting card for soldiers to send home from the desert. (Argyll and Sutherland Highlanders Museum)

could not afford to accept the loss of the bases at Habbaniyeh and Shaiba and acted quickly to defeat the insurgents and restore a pro-Allied government. Although the insurgents received support from the Vichy Government in the shape of supplies of small arms, some field guns and ammunition from Syria, which had not yet been occupied by the British, and air support from Italian and German forces, the conflict was over in less than a month.

There were other British deployments in the Middle East. When the war broke out the Scots Greys (2nd Dragoons) were stationed in Palestine, where they had formed part of the garrison provided by the British Government to maintain the peace under the auspices of the League of Nations. The Scots Greys were still functioning as a conventional mounted unit and carried out what was probably the last cavalry charge by the British Army against Arab rioters in February 1940. Elements of the regiment took part in Operation Exporter, a campaign to remove the Vichy French governments of Syria and Lebanon after the fall of France in 1940. The unit received its

Above *Scottish RAF troops posted to Shaiba, Iraq celebrate their Christmas party. (Courtesy of Ms Heather Johnson)*

Right *The RAF were often posted to foreign airbases, as shown here by this airman's identity card. (Courtesy of 603 Sqn RAFVR)*

first tanks in September 1941 – the American-built 'Stuart'. The lightly armoured and armed Stuart was no match for the German Panzerkampfwagen III and IV, but it was fast and mechanically reliable, and was relatively popular with the crews.

The Scots Greys were in action at El Alamein in October 1942, serving with the 22nd Armoured Brigade in the famous 7th Armoured Division. By June 1943 their Stuarts had been replaced with the Grant, a more heavily armoured vehicle, but which had the drawback of having its main gun mounted in a sponson on the right-hand side of the vehicle rather than in a proper rotating turret. This was a major disadvantage in battle since the whole tank had to turn around to engage an enemy to the flank or rear.

The Grant was really a stop-gap measure, deployed pending the introduction of the Sherman, but would go on to see extensive service in Burma, where it seriously outclassed the dated Japanese Chi-Ha. The Greys lost their Grants briefly when they were removed and issued to other units to make good losses incurred during the battles at Tobruk, but were in action in July 1943 with a mixture of Grants and Stuarts. Losses in battle and in transit coupled with a shortage of replacement vehicles led to the Scots Greys being forced to field a mixture of Grant, Sherman and Stuart tanks for a short period, which must have been an enormous challenge to the engineers, mechanics and fitters who had the task of keeping as many vehicles as possible ready for battle.

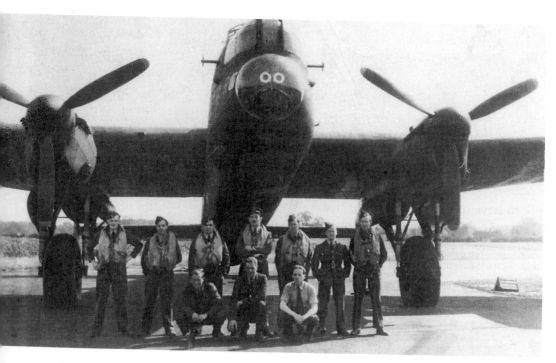

A rare, but poor quality, image of an RAF group in the desert. (Ms Heather Johnson)

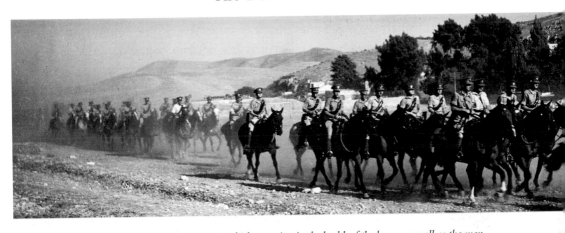

Cavalry moves across the desert, a harsh terrain in which to maintain the health of the horses, as well as the men. (Courtesy of Royal Scots Dragoon Guards Museum)

At the start of the Second World War the British Army had already had a long relationship with Egypt, dating back to the 1880s. In 1939 there were more than 35,000 British soldiers in the country, chiefly to ensure the safety of the Suez Canal and the oilfields of Arabia. Egypt was also the home of the 'Cairo Cavalry Brigade', a training formation which conducted a good deal of tactical and technical experimentation in the country, which had gained independence in 1922 but to all intents and purposes was firmly under British control. Shortly before the war Admiral Cunningham (an Irish-born Scot who would serve as the Lord High Commissioner to the General Assembly of the Church of Scotland) moved the headquarters of the Mediterranean Fleet of the Royal Navy from Malta to Alexandria as a precaution against possible Italian air attacks.

Not all of the Scots – or even Scottish units – that fought in North Africa served in the 51st Division, and naturally they were not always in combat. Gunner Robert Smith of the Scottish Horse remembered attending a race meeting in 1943 or 1944 with a group of friends. One member of the party was a bookmaker in civilian life and quickly realised that the signals used by Egyptian bookies were very similar to those used at home. With the benefit of the information gleaned, the entire party was able to leave the racecourse rather better off than they had been when they arrived. Gunner Smith and his comrades were not above taking advantage of other opportunities. The loss of a water bowser (a truck mounting a large water tank) had led to a considerable degree of discomfort for his unit. When his unit arrived in Tripoli Gunner Smith and his battery commander saw an unattended water bowser of the same model and promptly added it to the regimental strength for the rest of the war.

The El Alamein Campaign

The 51st Division arrived in Egypt on 14 August 1942 and therefore had only a little more than two months to adjust to the climate and learn the operational practices they would require for desert combat before being committed to battle as part of XXX Corps at El Alamein. The corps mounted an attack with four infantry divisions against the strongest part of the Axis lines, with the intention of forcing a breach through the enemy entrenchments and minefields which could then be exploited by a massive armoured force. During the night of 23/24 October, with the 2nd New Zealand Division to the south and 9th Australian Division to the north, 152nd and 154th brigades of the 51st, with 153rd Brigade in support, advanced from defensive positions about 30km east of El Alamein. The division met stubborn resistance, but made good progress; however, the advance slowed as the Germans and Italians reorganised. A second attack, Operation Supercharge, was mounted on 2 November and after two days of hard fighting XXX Corps was able to carry out a steady advance to the west with the aims of destroying the Axis desert army and uniting with the American and British forces which had landed in Morocco and Algeria in November and had comprehensively defeated the Vichy French forces in north-west Africa.

In January the 51st Division continued to advance westward. At dawn on the 20th, the leading brigade (154th) passed Hons only to discover a strong enemy position about 5km to the west, based on an old fort which the brigade immediately named 'Edinburgh'. With the support of the 40th Royal Tank Regiment, 2nd Seaforths, 7th Black Watch and 7th Argylls, they moved northwards to the coast road in order to outflank the enemy but encountered an anti-tank ditch which forced them to continue the advance on foot and without their supporting arms. They pressed on until they met with an armoured force, which they engaged briefly before realising that they were firing on British armoured vehicles. These turned out to be vehicles that the Germans had captured and the fighting was renewed for a period until the enemy was forced to break off the engagement and retreat.

The Germans and Italians were now under great pressure from both the east and the west, and were unable to change the course of the battle. Early on 23 January the 1st battalion of the Gordon Highlanders was able to ride into Tripoli on the back of the tanks of the 40th Royal Tank Regiment, facing little or no opposition.

The division was now able to make a steady advance to the west until it reached the Axis Mareth Line in Tunisia toward the end of February 1943, at which point there was a lull in the battle until the various formations of the Army could be replenished and rested before renewing the attack. The Battle of Mareth lasted a week – 20–27 March – and though there was a good deal of hard fighting, the Eighth Army had now closed the gap with the US Army advancing eastwards. The North Africa campaign was not finished by any means, but the back of Field Marshal Rommel's Afrika Korps had been broken and several Italian formations

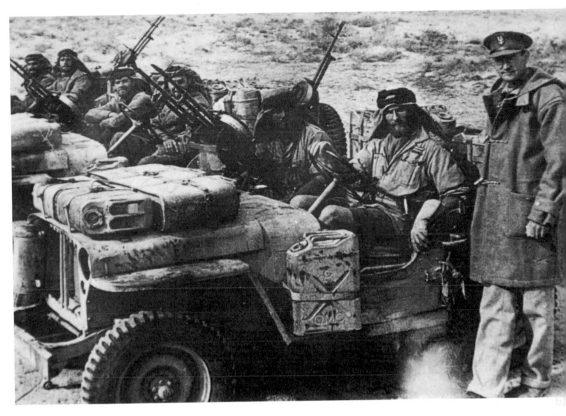

A famous photograph of special forces on operations in the Middle East. (Scots Guards Museum)

– including the remnants of the famed Ariete Division – had ceased to exist as a fighting force.

The 51st Division was in action again on 6/7 April on the Akarit Line in Tunisia, making an attack through minefields and fortifications in the Gabes Gap, a narrow strip of land bordered by the Mediterranean Sea to the north and a stretch of salt marshes to the south. Breaking through the Axis defences allowed the supporting formations to exploit the breach and destroy or capture large numbers of the enemy. Despite several counterattacks, the German and Italian forces were unable to restore their position and, with their flanks now seriously threatened, they were forced to retire on Tunis, which fell in early May with nearly a quarter of a million Axis men taken prisoner. The next target for the men of the Eighth Army and 51st Division would be Italy. Like any other combat formation in a long hard campaign, the division had had its ups and downs during desert operations. At one point Montgomery had felt it necessary to call in the divisional commander, Major General Douglas Wimberley, and give him an 'imperial rocket' of a row to 'ginger up' his troops. This had the desired effect but overall the division had established itself as a highly effective formation. As Montgomery himself would later put it: 'Of the many fine

divisions that served under me in the Second World War, none were finer than the Highland division.' He was not alone in this opinion. Field Marshal Lord Alanbrooke, arguably one of the greatest soldiers Britain has ever produced, expressed much the same sentiment:

> During the last war, I had the opportunity of seeing most of the British, Dominion and Indian Divisions, many American Divisions, and several French and Belgian Divisions, and I can assure you that, among all these, the 51st unquestionably takes its place alongside the very few which, through their valour and fighting record, stands in a category of their own.

No account of the Scots in the desert would be complete without this small anecdote recounted in one of Tom Shields' excellent *Tom Shields' Diary* volumes (Mainstream Publishing, 1991):

> Two Kilwinning men, serving with Monty in his desert campaign against the Germans, were in a foxhole, doing their best to shelter from the relentless sun.
> 'Here, d'ye ken whit day it is the day?' asks one.
> 'Naw. Whit day is it the day?' his pal replies. The first chap explains that it was Marymas Day, the big gala day in the area.
> 'They've got a grand day for it', the second man says, peering up at the cloudless skies.
> Clearly you really can take the boy out of Kilwinning, but you cannot take Kilwinning out of the boy.

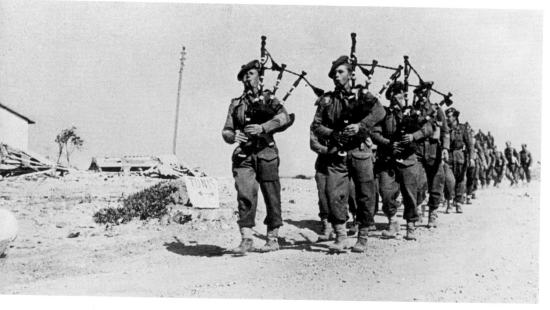

Troops march into battle led by the piper, an incongruous sight in the desert. (The Tank Museum, Bovington)

Madagascar

The operations in the more widely known theatres of the Second World War have tended to overshadow the fact that the war really was a global affair. British regiments, air squadrons and warships were in action from South America to the North Sea to the South China Sea. One of the conflicts that is generally overlooked is the invasion of Madagascar. Though it seldom makes more than a fleeting appearance in accounts of the conflict, the invasion of Madagascar in the early summer of 1942 was a crucial step in the process of the defeat of the Axis forces. It was vital to ensure that Japan did not secure a base on the western side of the Indian Ocean from which they could threaten the stream of men and materials headed for Burma and those flowing east from India. It also seemed that the acquisition of Madagascar, held by Vichy French forces, would help to prevent more effective co-operation between the Japanese in the east and the Germans and Italians in the west. The Japanese would not, in all probability, have had to make an assault on Madagascar. The Vichy Government in France would have been obliged to accept German demands either to surrender the island outright or at least to allow the Japanese to set up bases at their pleasure. Japanese naval operations had been sufficiently successful to force the Royal Navy to base its Far East Fleet in Mombasa, Kenya, because of the danger posed by Japanese submarines which, in 1942, were able to roam freely throughout the Indian Ocean.

The naval forces were largely supplied by the United States to release British warships for operations in the Mediterranean, but the land element was mostly British. In a telegram to President Roosevelt, Churchill proposed that the force should consist of 'two strong well-trained brigades, with a third in case of a check, together with tank-landing craft and two aircraft carriers, as well as a battleship and cruisers'. Neither of the formations chosen for the invasion was Scottish, but one of them, the 29th Independent Brigade, which had had specialist training for amphibious operations, included 1st Battalion Royal Scots. The 17th Brigade of the 5th Division, which included the 2nd Battalion Royal Scots Fusiliers, was also committed to the invasion force, named 'Force 121'.

The land operations commenced on 5 May and there was intense fighting for two days until the city of Diego Suarez was surrendered. Operations continued at a slow pace for several months, but in September a second landing was made at Majunga.

Sergeant Knox of the Royal Scots Fusiliers recalled:

> We got the ridge but were pinned down by enemy fire. We had lost several men wounded by shell-fire. Lieutenant Wright (commanding 16 Platoon, 'D' Company) and five others crawled forward to a shell hole. During this time Corporal Goodall was wounded. We found him and dragged him with us.
>
> At this point the Company Commander sent out an order for us to withdraw to the valley behind and work round to the right flank but this message was never received as the runner

was wounded. We tried several times to get out of our position but every time the snipers were too hot for us, so we then decided to wait till darkness and got successfully back at 2100 hours. [Hist. RSF]

The Vichy French forces consisted of about 6,000 Malagasy and 2,000 Senegalese soldiers of the French colonial forces and were prepared to fight fiercely, as Sergeant Knox relates:

We came under heavy machine gun fire from two posts and were pinned to the ground. One of these posts was silenced and we pushed forward 500 yards and were fired on, either by a 75-millimetre or mortar … I was hit on the steel helmet by something heavy and knocked out. Fusilier Docherty and Fusilier Bell went forward but both were wounded and made their way back to Battalion Headquarters, where they reported that I had been killed. When I recovered consciousness I searched for the other two but could not find them, but found the Bren and made my way to the rear company, 'D'. [ibid]

Several members of the Royal Scots Fusiliers were decorated or Mentioned in Despatches for their gallantry during the Madagascar campaign, but the most remarkable experience must be that of Lieutenant Reynier, whose conduct was commended by an enemy officer, one Lieutenant Bande, a French officer of the 2nd Madagascar Regiment. Lieutenant Bande wrote a letter to the commander of the fusiliers describing the action for which Lieutenant Reynier was awarded the Military Cross:

A rifle shot hit the man when he was several yards from the breastworks and a grenade which he was holding went off. The wounded man spoke French very well. He was hurt in the mouth by a bullet and wounded in the arm. The only arms he had was one hand grenade. He told us, and it is certainly the truth, that he had wanted to carry out an assault on the gun and open the path for your men. That action is one of a brave man. I believe I can tell you that, for you can be certain the French can pick one out [ibid].

Persia

For most people, the war in the Middle East is the same thing as the war in the desert, by which they generally mean the North Africa campaign through Egypt, Libya and Tunisia. In fact, the conflict was much more widespread. The war, per se, did not extend to Palestine or Jordan, though political conditions in those territories did demand substantial British garrisons, but there was a good deal of fighting throughout the rest of the region, notably in Syria, Iraq and the Lebanon. The Royal Scots Fusiliers spent some time there – a period described by Colonel Kemp:

Men take a break whilst on operations. (Scotsman Publications)

... the Fusiliers passed through Baghdad into the heart of Persia and reached Kermanshah, where they were visited by the Colonel of the Regiment and by General Sir Henry Maitland Wilson, who explained the underlying reasons for the frequent moves of the recent weeks. By October the Battalion had arrived at Qum, and for the first time since it left Diego Suarez was joined by its motor transport and carriers. The camp site at Qum, which the Battalion occupied for three months, was a bare, exposed hillside.

It was a bitterly cold winter. In order to resist the cold at nights the Fusiliers dug pits five or six feet deep underneath the tents. The countryside was inhospitable and Qum, in spite of its famous golden dome, was no more than a normally dirty Persian village. Relations with the inhabitants were cordial, except perhaps on St. Andrew's night when Sergeant Hutchison bought a sheep from which to produce haggis, but unhappily discovered that he had bought a goat. The New Year celebrations at Qum included the annual football match between officers and sergeants [Hist. RSF].

Spending St Andrew's night and Hogmanay far from home and with little or nothing in the way of the traditional comestibles associated with either meant that Iraq had not been a particularly pleasant interlude, but the fusiliers were not destined

to stay there for very long and were soon on their way for a veritable tour of the Middle East:

> On February 9, reinforced by a recently arrived draft, the Scots Fusiliers joined a huge convoy of vehicles crossing the Syrian Desert and moved into Palestine. From Tulkarm on February 15 they travelled on by rail to a combined operations school at Kalvit on the Great Lakes. After a course at the school the Battalion moved to Syria and continued its training in a series of exercises in the vicinity of Mount Hermon. The institution of regular leave parties to Beirut, on the Lebanon coast, was a popular feature of this time.
>
> Meanwhile there were signs of future events. The first jeeps were delivered, and instruction began in the latest infantry anti-tank weapon, the 'Piat'. Two austerity periods of 48 hours were imposed each week, during which the sole rations consisted of bully beef, biscuits and tea. In the middle of June the Fusiliers travelled by rail to Egypt, where they occupied a desert camp at El Shatt. Although no final destination had yet been revealed, training went on steadily according to a set invasion plan. The Battalion sailed in the *Monarch of Bermuda* in convoy down the Suez Canal into the Gulf of Aquaba, a desolate region dominated by Mount Sinai, where bonfires on the shore marked the so-called neutral territory of Saudi Arabia. On the sandy shores exercises usually began at about 3 a.m. and ended at about midday, when everybody bathed, in spite of rumours that the bay was full of sharks [ibid].

The 'austerity periods' helped to reduce the strain on the supply of foodstuffs, but they were also a part of the general conditioning of the troops. Once the battalion was in battle they might well be forced to subsist on limited rations from time to time and ensuring that the unit could continue to function as it should was an important element of their training and preparation for combat. 'Bully' (corned beef), ration biscuits and tea fell a long way short of being an attractive diet, and were only adequate in the sense that the Army claimed they were. In practice the diet was short on vitamins and fibre. Poor nutrition was a problem in every theatre and could only be tolerated because the troops were young and fit.

5

ITALY

The Allied landings on Sicily were a prelude to the first invasion of mainland Europe. For some time the Soviet Union had been calling for the Western Allies to become more closely involved in the struggle against Germany and Italy, though this was largely a matter of politics rather than strategy. Although the United States had already started to enlarge and modernise her armed forces before she entered the war in December 1941, she was not in a position to commit to the scale of effort that would be required to open the 'second front' in northern Europe that the Soviets wanted. The US Army and Navy were in the process of expansion at a very rapid rate, but that process would take some time and the Americans were also at war in the Pacific. Roosevelt was prepared to make the European theatre the first priority for American arms, but not the sole priority.

Overall command of the Sicily landings – Operation Husky – was entrusted to General Eisenhower, with General Alexander as his deputy and Admiral Cunningham as the chief of naval operations. The entirety of the 51st Division was committed to the operation, as were the 1st Argylls and 2nd Highland Light Infantry among the army troops (units that came directly under the control of the army commander and were not permanently attached to any of the subordinate formations), the 8th Argylls, 2nd Cameronians, 2nd Royal Scots Fusiliers and 6th Seaforths in the 17th, serving in 5th Division, and the 1st London Scottish in the 50th Division, and the 48th Highlanders of Canada and Seaforth Highlanders of Canada in 1st Canadian Division. As ever, a great many more Scots were serving in other infantry formations and in the different branches of the Army as well as in the Royal Navy and the RAF units committed to the operation.

The invasion was preceded by an extensive bombing campaign with targets spread all across southern Italy in an effort to keep the Axis forces off balance and unsure as to where the Allied offensive would land. By the time of the landings there were

only two serviceable airfields left on Sicily, which seriously undermined the ability of the Axis air forces to provide adequate support to the troops on the ground. The seaborne landings were disrupted by adverse weather conditions and the discovery of sandbanks; however, the Axis forces did not take immediate action against the landings on any scale and almost all the formations were able to get back on schedule in a very short period. The campaign lasted six weeks and ended with the withdrawal of most of the German formations and some Italians, but the bulk of the Italian troops – nearly 150,000 – were taken prisoner; a factor which did little to encourage Italian troops on the mainland.

The speed of the campaign and the large number of prisoners taken disguises the fierce nature of the fighting, as the following excerpt from Colonel Kemp's regimental history of the Royal Scots Fusiliers demonstrates. The airborne troops to which the writer refers were members of 1st Airborne Division, which had been deployed to seize various targets in advance of the seaborne troops:

> For the first mile or so the Scots Fusiliers found open country with rocky outcrop. The track running north from the beach was rough for wheeled vehicles and deep in dust. For two miles it led the companies along the side of a railway embankment and through thick orchards, and the pace slackened as the vanguard of 'B' Company worked through the cover. About four miles from the beach-head, in the vicinity of the village of Gesuili Saraconi, 'B' Company was fired upon by light machine guns from the walled farm of La Villa and engaged by snipers from a level crossing over the railway. It was now 8.15 a.m. and this marked the first direct contact with the enemy, apart from the pillbox encountered after landing. 'B' Company deployed to the right and made some progress, but came under fire from hummocks on the coast. The snipers were ousted from the level crossing by a platoon of 'C' Company and 'B' Company crossed to the protection of a wall south of the farm which stood in open country and was strongly held. The Commanding Officer sent 'C' Company across the road, where they were defiladed, with orders to approach the farm from the west under covering fire from 'B' and 'C' Companies' 2-inch mortars and a Piat. Captain J. H. F. MacMichael carried out this attack with great dash; the farm was taken and 50 Italians captured. Twenty-five participants in the British airborne attack which had preceded the seaborne landings, who had been made prisoner earlier in the morning, including some wounded, were released. [Hist. RSF]

The relatively light resistance encountered on the beaches allowed the fusiliers to make good progress, but they soon encountered well-constructed fortifications. The battalion had lost a number of Bren Carriers and other heavy equipment during the landings and the artillery units, which they would normally have in support, had not yet finished disembarking. However, they were able to call on the guns of Royal Navy ships lying offshore before they found their advance obstructed by an enemy strongpoint:

… at about 10 a.m. Captain G. E. Banes arrived with three carriers, the first three to leave the landing craft having been 'drowned' during disembarkation, and their arrival set the pattern of the attack. Colonel MacInnes describes the engagement as follows: 'The three carriers were sent to shoot up the level crossing and move up the main road to the area of Madrenza to watch the left flank and the enemy position; "C" and "D" Companies to attack this strongpoint from the left flank, coming in from the west. The forward observation officer was to get the cruiser *Erebus* to shell the fork roads in order to keep the enemy, if there, quiet. The reserve platoon of "B" Company under Lieutenant D. R. Coutts and one carrier were sent to watch the enemy's flank. During this flanking movement an unfortunate accident occurred. The naval shells were allowed to creep towards our troops with the result that one shell landed among Lieutenant Jones' platoon of "C" Company, the casualties being 10 killed and wounded. "C" and "D" Companies attacked through thick orchards and were drawn to the north by very thick wire. On crossing the road they were engaged by the enemy, who were in trenches to the west of Troia. Fire was now coming from their right flank and their front, as they were facing east. So as not to change direction under fire, they went straight on, attacked and captured the enemy position, taking 150 prisoners and releasing many more airborne troops. Captain D. M. Gray ("B" Company) Captain R. R. D. Adamson ("D" Company) and Lieutenant Devine were wounded. While this attack was going on Lance-Sergeant Dunlop in his carrier had worked round the right flank through the enemy pillboxes which were now holding up "D" Company. This occurred just as the "Piat" was being got into position. Lance-Sergeant Dunlop turned about and went straight back up the road in his carrier, firing his light machine gun. Forty Italians surrendered.' [ibid]

Contrary to what we might expect from the many films and books about the Second World War, the overwhelming majority of casualties are not inflicted by small arms fire or in armoured actions, but by artillery and air strikes. This has been the case for a hundred years or more, but is not widely recognised. Since the late nineteenth century, the range of field, medium and heavy artillery has been such that the guns themselves are seldom within line of sight of the enemy. This being the case, the fire is almost always directed by forward observers who identify targets and relay the information back to the gun-control position artillery, where calculations are made based on range tables – a collection of data about the performance (range) of the guns with a specified level of propellant charge and at a particular elevation, or the angle of the trajectory of the shell when it leaves the muzzle of the weapon. The precise path of the shell is affected by a number of factors, chiefly wind direction and air temperature, so, detailed as the range tables might be, there is almost always some need for minor adjustments. These adjustments are directed by the observer, who informs the battery that they need to add or deduct distance or adjust the fire to the left or right until such time as the shells are landing on the target area. A similar process can be applied for air strikes, though the pilot of an aircraft is much more likely to be able to identify targets from the cockpit than artillerymen from a gun position.

The job of the forward observer is a dangerous one. Clearly, since the observer must be close enough to the target to see what is happening, he must also be close enough to be at risk from enemy fire, but they may also be exposed to the fire of 'friendly' artillery units, particularly if the exchange of information or effective communication with all of the other units in the area is not perfect, which it rarely is. Naturally, all of the elements of a unit in or close to the frontline can be at risk; Captain I.P. MacLaren recorded his experience during the 1943 campaign in eastern Italy in his book, *593: The Story of a Field Battery*, which was published for his comrades. His recollection of this incident was later reprinted in Colonel Kemp's *History of the Royal Scots Fusiliers*:

The Roman Way ran between a deep cleft in the sandstone heights above the south bank of the Moro and, on emerging, wound round an exceedingly slippery slope for 1,000 yards to the shingle bed of the ford. By 2100 hours a slight breeze had cleared the mist and the moon lit up the long ghostly column. The only sounds were the clink of the bundles of shovels slung on the mules, the slipping of boots on the bluey clay and the heavy breathing of marching men.

As the first company crossed the river and was climbing the steep bank on the other side, and as the mule train was in the river bed, the Boche began to shell us. There was a short, sharp concentration. One mule went down and, after a moment's confusion, the muleteers went to ground but kept hold of their mules. The column re-formed and moved on. We reached a company of Northamptonshires where we rested while guides were supplied. 'D' Company then moved up to attack their objective. I, and my party, were detailed to follow with 'A' Company. When 'D' Company reached their objective, they found a German mortar observation post party, which surrendered. They told us that facing us up the road were 42 machine guns. We were sceptical but, none the less, it was not an encouraging thought. The road was about 600 yards ahead. 'A' Company moved into position on the left of 'D' Company and to the right of the flank company of the Northamptonshires. We established communications and began to dig, but at the first noise made by the shovels a fusillade of bullets whistled overhead from a machine gun in front of us. Then the Hun defensive fire was brought down upon us. A Fusilier, and Ede, the observation post 'Ack', were hit. Major Sandilands asked for all the defensive fire to be brought down in succession, and this proved satisfactory. Then he asked for the stonk 'Wellington', which covered 600 yards of the road in front [a 'stonk' was a pre-planned concentration of artillery or mortar fire]. This was unfortunate as it was a Corps target and had not been shot-in, and when it arrived we spent an extremely uncomfortable 15 minutes with rounds landing all about us ... By first light, we were in trenches of sorts, extremely tired, rather uneasy because we were on a steep reverse slope and I was unable to find an observation post which would give me any field of view. [ibid]

The process of battle is not simply a matter of making contact with the enemy and then engaging him. There is another perennial problem for combat soldiers: the terrain.

The 2nd Royal Scots Fusiliers move through the Nozzolo route, September 1944. (Royal Scots Museum)

Any kind of countryside has threats and opportunities for both the defence and attack. Steep rocky inclines give the defenders rather obvious advantages: they can often observe the movements of their enemy for a considerable distance and take action accordingly. On the other hand, those same defenders may find it difficult to relocate troops, dig trenches and foxholes or to bring up supplies; they may find that their artillery cannot provide adequate supporting fire because the hills and mountains are too high to fire over. The attacker faces the same sort of problems. Moving along narrow, winding mountain roads may be too dangerous for tanks and the infantry may well have to get on with the job without armoured support. Rivers present a different range of challenges, hence the large number of operations – sometimes involving a very high degree of risk – that have been mounted simply to capture bridges intact. Although all armies

Here troops and their pack mules have stopped for a brief rest, note the sea of mud – almost impossible to wade through. (Royal Scots Museum)

had developed amphibious vehicles and even amphibious tanks, effecting a river cross-ing in the face of the enemy continued to be a risky business. An amphibious vehicle cannot be effectively camouflaged, and even laying the thickest smokescreen possible is unlikely to really conceal the movement of a large number of vehicles across open water; indeed, it is more likely to draw the enemy's attention to the operation. In the winter of 1943/44, the Garigliano River was an important element in the German defence of Italy. The Royal Scots Fusiliers were involved in an attempt to outflank the German defences on the northern bank of the river by using amphibious vehicles known as DUKWs. The DUKW was essentially a truck with a boat built around it. The name was not derived from an acronym, though it was, phonically, exceptionally appropriate given the role of the vehicle. The letters of the name came from the system of classification that General Motors applied to their military contracts: the letter 'D' denoted the year of design (1942), 'U' for utility, 'K' for six-wheel drive and 'W' to indicate that the two rear axles were powered individually. The British Army acquired at least 2,000 DUKWs,

and they proved their worth in the Italy and northern Europe campaigns. They were not really designed to cope with the sea, but for river and lake operations; however, absence of a more suitable piece of equipment could lead to DUKWs being put to all sorts of uses, including crossing a major estuary with a fast and powerful current. Colonel Kemp seems to suggest that the consequences seem to have come as no great surprise to the fusiliers:

> The plan was ambitious and depended for success on accuracy in timing and execution. However the DUKWs failed not only to land the force on time but also to put the companies ashore on their allotted beaches. Indeed, it is recorded that one of these craft was carried so far out to sea that it encountered a British submarine. A sailor thrust his head out of the submarine's hatch and demanded, 'Who are you?' When informed, he remarked, 'Never heard of you', slammed down the hatch cover and submerged his craft. A more serious mishap was the delay in arrival of the Royal Engineers who were to deal with the minefields on the beaches, which immobilised the whole assault. [ibid]

The war diary of the 2nd Battalion Royal Scots Fusiliers observes:

> The plan for landing the Battalion on the assault beaches completely miscarried and the unit was badly disorganised at the very outset. Several things contributed to this. The principal reason was the total absence of expert navigators in the crews of the amphibious craft. Many of the drivers went too far from the coast and were consequently unable to make use of the guiding lights set out at intervals along the shore or even to see the river mouth, which should have been the surest guide. In the case of the later serials, the gun flashes and miscellaneous lights of battle in the river area added to the difficulties. Not one of the craft carrying the assaulting companies of Royal Engineers found the correct beaches. [ibid]

This incident is a good example of one of the difficulties of war that is seldom discussed, though it is an everyday facet of soldiering: people (and of course equipment and supplies) simply get lost. This is not always an accident caused by poor visibility or bad map reading. An anonymous soldier of an unnamed Scottish battalion in Italy took cover when his section came under fire:

> I pushed my way through some bushes and there was a burn. There was a lot of shooting going on so I got down the bank and just stayed there. I could hear the rest of the fellows moving over to the left of me and some firing, but I'd just had enough that day so I just decided to stay put. After a bit I heard somebody moving round a bit further up the burn, so I crawled back up the back into the bushes. After a bit a German came round the bend and I just watched him 'til he passed by. When it started to get darker I set off back the way we'd come and found the rest of my unit. My sergeant gave me a bit of a funny look when I got back, but nobody said anything.

Failing to keep up with his comrades was certainly a dereliction of duty, but it is impossible for those of us who have never been in battle to really understand the stresses and strains of combat. For obvious reasons the men in the infantry and armoured units who are in closest contact with the enemy are the ones most prone to combat fatigue, but it affects others. At much the same time that the fusiliers were attempting to cross the mouth of the Garigliano, Gunner Smith of Arran found himself 'driven to distraction' by the sheer racket of his unit, a regiment of 25 pounder guns, which had been firing almost constantly for hours on end. Unable to bear it any longer he set off on a walk. He walked for about two hours and then found himself in the rear area of an infantry battalion, watching casualties being carried back to the regimental aid post. Realising that he was now in a very dangerous area, he immediately turned about and trudged back to his regiment. He was serving as a despatch rider at the time and since the unit was stationary and engaged in a lengthy barrage, his absence was not noticed. He had had no particular destination in mind, and was certainly not contemplating desertion, but in the strictest sense he was certainly 'Absent Without Leave' and could have faced serious consequences if it had been noticed at his unit or if he had been found by the Military Police.

Gunner Smith was deeply affected by the sight of wounded infantrymen at the aid post, but collecting casualties so that they could be treated was a problem in itself. Stretcher-bearers and medics were as much at risk from fire as anyone else. Sometimes human feeling could prevail, sometimes not, as Colonel Kemp observed:

[The heavy fighting] also produced serious problems in the evacuation of the wounded. An arrangement was made with the enemy, who were themselves in similar difficulties, whereby casualties could be brought back to safety under a Red Cross flag. When the Battalion stretcher-bearers reached the edge of the 600 yards carry across open country, they awaited the signal to pass from the Germans; a burst from a machine gun fired into the air, and then moved on. Major Batey makes these comments on this practice: 'From the main observation post there was a very pretty view of the exceedingly industrious paratroops on whom the Battery (593) inflicted punishing casualties. They were curious people. They fired mortars from under Red Cross flags. After the mortars had been silenced they had the effrontery to bring out their stretcher-bearers to collect casualties under yet more Red Cross flags. In spite of these lapses the Geneva Cross was generally respected. The Boche was inclined to sail rather close to the wind in these exchanges and take the opportunity to stand up and survey our positions. On one occasion a German officer actually walked into a forward platoon position under a Red Cross flag and asked leave to collect his casualties. This was granted; but when he was told politely that, having seen our dispositions and furthermore, being armed, he could not return, he grew livid with rage. [Hist. RSF]

The 51st Division was heavily engaged in the Italian campaign before being returned to the UK to prepare for Normandy, but several Scottish units stayed on, including

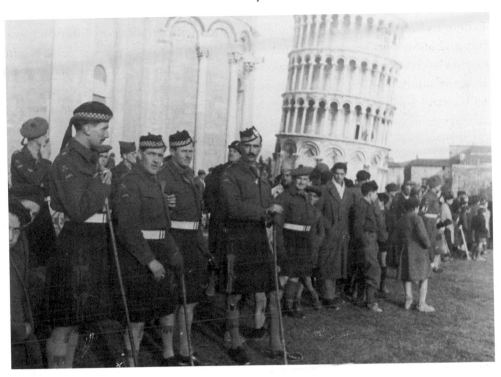

Men outside the leaning tower of Pisa, a brief spot of sight-seeing for the Royal Scots. (Argyll and Sutherland Highlanders Museum)

6th Battalion the Black Watch, who took part in several actions to penetrate German defensive lines, such as the famous Battle of Monte Cassino, as did the Cameronians, the Royal Scots Fusiliers and the Scots Guards. The battalion remained in Italy and fought in the offensive to breach the German Gothic Line before being sent to Greece where they conducted operations against the Communist insurgents, who hoped to exploit the situation caused by the withdrawal of German and Italian occupation forces and set up an administration before the Greek Government in exile could return from London.

Most combat units would fight as a collective entity, but some, particularly armoured units, might find themselves split into subunits for a specific task. During the approach to Naples the three squadrons of the Scots Greys were each assigned to brigades of the 56th Infantry Division, a London-based formation which included 1st Battalion London Scottish and took part in the defeat of a counter-attack by the 16th Panzer Division, which had been reformed after its near complete destruction at Stalingrad the year before. By mid-September the three squadrons had been reunited and fought as a complete regiment in operations to allow the breakout of X Corps from the invasion beachhead. The regiment fought on in Italy until the advance was halted by stubborn German resistance at the Garigliano River, when it turned its Shermans over to other units and returned to Britain to refit and prepare

for the landings in Normandy. A significant factor of the Italian campaign was the fall of Mussolini and the surrender of the Italian armed forces. A small number of Italian soldiers committed to Fascism, or perhaps just committed to soldiering and unhappy at the decision of the new government to give up the struggle while there were foreign soldiers on Italian soil, attached themselves to German units and carried on fighting. For most Italians – military and civilian alike – the end of the war was a welcome development. Defeat in the desert and the loss of the African colonies that Mussolini had conquered before the war had undermined the credibility of the Fascists and a good relationship with the Allied troops was easily achieved. Gunner Robert Smith recalled that almost anything could be exchanged for almost anything else – cigarettes, wine, fruit, eggs, meat, vegetables – and all with a considerable amount of sangfroid; almost as if the Italians had never been at war with the British. Even so, few can have had as casual an attitude to the by-products of combat as the elderly man encountered by one of Colonel Kemp's contributors:

> The area was officially cleared of all Italian civilians, but a number remained in the ruins of Anzio and Nettuno, and in the country there were a few shepherds still watching over their flocks. I remember one day meeting one such shepherd, an old man, with a small flock of sheep which were grazing contentedly although the place was plastered with mines. The mortality rate of sheep must have been enormous. [ibid]

6

NORTHERN EUROPE

The invasion of Normandy on 6 June 1944 (Operation Overlord) was the largest amphibious assault that had ever been mounted, or is ever likely to be mounted. Tens of thousands of Scottish service men and women, in the Royal Navy, RAF and Army, took part in the landings and the subsequent campaigns through France, Belgium and the Netherlands, and eventually into Germany and Austria. The landings were preceded by a carefully planned series of bombing raids, designed to disrupt the road and rail networks of France without giving away the intended target area in Normandy. In this – and with the aid of an intricate and carefully orchestrated intelligence operation to mislead the Germans – the Allies were completely successful, leading Hitler and some of his senior officers to believe, even in the period immediately after the landings, that the Normandy operation was no more than a ruse and that the real invasion would be mounted at the Pas-de-Calais.

In addition to the many Scots serving in the artillery, engineers, parachute formations and others, there were a number of Scottish units deployed to Normandy other than those of the 15th and 51st Divisions, including the 1st Lothian and Borders Horse in 79th Division, who operated a variety of specialist armour, including the Sherman Crab, a mine-clearing vehicle with enormous chain flails which pounded and tore the soil to detonate or displace anti-personnel mines. The 1st Battalion King's Own Scottish Borderers was assigned to the 3rd (Mechanised) Division. The 2nd Fife and Forfar Yeomanry served in the 11th Armoured Division, as did the 58th Light Anti-aircraft Regiment, which had originally been raised as a battalion of the Argyll and Sutherland Highlanders. The 11th Battalion Royal Scots Fusiliers fought in the 49th (West Riding) Division and 1st Highland Light Infantry in the 53rd (Welsh) Division.

Serving with English or Welsh formations was by no means unusual for Scottish infantry battalions and was normal practice for armoured regiments since there

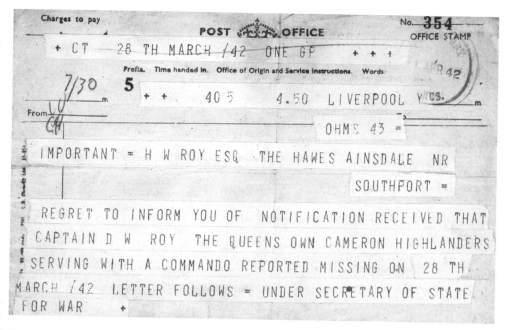

Prior to the D-Day Landings casualties in Europe were mounting and letters such as these were sadly a frequent occurrence.

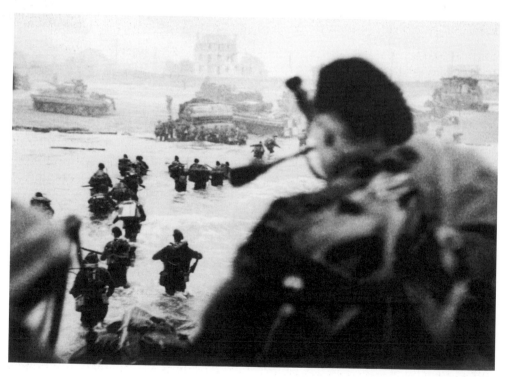

Men disembark from troop carriers onto the beaches to be faced by severe enemy resistance. (Scotsman Publications)

Men from the 8th Royal Scots Fusiliers follow a Churchill tank of 7th Royal Tank Regiment through a hedge in Normandy. (Royal Scots Museum)

was no attempt to identify armoured divisions with particular parts of the United Kingdom. In Italy the 2nd Lothian and Borders Horse had served as part of the 56th Armoured Division, as did the 2nd Scots Guards, and in Egypt the Royal Scots Greys had served with the 8th Armoured Brigade. In Normandy, the 3rd Battalion Scots Guards served as a tank regiment (unusually, guards armoured units kept the subunit titles of companies and platoons rather than the traditional squadrons and troops of armoured units) equipped with Churchills. Designed for an infantry-support role, the Churchill was a poor vehicle for armoured combat, and when a column of Scots Guards was ambushed at Mont Pincon they lost eleven tanks when they were surprised by a force of just three German Jagdpanther tank destroyers, which withdrew without loss.

The first great test for 15th Division came only a week after they landed in France. The development of an extended perimeter protecting the beachheads and the capture of the city of Caen had not progressed as quickly as Montgomery had hoped. Although the Overlord planners had made great effort to ensure that the invasion

Canadian Scottish troops disembarking in Normandy, June 1940. (Museum of the Black Watch, Royal Highland Regiment of Canada)

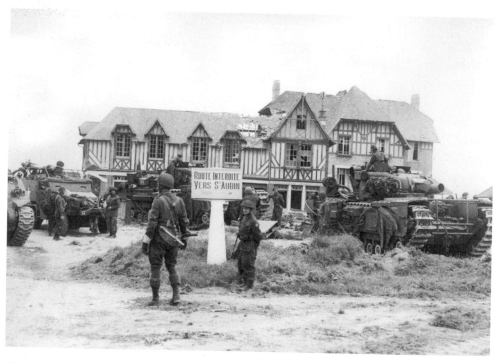

Canadian Scottish troops in Normandy with British-made Churchill and American-made M3 half-tracks and Sherman tanks. (Museum of the Black Watch, Royal Highland Regiment of Canada)

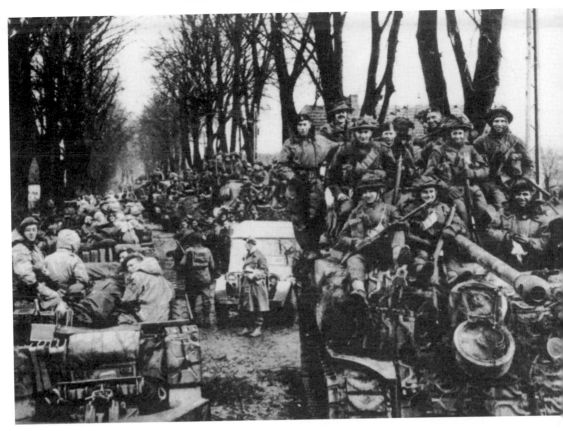

After D-Day the roads in Northern Europe often became clogged with men and machinery moving in every direction. (Royal Scots Museum)

force would be adequate for overcoming local resistance in short order, and despite the fact that Hitler refused to release reserve armoured formations for the Normandy front, the skill and commitment of the German forces brought the advance from the sea to a halt. Within a few days it became apparent that the Allied forces would have to mount a major co-ordinated attack to capture Caen and to break out of the dense 'bocage' countryside which so clearly favoured the defence. Although the capture of Caen had initially been seen as an objective for the first day of the invasion, it was probably too ambitious a target, and the massive congestion on the beaches which slowed the disembarkation and marshalling of tanks prevented a strong armoured attack being mounted for some days. The stubborn resistance of the German Army was enhanced by weather conditions. A storm that blew up on 19 June and lasted for three days drove convoys of reinforcements back to Britain and seriously damaged the Mulberry floating harbour which had been erected. The storm also prevented adequate air support and, because of impaired visibility, reduced the effectiveness of the artillery. The Germans were able to use this time to redeploy, bring up more troops and work on fortifying Caen and the thick hedgerows of the region. By the

Lieutenant Colonel Payton, DSO, OC, 7th King's Own Scottish Borderers, 1943–45. (Paradata collection)

8th Battalion the Royal Scots Fusiliers advancing through a cornfield supported by 7th Royal Tank Regiment, Normandy 1944. (Royal Scots Museum)

time the Allies were able to renew the attack with Operation Epsom on 26 June, the Germans had recovered their equilibrium after the shock of the landings and were ready to make a hard fight of it. Additionally, the German High Command was no longer convinced that the Normandy landing was a diversion and was therefore more inclined to release resources for the battle.

The 51st Division landed on 6–7 June and made contact with the 6th Airborne Division, who had landed on the night of 5/6 June. Like several other formations, the 51st published a regular newssheet which disseminated material about the division and small items of news from home, such as football and rugby results, that might not otherwise find its way to the troops. The first issue of *Piobreachd* (a piobreachd is a piece of pipe music) published in Normandy carried a message from the divisional commander:

This is the first daily newssheet to be issued since the Division returned to France. Four years ago, our Division fought the Germans in France. Through weight of numbers, overpowering air support and equipment generally, the Germans were then able to oust us, despite every gallant endeavour, from France.

Today the picture is different. The much vaunted Western Wall has been pierced and shattered by the assaulting troops. Already we have been into France, well into France too, for 9 days, whereas the Germans said they would defeat the invasion on the beaches.

The Division has played its part, with at first only small forces engaged, in a notable way towards the 2nd Army's grand achievements. The 5th Black Watch, the first battalion of the Division into action, has covered itself with glory, and the fields of Normandy with dead Germans. The Gordon Highlanders have had a good fight, and have more than held their own. The Seaforth and Cameron Highlanders were in action, and ready as always to do likewise. Our Gunners, and Machine Gunners, have already fired many shells, bombs and

bullets, had many successes and done much sterling work, and so have all the other units in the Division.

So we have made a start. Not a spectacular start, such as was the Division's fortune at Alamein, but a brave start none the less. Before us lie hard days and hard fighting. But there is no doubt that our present operations are going well, and that we are making a great contribution to those operations.

Let us go ahead, then, with confidence in ourselves, faith in our cause, and with a grim determination to do our best at all times, so that Germany can quickly be brought to her knees, and the War won.

To all ranks in the Division, I send you my greetings, and the best of good luck. I have absolute confidence in you. So has the Army.

In Africa and Sicily, we showed the world what the sons of Scotland can do. That was nine months ago. We will show it again now.

(Signed) D.C. Bullen-Smith. [WWW.51HD]

Despite the exhortations of General Bullen-Smith, the campaign did not start well for the 51st Division; they had clearly not been able to maintain the high state of efficiency and morale that they had attained in the Mediterranean theatre. Montgomery voiced his concerns in a signal to Field Marshal Brooke, telling him that the 51st Division had failed 'every mission it was given'. It is not clear why this should have been the case, but it prompted the removal of the divisional commander, Major General Bullen-Smith, and his replacement by Major General Thomas Rennie, who had been commanding the 3rd Division. Rennie had been a member of the original 51st Division which had surrendered in 1940. He escaped

'Attack by Crocodile (Churchill) flame-thrower in village of Uphusen towards Bremen, infantry cooperation, 1945.' Drawing from 'With the Jocks' by Peter White (Courtesy of the Peter White Estate/The History Press)

Men stop to try and mend the tracks of a Buffalo amphibious vehicle, possibly damaged by the terrain. (Royal Scots Museum)

Tanks and men progress into the rural areas, making their way across Northern Europe. (The Tank Museum, Bovington)

Opposite, from top

'Waldfeucht, Operation "Blackcock", 1945. Sherman tank on right knocked out by the Tiger tank (left) and burnt. Tiger was then knocked out by 5th Bn KOSB A/tk guns. (Capt. Hunter got MC).' Drawing from 'With the Jocks' by Peter White (courtesy of the Peter White Estate/The History Press)

'Counter-attack by Tiger tanks at Waldfeucht. "We dashed back to the small alley which let at right angles on to the main road down which the Tiger would come and dropped into the gutter. The three of us lay side by side, McKenzie in the centre with the projector and Brown his no. 2, with spare bombs to reload on his other side. Our hearts were pounding furiously."' Drawing from 'With the Jocks' by Peter White (courtesy of the Peter White Estate/The History Press)

WALDFEUCHT. OPERATION BLACKCOCK 1965. SHERMAN TANK ON RIGHT, KNOCKED OUT BY THE TIGER TANK (LEFT) & BURNT. TIGER WAS THEN KNOCKED OUT BY 5TH BN MOSS A/TK GUNS. (Capt HUNTER GOT M.C.)

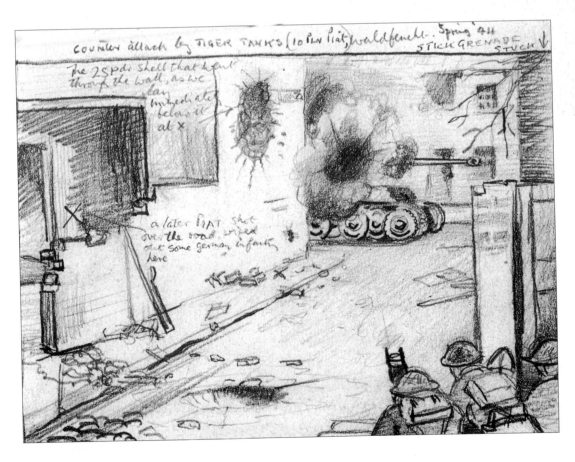

81

a few days after the surrender, made his way back to Britain, and by 1942 was in North Africa where he commanded 5th Battalion the Black Watch, before being promoted to command 154th Brigade. Rennie was, therefore, no stranger to the division. He was able to assert his authority very quickly and restore the effectiveness that had been a hallmark of the 51st Division in the past. He remained in command until he was killed in action in March 1945 after the Rhine Crossings.

The 15th Division had started disembarking in Normandy on 14 June, eight days after the landings. Initially the division was under the command of Major General G.H. MacMillan and had not been in battle before. Their first major action was to take a leading part in Operation Epsom, otherwise known as the first battle of Odon, which opened on 26 June. Having made a number of attacks to clear their front of potential obstacles and to ensure that they had enough room to deploy properly, the 44th and 46th brigades of the 15th Division, with the support of the Churchills of the 31st Tank Brigade, started their attack, moving forward behind a massive rolling barrage. An aerial bombardment that had been planned was abandoned because of the weather, but by the end of the day the two brigades had made reasonably good progress and had repulsed a number of local German counterattacks.

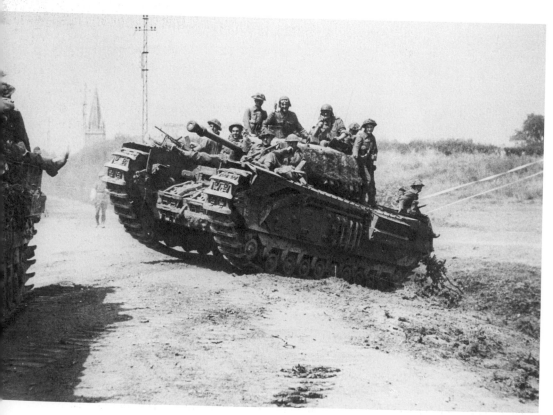

Churchill tanks of the Scots Guards armoured regiment in France, 1944. (The Tank Museum, Bovington)

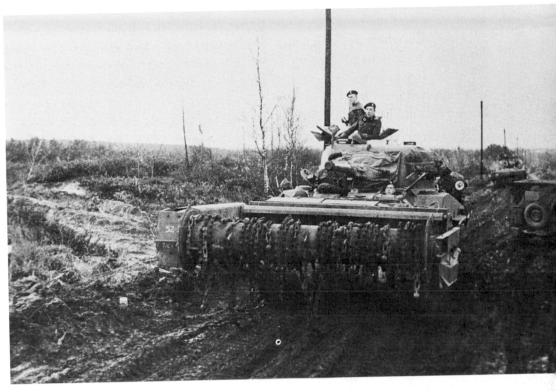

A mine-sweeper tank moves from the landings into Northern Europe. (The Tank Museum, Bovington)

Over the next few days there would be a succession of brutal and exhausting actions which, although they made some progress on the ground, were very costly. The operation did not succeed tactically: the objectives were not taken and the Germans had been able to slow, though not entirely contain, the British advance. The strategic result was arguably more significant. The forces that Rommel had intended to use in a major counterattack to break through the Allied bridgehead and divide their forces were no longer fit for a major offensive operation. Rommel had been forced to commit them to prevent a major breakout. Strategic considerations were doubtless lost on the men in the battle; they were too busy dealing with the enemy in front of them. Colonel Kemp describes the action as it appeared to the 6th Battalion Royal Scots Fusiliers in 44th Brigade:

[Despite the intensity of the British barrage] a heavy toll was taken by the German defensive fire, and every yard was a struggle until the first stage of the attack was reached, the Norrey-en-Bessin road to St. Mauvieu. Eventually 'C' and 'D' Companies, although much weakened by casualties, penetrated into the village and began the task of clearing it. All day there was confused fighting. However, by late afternoon the northern end of St. Mauvieu had been cleared, though this was achieved only with help from armoured flame-throwers.

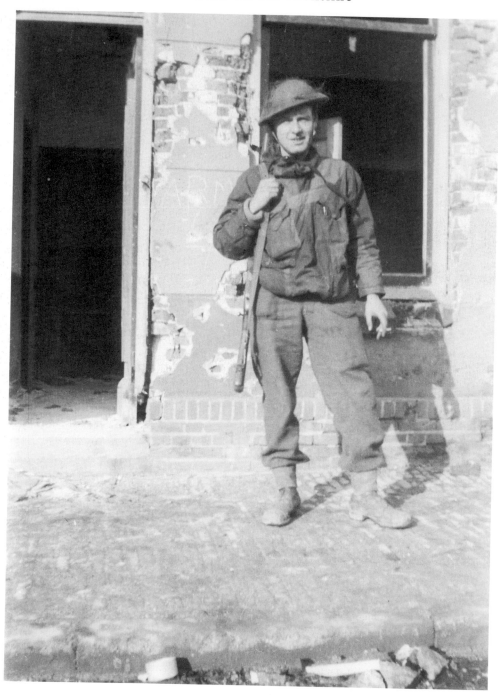

A soldier of the King's Own Scottish Borderers poses for a moment outside a bombed house in the Netherlands or Germany, 1944–45. (KOSB Museum)

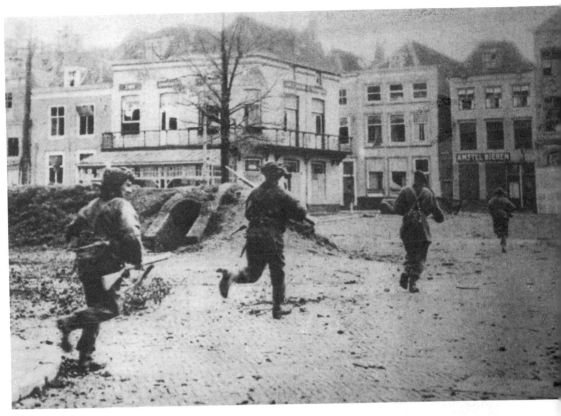

The King's Own Scottish Borderers move into a town to clear it of the enemy. This kind of urban combat was challenging and became a regular part of the campaign in Northern Europe after D-Day. (KOSB Museum)

At about 6 p.m. elements of the 12th Special Service and 21st Panzer Divisions counter-attacked on the left flank of the Scots Fusiliers from Marcelet, a village about 2,000 yards east of St. Mauvieu. With some assistance the Battalion withstood this assault, but later in the day further reinforcements from the 44th Brigade had to be called up to beat off renewed attacks. The Battalion's casualties were now so heavy that the Brigade Commander, Brigadier H. D. K. Money, sent up the reserve Battalion, the 6th King's Own Scottish Borderers, to take over the position. By midnight on June 26, in torrential rain, the Fusiliers had moved into reserve in the vicinity of Le Mesnil Patry. Their casualties were 21 killed (including four officers, two of whom were company commanders), 113 wounded and nine missing. Nevertheless they had played a major part in opening the vital gap which has become known in military history as the 'Scottish Corridor.' [Hist. RSF]

The 'armoured flame-throwers' referred to were probably 'crocodiles', a variant of the Churchill tank. Normandy was the first campaign where the Churchill was deployed in large numbers. The Churchill was a slow but heavily armoured vehicle and its primary function was to provide close support for infantry formations. The 'Scottish

Corridor' has become relatively well known, but there were two Scottish divisions and at least eight Scottish units serving in Normandy, and of course many Scots in the Royal Army Service Corps, Royal Engineers, Royal Army Medical Corps and others. It is likely that 40,000 or more Scots were deployed to the Normandy campaign, forming, in a sense, the biggest Scottish force in history.

The attack had made some progress, but clearly there was not going to be a rapid breakout, and the Germans mounted several local counterattacks with armour and infantry on 27 June. Both sides found the dense bocage country difficult for the attack. The tiny fields surrounded by ditches and embankments topped with thick hedges and the narrow country lanes strongly favoured the defence. Troops could seldom see more than a hundred metres in any direction and armoured vehicles were therefore at great risk to even the lightest of anti-tank weapons, since they could be used at such close range. Despite the German activity, the 15th Division was able to make some progress on 27 June, capturing a bridge over the River Odon. Their success allowed the supporting formation, the 11th Armoured Division, to advance on an area of high ground, which the British called Hill 112; if taken, this would form a salient into the German lines from which they could outflank enemy formations and gain better positions for artillery observers. German resistance was exceptionally strong and the

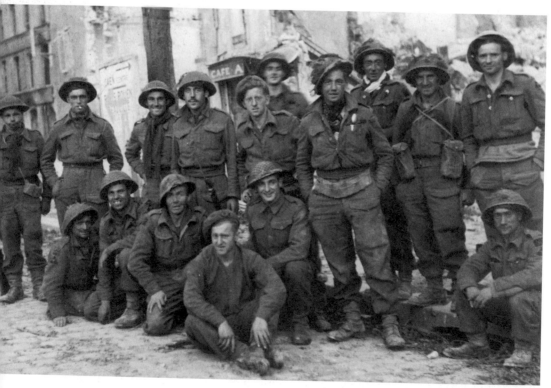

The King's Own Scottish Borderers pose outside a shop, once the area is secure. (KOSB Museum)

A Dutch civilian and Allied tank driver. (Royal Scots Museum)

hill was not taken until August. However, the German command had been forced to keep units in the frontline which they had intended to withdraw so that they could form a powerful reserve for a major counterattack intended to cut deep into the Normandy bridgehead, disrupting the general Allied advance and possibly divide the British, Canadian and American armies.

Armoured units found the bocage hard going. The Scots Greys took part in the fighting for Hill 112 and discovered that their while their Shermans were a reasonable match for the Panzer IV, they could not hold their own against the Panthers and Tigers of the German armoured formations. At anything other than very close range, their 75mm armour-piercing shells simply bounced off the sloped front of a Panther. The Allies did have the advantage in terms of numbers and even the mighty Tiger

was vulnerable if attacked in the flanks or rear, but the price was high; the British lost something in the region of 500 tanks in Normandy.

While the infantry battalions of the 15th Division were assembling for Operation Epsom and carrying out the attacks of 26–30 June, the other elements of the division were kept busy. The experiences of the 15th Scottish Reconnaissance Regiment (as recorded by Captains Kemsley and Riesco, whose complete account can be read at www.15threcces.org) were probably fairly typical of the division as a whole: 'The crossing (of the Channel) was uneventful, though with plenty of seasickness, and the advance party of the regiment disembarked onto French soil without serious mishap, passing through the battle area of the days since the landings on 6th June.'

A fortnight of hard fighting had left its mark on the countryside and the stubborn resistance of the Germans meant that the advance into Normandy had been slow, but the build-up of men and material had a fixed timetable and the rear areas of the bridgehead became very congested, making movement difficult:

As the vehicles passed slowly along roads busy with military traffic drivers reminded them-selves repeatedly that they must keep to the right, and commanders looked anxiously from map to land, realising that finding the way, with these maps of smaller scale, was harder over

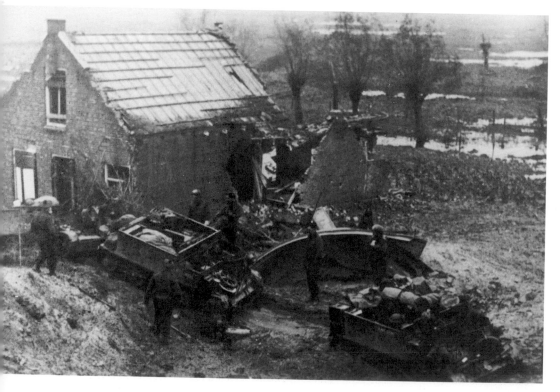

Canadian Scottish Bren Gun Carriers. (Museum of the Black Watch, Royal Highland Regiment of Canada)

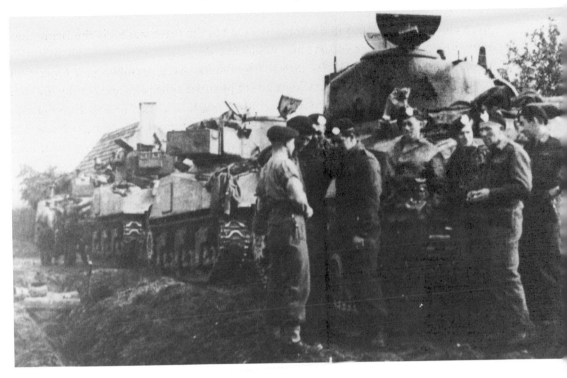

A column of Sherman tanks awaiting resupply. (Royal Scots Museum)

here. The painting of a picture of Normandy was beginning to become a picture that was to be framed in the memory around dusty roads scalloped by shell-bursts; fields crowded with men and trucks and guns; grim 'Mienen' notices; dead animals, swollen and with stiff legs pointing skyward; trampled hedges and crumpled buildings; route signs which first seemed hopeless in their very profusion; reddened, knocked-out tanks; and the French country people, inevitably dressed in black, somehow surviving it all. [ibid]

Sergeant Milroy of the advanced party recorded his own experience. His party found the 15th Division headquarters with relatively little difficulty, but the area assigned for his regiment – and which the advance party was supposed to prepare for the regiment's arrival – proved to be inaccessible:

The regimental area (never used by the regiment) was a few hundred yards away, across two or three fields, but owing to the traffic system the journey was more than a mile by road. It was a farm which was unapproachable for half the day because it was beyond the one spring in the area and therefore the rendezvous, it seemed, of every water truck east of Bayeux. The first night we slept in a field, and woke wet. Thereafter we shared an outhouse with the cattle. There we stayed for seven days – unitless, midway between the coast and the Battle of Cheux. [www.15threcce.org]

To begin with the life of the advance party was uncomfortable, but on the whole not too onerous. The balance of the regiment had yet to arrive, and until they did there was not a great deal to do. In all probability, the tasks they were given were as much a matter of the divisional HQ trying to keep the party occupied with something, if only because of the traditional antipathy of commanders (and not just British ones) to the idea that soldiers might just have a bit of a break:

Having a splendid ration system (it allowed a fair surplus), and ability to speak the tongue, and three sets of earphones through which the farm people and an increasing number of their friends could listen to the news in French, we were soon properly 'feet under' with the farm, the laundry girl and the barber. Our days consisted of searching for ammunition that had been left about by the Germans; driving down to the beach to see whether the regiment had arrived on the tide; visiting divisional, corps and army headquarters (in chateaux of increasing magnificence); being constipated; and fetching mail until we were surrounded by it. In the evenings, we had the company of the people of Vienne en Bessin from 9.15 ('Ici Londres') until midnight, [Throughout the war years 'Ici Londres' was the opening line of the BBC's French language news programme] at which time the bombing of the coast was deemed to have ended and Madame la Fermiere would order 'Au lit' [bedtime] in such a military fashion that none refused. The two most vivid memories of these days are of digging the car out of an immense dung pit, into which Kay had tactlessly backed it, and of listening to the peculiar

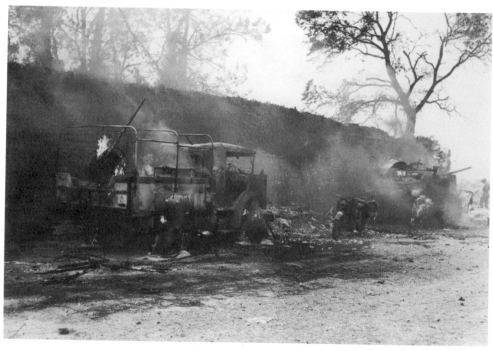

Damage done by a Luftwaffe bombardment, August 1944. (Museum of the Black Watch, Royal Highland Regiment of Canada)

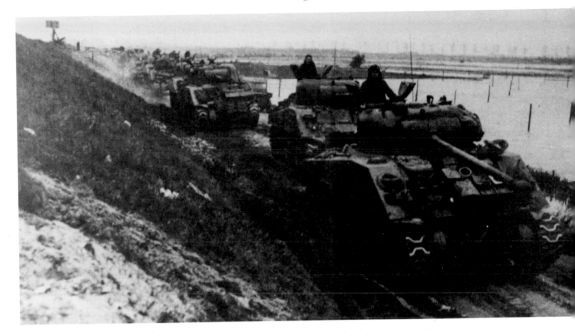

A column of Sherman tanks drive down past flooded fields. (Royal Scots Museum)

gurgle of the large shells fired from the battleships in Arromanche Bay at Germans fifteen miles away. In spite of the sound of the shells and the sight of the Allies' big bombing raids, this life was altogether too much like an exercise to last. We were ousted by a mapmaking unit and relegated to a ditch outside St Gabriel. The next day, unannounced, the regiment arrived. The holiday in France was over. [ibid]

The armies were engaged in hard fighting at close quarters during the early part of the invasion campaign, with little scope for the proper role of a reconnaissance regiment, but the presence of the enemy soon made itself felt:

Back at Putot en Bessin, RHQ [regimental headquarters] had become the first part of the regiment to experience enemy shellfire somewhat to its own surprise and certainly to the loss of some of its dignity. This happened not long after C Squadron had left on June 30th. Everybody was becoming accustomed to the shriek of shells which followed the crack of the guns in the neighbouring fields, and the dinner queue at the cook's truck did not realise until two shells had burst that this time the crack followed the whine. The awful truth seemed to explode in every mind at once. In a few moments, the only people who remained above the ground were the colonel, sitting at his wireless and calling for a 'shellrep' [shelling report], his wireless operator, and those who lay prone under the cook's truck, having been slow starters in the race to the slit trenches. In the rush a plate of rice pudding, borne in the second 'wave', spread itself over the head of one of the swift starters who had already reached

the comforting depths of a trench. That was the only direct hit, although twenty-five shrapnel shells exploded over the area and there were casualties nearby. [ibid]

A good deal of such contact as was made between the units in Normandy and the local populace involved trading – particularly for eggs and alcohol, neither of which were readily available through the normal channels of military supply, or at least not in the desired quantities. The passage of the fighting across the country inevitably brought civilians into the frontline. A contributor to 15th Regiment history (Lieutenant Royle) described his first encounter with a civilian in the battle area:

> She cried out to us not to shoot because there was somebody else coming, and a moment later we saw an old woman running down the road faster than I had ever seen an old woman run before. The old woman told me that there were about a hundred Germans in the wood round the house where she lived, and others in the house. She asked us to fire on them. We gave the information to the artillery, and as shells landed on her home she jumped for joy. [ibid]

At the end of July the 51st Division were taken out of the line to refit and assigned to the 1st Canadian Corps. On the night of 7 August they were back into battle to

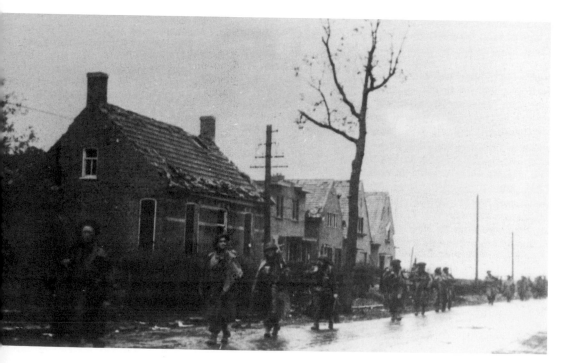

Canadian Scottish troops march into Middleburg. (Museum of the Black Watch, Royal Highland Regiment of Canada)

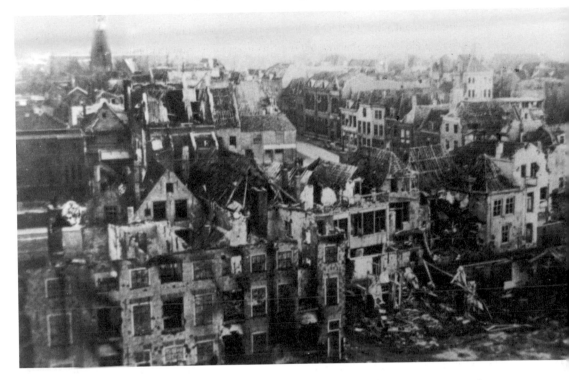

The bomb-damaged outskirts of Middleburg. (Royal Scots Museum)

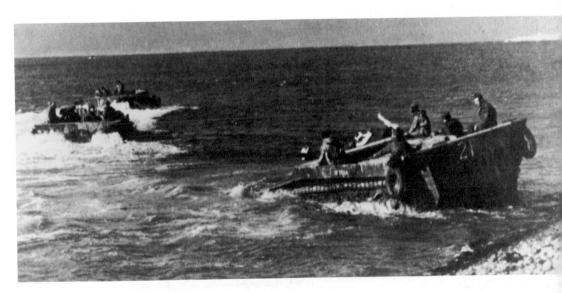

Buffalos crossing the Scheldt Estuary. (Royal Scots Museum)

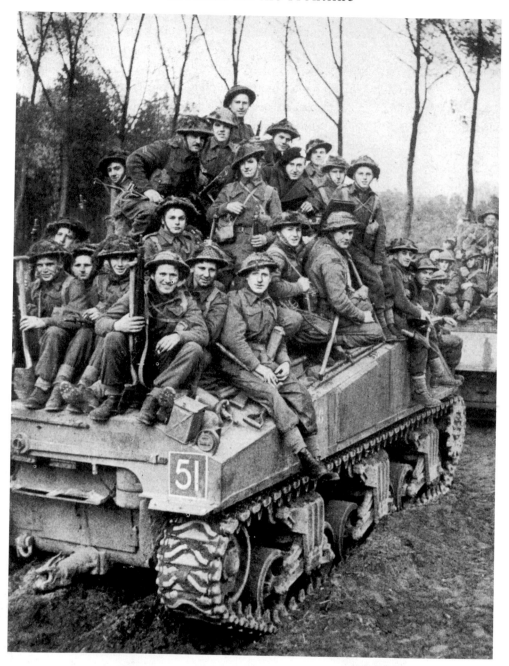

Men of the Royal Scots during operation Market Garden in the Netherlands, 1944 (Royal Scots Museum)

take part in Operation Totalise and had secured all their objectives by the conclusion of the operation four days later, but the division remained in the frontline and were in action continuously until the fall of Lisieux to 153rd Brigade on 22 August. After a short period to refit and absorb replacements, the division moved eastwards, crossing the Seine, taking Le Havre and then capturing St-Valéry-en-Caux, where the original 51st Division had been forced to surrender four years previously.

Major General Rennie gave a speech to the division to commemorate the moment:

> This is a very great occasion in the history of our famous division. Here at St Valéry on the 12th June 1940, a portion of the Highland Division, including its Headquarters, 152 and 153 Brigades, was captured by a large German force.
>
> That magnificent Division was sacrificed in a last effort to keep the French in the war. True to Highland tradition the Division remained to the last with the remnants of our French Allies, although it was within its capacity to withdraw on Le Havre.
>
> The Division drew on St Valéry the German 4th Corps, a Panzer and a Motor Division – in all six Divisions – and thereby diverted this force from harassing the withdrawal of other British troops on Le Havre and Cherbourg.

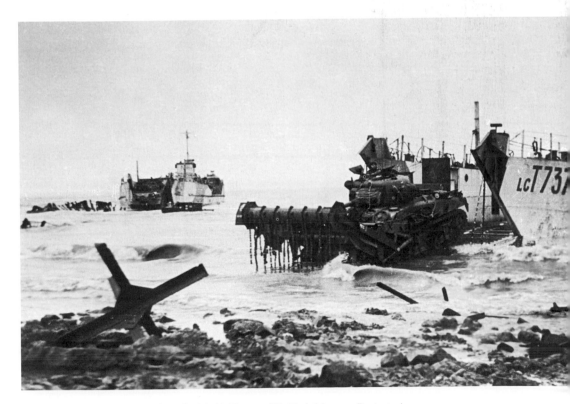

Flail tank landing on the beach from the Scheldt Estuary. (The Tank Museum, Bovington)

Men of the King's Own Scottish Borderers donning life jackets prior to Operation Plunder, which took the British Army across the Rhine and into Germany. (KOSB Museum)

General Victor Fortune ordered the surrender of the division when it had run out of ammunition and food and all prospects of evacuation, which had been carefully planned by him, had failed.

That Highland Division was Scotland's pride; and its loss, and with it the magnificent men drawn from practically every town, village, and croft in Scotland was a great blow. But this Division, then the 9th Highland Division, took its place and became the new 51st Highland Division. It had been our task to avenge the fate of our less fortunate comrades and that we have nearly accomplished. We have played a major part in both the great decisive battles of this war – the Battle of Egypt and the Battle of France – and have also borne our share of the skirmishes and those costly periods of defensive fighting which made these great victories possible. We have lived up to the great traditions of the 51st and of Scotland.

I have disposed the Division, as far as is possible, in the areas where it fought at St Valéry. General Victor Fortune had his HQ here, 152 Brigade held the sector to the west, and 153 Brigade to the east. The Lothians and Border Horse held the sector to the south. The 154 Brigade and 'A' Brigade ('A' Brigade was at that time operating with the Division) embarked at Le Havre.

I hoped by disposing the Division in that way to make it easier for some of you to find the graves of your relatives or friends who lost their lives with the St Valéry 51st. You will find at St Valéry and in the village cemeteries around, that the graves of our comrades have been beautifully cared for.

We have today playing with the Pipes and Drums of the Highland Division those of the Scottish Horse. There are also officers and men of the Lothians and Border Horse at this meeting. [www.51HD.co.uk]

The breakout from Normandy and the capture of enormous numbers of prisoners and equipment at Falaise took the Allied forces into a different sort of combat environment. The Germans spent the high summer of 1944 in rapid retreat across France and into Belgium, and the Allies started to become a little too confident that

RSM Forsyth being decorated with the MC by Field Marshal Bernard Law Montgomery, 5 September 1944. (Royal Scots Museum)

the war was won. The advance started to falter in early September as the German Army regained its equilibrium. In the hope of giving the campaign a 'kick-start' and giving the Germans another great blow that would send them reeling back through Germany, Montgomery and his staff formulated a daring plan to seize a chain of bridges across the many rivers and canals of the Netherlands. These waterways could provide a series of strong defensive lines for the Germans, each of which would have to be the subject of a major operation. Opposed river crossings are always a challenge, but the plan put forward involved making attempts on several targets in one vast operation.

Aware that the enemy had lost thousands of armoured vehicles in France and confident that the Germans were too disorganised to mount effective counterattacks on any scale, Montgomery proposed to land huge numbers of parachute- and glider-borne infantry across the Netherlands. These formations would seize bridgeheads at Grave, Nijmegen and Arnhem and form an 'airborne carpet' that would allow the rest of the Army to pass through and make a great

A signed photograph by Monty as a memento for this soldier. (KOSB Museum)

8th Battalion, 15th Division in Germany. Men of the Royal Scots move up to the forward line near Liesel, 3 November 1944. (Royal Scots Museum)

armoured thrust into Germany. Both the 15th and 51st Divisions – and of course many Scottish battalions in other divisions – would take part in the surface operations. The glider-borne troops of 7th Battalion King's Own Scottish Borderers and the Independent Polish Parachute Brigade, which had been formed and largely trained in Scotland, would land at Arnhem in gliders as part of the airborne element. The operation was an utter disaster, though both the Poles and the KOSBs would carry out their duties in an exemplary fashion.

The failure of the Market Garden operation meant that the Rhine remained as a final great barrier to be overcome before the Allies could advance into northern Germany. In an effort to destabilise the Allies, Hitler launched a massive counteroffensive in the

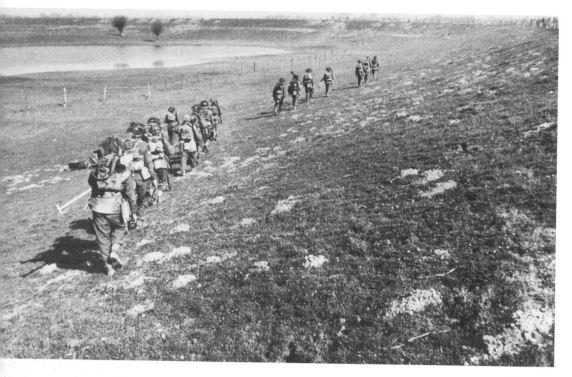

A mortar platoon of 8th Royal Scots moving into position for the Rhine Crossings. (Royal Scots Museum)

Ardennes region in December 1944. The attack made stunning progress for a short while, but the British, Americans and Canadians soon recovered their balance and the last German offensive in the west came to nothing.

Fighting continued in January and February, but by March the Allies were ready to launch another major offensive to cross the Rhine. The newssheet of the 51st Division described the opening phase of the attack:

> AT REES. Yesterday evening our own troops opened Monty's great assault. We got over very quickly on both sides of REES, which is now almost completely encircled. We have captured ESSERDEN, SPELDROP and other villages to the North-West of REES and are now attacking up the road that runs North towards BOCHOLT. Our casualties have been very light, and this morning we already had 360 prisoners in a cage. Amphibious tanks are over the river, and we have a raft ferry service running. Pontoon bridges are not likely to be in operation for some time. This morning, every eye has seen the hundreds of Dakotas and Horsas which are landing two para divs [parachute divisions] between our bridgehead and BOCHOLT. No more impressive comment can be made. [ibid]

Hitler's winter offensive had exhausted German reserves in the west; the armour that might have stemmed the advance across the Rhine had been destroyed in the

A tank crew rest in a square in Northern Europe. (Argyll and Sutherland Highlanders Museum)

Buffalo 29 with captured German troops inside. (Royal Scots Museum)

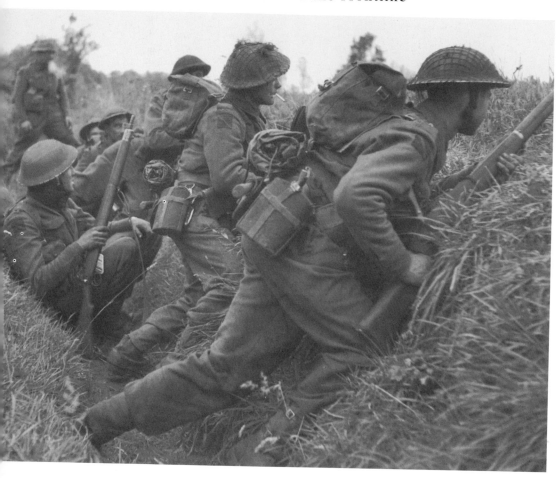

8th Royal Scots take a ditch on the Moortdyke Road and consolidate their position. (Royal Scots Museum)

Opposite, from top

8th Royal Scots go into the assault on Blerick riding on a Kangaroo. (Royal Scots Museum)

A Kangaroo carrier in Germany, 1945. (Royal Scots Museum)

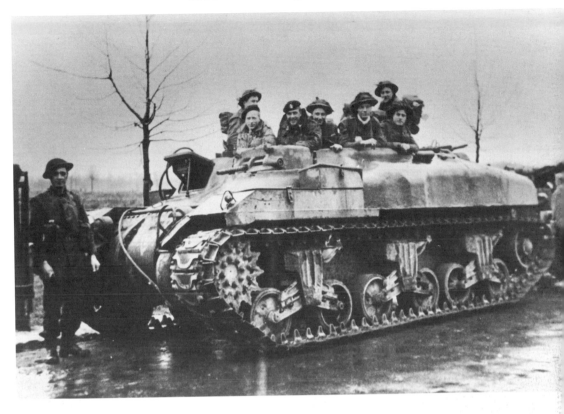

Crossing the Rhine saw US troops and their British Army counterparts working closely together to overcome this last major obstacle before pushing victory home in Europe. (Department of Defense Visual information (DVIC), US Army)

Ardennes, and Allied progress was now unstoppable. The next edition of *Piobreachd* had an encouraging tone underneath the headline 'MARKING-UP THE RHINE MAP':

> The battle of the Rhine bridgeheads is going very well. On the 21 Army Group front, 15 miles of the East bank is held, with four solid bridgeheads established and a penetration of up to 5 miles already made in the enemy defences.
>
> REES. With German paratroopers still fighting desperately against our encircling forces, inside the town of REES, our own bridgehead is very firm and considerable progress has been made. We have cut the road leading North-East towards BOCHOLT, and one of our battalions has stormed and taken a strong enemy position in a brickworks a mile and a half North of REES. The small village of GROIN just East of the road has also been captured. We have advanced towards the road running North and West from the town, after taking SPELDROP, and are attacking stubborn enemy defences around BIENEN. To the right of the sector, the peninsula between the Rhine and the Alter Rhein has been completely cleared of enemy. The PW [prisoner of war] total up to 11 o'c this morning was just short of 1,000. [ibid]

Men of 8th Royal Scots firing a 4.2in mortar at enemy positions, March 1945. (Royal Scots Museum)

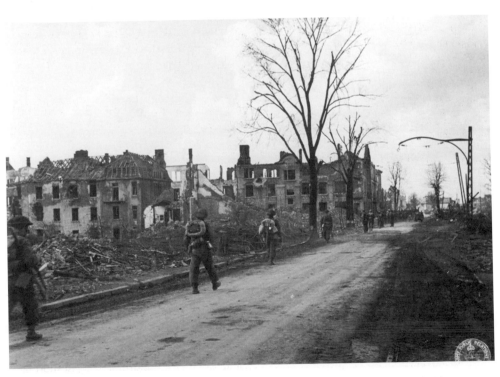

Men of 1st Battalion the Black Watch entering Emmerich, Germany in March 1945. (Museum of the Black Watch, Royal Highland Regiment of Canada)

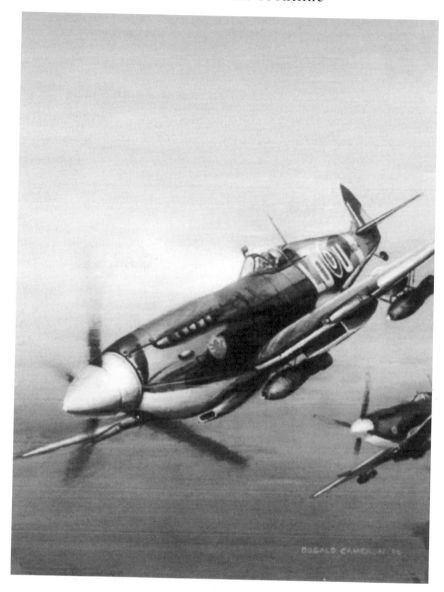

Spitfire XVIs of 602 (City of Glasgow) Squadron on an operation to find and dive-bomb German V2 rocket sites in Holland in 1944/45. Based in Norfolk, the operations required a long return flight across the cold North Sea in a single engined aeroplane to find the launchers around the Hague. (Painting reproduced by kind permission of Prof. Dugald Cameron)

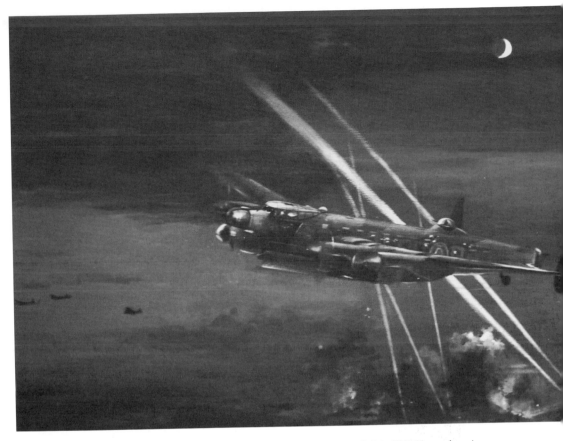

William Reid flew a number of daring raids on Dusseldorf, for which he was awarded the VC. He was born in Baillieston, Lanarkshire. (603 Sqn RAFVR)

Both the 51st and 15th Divisions would remain in the northern Europe theatre for the rest of the war and would be involved in all of the major offensive operations, including Market Garden and the Rhine Crossings. Unlike any other divisions of the British Army, the 15th would take part in all of the great river crossings: the Seine, the Rhine and in the last operation of its kind in Europe, the crossing of the Elbe at the end of April 1945. The division spent the last weeks of the war fighting through northern Germany, capturing Lubeck and Kiel. The northern Europe campaign came to an end with the surrender of the German Army on Luneberg Heath in May 1945. In addition to the thousands of men killed or wounded in the RAF and the Royal Navy, and the thousands more serving with other divisions, the 15th and 51st had suffered more than 25,000 casualties between them.

7

TRAINING AND PREPARATION – AND A LITTLE LEISURE

For many service personnel, a good deal more time was spent in training and preparation than on active service. To some degree this was less the case for the Royal Navy than for the Army. Once a man was trained to do his job and posted to a ship he might undergo additional training from time to time and might be sent on specialist courses of one kind or another, but a warship at sea might come under attack at any moment. This was more the case in the Second World War than in previous conflicts due in part to the threat of submarines, but also because of the threat of enemy aircraft. Neither the Germans nor the Italians ever built an aircraft carrier, but the Japanese Navy had several and demonstrated their value in the raid on Pearl Harbor in December 1941. Land-based aircraft were just as much of a threat. On 10 December 1941 HM ships *Repulse* and *Prince of Wales* were sunk by Japanese 'Nell' bombers operating from airfields in the French Indo-China. The large quantities of highly combustible fuel that a carrier needed for both the ship and the aircraft meant that they were vulnerable targets, but they could be just as vulnerable to accident. The largest single loss to the Royal Navy in Scottish waters occurred when HMS *Dasher* was conducting aircrew training in the Clyde, when an explosion occurred in the main fuel storage area, probably due to a carelessly dropped cigarette. Only 149 men survived from a complement of more than 500.

Scotland was liberally covered with training areas on land as well as sea. Thousands of men passed through the commando training facilities at Achnacary; the 52nd Division trained extensively for mountain warfare all over the Highlands, though they never actually fought in that role and were converted to an 'air-portable' role in 1944, when it became apparent that there would be no need for a mountain division.

Scots may have served all over the world during the war, but to some degree the rest of the world also came to Scotland. Men from Norway, Canada, America, France and many other nations trained at locations all over the country in preparation for

Pipes and drums playing on an aircraft carrier, Gibraltar 1943. (Royal Scots Museum)

the day when they would be back on the frontline. There were very large numbers of Poles, in particular, spread across the country from Duns to Forres. Scotland was home to the staff college of the Polish Army in exile, an engineering school, a Polish medical school at Edinburgh University and, perhaps most famously, the training establishment for General Stanislas Sosabowski's Independent Polish Parachute Brigade near Leven in Fife.

Life for the exiles was not always comfortable; the following examples are drawn from *The Lion and the Eagle* (ed. Dr Diana Henderson, courtesy of Cualann Press).

Squadron Leader Leslaw Miedzybrodzki recorded his experience in the West Highlands:

I was on Benbecula for six weeks flying Wellington Bombers Mark 14 while patrolling the northern sea approaches north of Benbecula. It was November. We were living in Nissen huts. The nights were long and we had problems with the wind, sheep on the runway and the mice eating our woollen uniforms which we had to hang from string, attached to the ceiling.

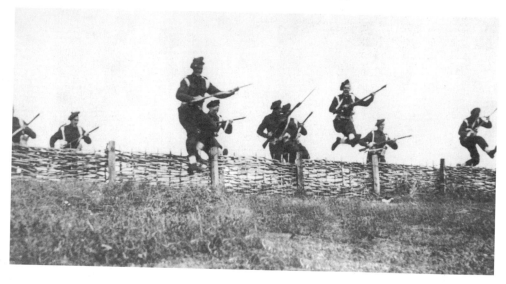

No 2 Commando on training, their exercises were designed to be tough and test endurance to the limits. (Collection of Desiree Roderick, courtesy of the Commando Veterans Association)

We did not have much contact with the local people, but when we went to get our washing done by the locals, there was great difficulty because they were Gaelic speakers.

The squadron leader was not alone in his experience of Scottish weather. Michael Zawada served on a French destroyer, the *Ouragan*, which had a Polish Navy crew:

In December 1940 I remember we went to escort a convoy to Iceland and then we went to Orkney and Shetland as part of the Home Fleet escort for HMS Hood. Off the Shetlands we were caught in a very bad storm. At Scapa Flow I did not go ashore but I had formed a very bad impression of the place; there was so little daylight. I thought 'What a place, you hardly see the sun, it is always raining or snowing and nothing grows.' [ibid]

Wieslaw Szczgiel found himself building a camp in Tentsmuir Forest near Leuchars:

Soon the Scottish weather set in. The rains of September and October did not help the troops with their task of building the camp. Many a day it was too wet to work and we spent the hours in the dripping tents, chatting and smoking. [ibid]

If the weather was poor, other conditions left a good deal to be desired, but could be overcome if one was resourceful:

The monotony of the Autumn days and evenings was brightened when on Saturdays, the company officers, led by Captain Wajdowicz, went by the company truck to St. Andrews. There in the Tudor Cafe, we had high tea. By that time the food rationing had begun to bite

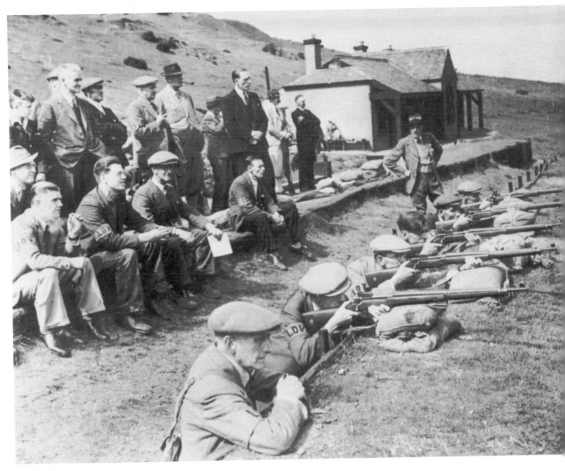

It was just as important to train those defending home soil, as those deployed around the world. Here, men of the Home Guard are given rifle training. (Scotsman Publications)

and you were allowed only one egg, one rasher of bacon and one sausage for your high tea. So we usually had our first high tea, by which time the bar in the adjoining Imperial Hotel was open. After suitable refreshment there, we were back at the Tudor cafe for our second high tea. [ibid]

This period did not last long and by the end of spring Captain Wajdowicz had been on a course at Inverlochy castle to learn what he called 'cloak and dagger stuff'.

Not all were selected for further secret training but this was the beginning of the formation of our future parachute brigade. The Spring saw the creation of the 'Monkey Grove' or 'Malpi Gaj' in Largo House [the Monkey Grove was a tower, built within Largo House itself, on which prospective paratroops could practice the actions of leaving an aircraft and landing]. The engineer officers and one or two other ranks with technical skills started

constructing parachute training contraptions among the old outbuildings and trees of the grounds of Largo House. [ibid]

Polish infantry and armoured units trained in Scotland and fought in the Middle East, Italy, France, Belgium, Holland and Germany. In the late summer of 1944 the Polish Government in exile harboured hopes that the Independent Parachute Brigade would be dropped into Poland in an effort to set up some sort of government between the departure of the Germans retreating westward and the arrival of the Russian advance. This was never a realistic proposition: the distance was too great, the Russians were not inclined to co-operate since they had already formed their own Communist 'Government in Exile' and, in any case, a brigade of little more than 2,000 men could only have a very limited impact. The brigade was instead committed to the Market Garden operation (the battle of which inspired the film *A Bridge Too Far*), where it performed magnificently. Although General Sosabowski

Scottish girls meet Poles at Crawford Camp, 1940. (Scotsman Publications)

A minister from the Royal Army Chaplains' Department delivers a sermon to Scottish troops. (Royal Scots Museum)

was treated shamefully by his superiors after the battle, the Polish Parachute Brigade had invented many of the techniques which were adopted as standard parachute procedures by the British Army, and therefore made a great contribution to the development of the airborne forces.

Units and individuals would need additional training from time to time to familiarise them with new equipment. Every time an armoured unit received new vehicles – and some British armoured units would have to get to grips with as many as a dozen different types of tanks and other armoured vehicles between 1939 and 1945 – they would need to undergo extensive retraining, not just for the crews, but for the many technicians who kept the vehicles running. Troops would also have to receive training for different theatres of war. The skills required for combat in the desert were very different to those needed in Europe or Asia.

Captain Wilson served in the Argylls during the Malaya campaign and just before the surrender he was one of a number of officers and NCOs ordered to India to help with developing the techniques for jungle warfare. The Argylls were one the few units that had undertaken any serious jungle training before the Japanese invasion

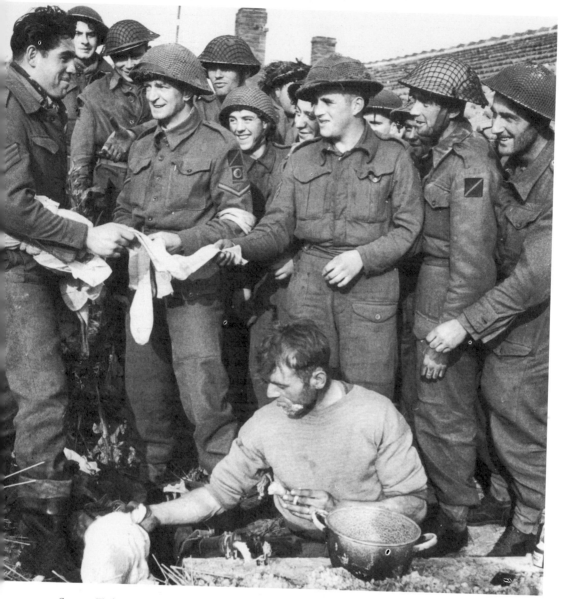

Sergeant Taylor, C Company issuing fresh socks to men of his platoon. (Royal Scots Museum)

and had performed exceptionally well. He had several interesting observations to make about the nature of war in hot, mountainous jungle conditions, which appear in Julian Thompson's book, *Forgotten Voices of Burma* (hereafter 'Forgotten Voices').

At night you are on your own. You are susceptible to noise made by the enemy and shooting at noises and shadows, which you mustn't do. The antidote is endless training; practising movement by night, the use of pole charges to attack bunkers and bringing

Men were expected to keep meticulous records of their service and training. (Ms Heather Johnson)

down supporting fire from mortars and guns very close to us. There was a very great deal to learn. There were problems with wireless in jungle and hills, caused by blank areas for communicating, especially at night.

The contemporary concepts of mobile warfare could not be applied in Burma and the troops had to learn to take a very different approach to combat. In the attack, the Japanese were utterly ferocious, but in the defence they were tenacious in the

The Scottish weather was certainly a good test of morale for those on training exercises! (Scotsman Publications)

extreme, constructing strongpoints that they would defend to the last, and which therefore had to be totally demolished. In Europe and the desert, once a strongpoint had been surrounded the occupants would be more likely to either surrender or attempt a breakout, indeed they could generally be expected to withdraw before being completely encircled. Japanese troops could be relied on to hold their position until physically destroyed, unless specifically ordered to breakout:

We learnt about their string of defensives [sic] and use of local materials to build bunkers, which were shellproof, even against anti-tank guns, and marvellously well-concealed. You seldom saw a Japanese move by day. They took pains to conceal their tracks because by 1944 we had superiority in the air and in artillery. They realised this and they trained to operate by night. Their positions were well sited to support each other. They tunnelled and connected firing positions with covered ways. They could call down their own gun and mortar fire on their own positions. They cleared fields of fire, but not in such a way that it gave away the location of their bunker. What you could do was to try and draw their fire at night by shooting at them, moving about etc. They did it to us. Bill Slim's [General William Slim] adage was 'the answer to noise is silence.' It was almost a crime to shoot without having a corpse

Shetland men provided guncrews for the most southerly command in the British Empire in South Georgia.
(Shetland Museum Service)

Men quickly learnt how to make the best out of the rations they had. (Argyll and Sutherland Highlanders Museum)

to show for it the next morning. We used the PIAT for bunker-busting, and sometimes wheeled up a six-pounder anti-tank gun, which was very risky. [ibid]

Despite a major increase in defence investment in the immediate pre-war period, a great deal of British military equipment was still of poor quality or simply did not exist. The tactical environment was very different to that of the 1914–18 war and some units simply did not have the right sort of equipment for the tasks that they were expected to perform on the battlefield. In the First World War, infantry divisions had included a cavalry unit – often one squadron – for reconnaissance purposes. Clearly theses needed to be replaced with motorised troops to match the mobility from the rest of the division, but there was a desperate shortage of suitable military vehicles, as we can see from this excerpt from the history of the 15th Scottish Reconnaissance Regiment:

The reconnaissance Corps had been founded … to do in the war of the internal combustion engine the work which had been done by the old horsed divisional cavalry in the wars of marching men; to look and to listen, to find out and report back, to be a screen

against surprise, to see that the division was forearmed by being forewarned, to seize and to hold. Reconnaissance battalions grew mainly from the brigade anti-tank companies, and the battalion's part in the armies of liberation was evolved in training by a process of trial and error and (in those days of shortage) improvisation. With motorcycles of civilian origin, a few ungainly armoured trucks called 'meatsafes' (which is what they would have been in action), anti-tank rifles and wireless sets lamentably insufficient in power and numbers, infantrymen began to learn the job which they were to do as mechanised cavalry with fast and powerful armoured cars and reconnaissance cars, an impressive assortment of tracked and half-tracked vehicles, a wireless system which could give communication over many miles and a regiment's fire power equal to that of an infantry brigade … Officers and other ranks were drawn from all the infantry regiments then in the division; the 6th and 7th King's Own Scottish Borderers, the 8th Royal Scots, the 9th and 10th Cameronians, the 6th Royal Scots, the 2nd Glasgow Highlanders and 10th and 11th Highland Light Infantry. This recce unit was broken up in January 1942 to form three Independent reconnaissance Companies – 15th, 48th and 77th. 15th Company stayed with the division and became the foundation of the 15th Scottish Reconnaissance Regiment, Recce units having by this time adopted cavalry terms – Regiment instead of battalion, squadron instead of company, troop instead of platoon [www.15threcce.org]

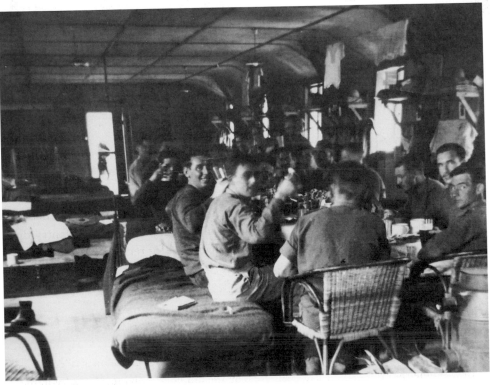

Mealtimes provided a moment to relax and enjoy each other's company. (Argyll and Sutherland Highlanders Museum)

A famous staged photograph of training in disguise and secret operations. (Scotsman Publications)

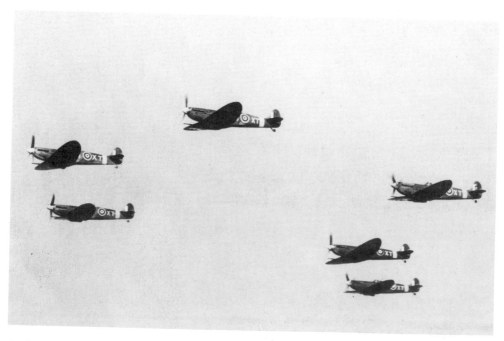

Spitfires of 603 (City of Edinburgh) Squadron on training. (603 Sqn RAFVR)

Right Aircraft carriers became a key part of ensuring that men and air support could be delivered to where they were needed. (603 Sqn RAFVR)

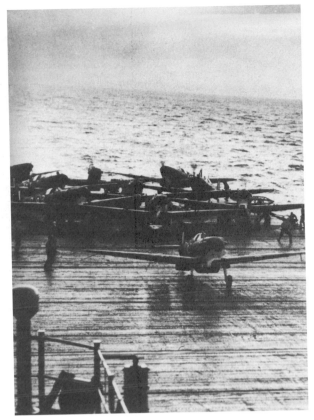

Below Training manuals were a key part of instruction and provide a clear insight into doctrine and tactics. (Ms Heather Johnson)

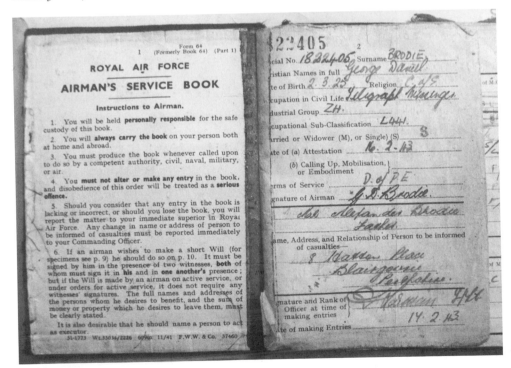

British Army Bren Gun Carriers in action whilst on manoeuvres, 27 February 1940. (Royal Scots Museum)

As time passed and material shortages were, at least to some extent, overcome, the reconnaissance regiments were re-equipped with appropriate vehicles: Daimler and Humber armoured cars, American-built White scout cars, jeeps and M3 half-tracks were added to the ubiquitous Bren Carrier. Eventually a reconnaissance regiment would have a complement of:

270 vehicles (which) included 28 armoured cars, 24 light reconnaissance cars, 69 carriers, 55 motor-cycles (some of which were later discarded), armoured half-tracks, jeeps and three-ton and fifteen hundred-weight trucks. In addition to the 37 mm gun and Besa machine gun mounted in the turret of each Humber armoured car, the regiment was armed with 151 Bren guns, 36 PlATs, 8 six-pounder anti-tank guns, 6 three-inch mortars, 25 two-inch mortars, 410 rifles, 223 Sten guns and 88 pistols ... Each of the three reconnaissance squadrons had three car troops (each of three armoured cars and two light cars), three tracked carrier troops (each of seven carriers) and an assault troop of four sections equipped as infantry and carried in halftracks. [ibid]

A pre-war training march in Malaya. Even in such difficult climates regiments would still carry the pipe and drums. (Argyll and Sutherland Highlanders Museum)

Training in Malaya before the Japanese invasion. Proficiency in camouflage and accurate fire were key to maintaining tactical surprise in every theatre of the war. (Argyll and Sutherland Highlanders Museum)

Home Guard soldiers training in Scotland. Urban and close-quarters combat training was vital, especially for those units deployed in Northern Europe. (Scotsman Publications)

Training could, from time to time, give way to something in the way of leisure activities. Sports of all sorts were given some encouragement; it should come as no surprise that the King's Own Scottish Borderers should have fielded pretty convincing rugby teams as it is part of the cultural tradition of the Borderers. Horses have always been important to soldiers – during the First World War divisional horse shows were big occasions, though one suspects that the equestrian event held by the Royal Scots Fusiliers at Troia that Colonel Kemp recorded might not have been seen as in keeping with the Army horsemanship tradition:

> … a sports meeting was held by way of relaxation, at which the main attraction was a mule race. Mountain warfare in Italy was about to restore the mule train to its traditional place in the transport of the British Army. Mules were in short supply, and the rules of the race admitted any quadruped which could support a jockey. Sergeant Guthrie ran a 'book' on

A mortar platoon in training. (Collection of the Commando Museum, Spean Bridge Hotel/Courtesy of The Commando Veterans Association)

the event, for which there were 15 entrants. The Colonel and Father Bluett had chargers; the Adjutant, Captain A. M. L. MacFarlan, rode a Shetland pony; while the rest of the starters consisted of an assortment of donkeys and mules. The course extended from a tape at the top of a field down to a turning point, and measured 500 yards. Most of the riders were literally 'off' at the start, and every runner took a different direction. Father Bluett was dragged a considerable distance along the ground by his charger, and only the Adjutant on his Shetland pony, which he steered by keeping his feet on the ground, finished the course. It took him 10 minutes. [Hist. RSF]

Mortar platoon of the King's Own Scottish Borderers undergoing an inspection. The Bren Carrier in the background could transport the mortar team over almost any terrain. (KOSB Museum)

Senior officers inspecting a 6 pounder anti-tank gun of the Argyll and Sutherland Highlanders (Argyll and Sutherland Highlanders Museum)

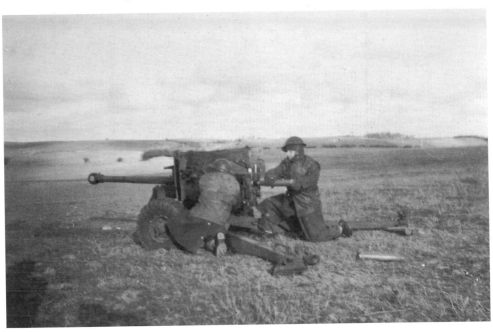

A 6 pounder anti-tank gun is deployed on exercise. (Argyll and Sutherland Highlanders Museum)

Inter-athletic meeting in Gibraltar, 14 September 1943. (Royal Scots Museum)

A friendly boxing match. Such activities helped to stave off boredom while on training and maintained physical fitness. (The Guards Museum)

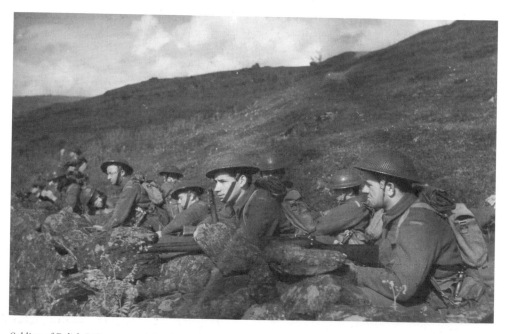

Soldiers of Polish I Corps on training in Scotland. (Polish Information Center, 1st Ed., New York 1941)

The Scottish Borderers Rugby team. (KOSB Museum)

The Scottish Borderers relaxing with a pint. (KOSB Museum)

Commando Pipes and Drums at Achnacary (Collection of Clan Cameron Museum/Courtesy of the Commando Veterans Association)

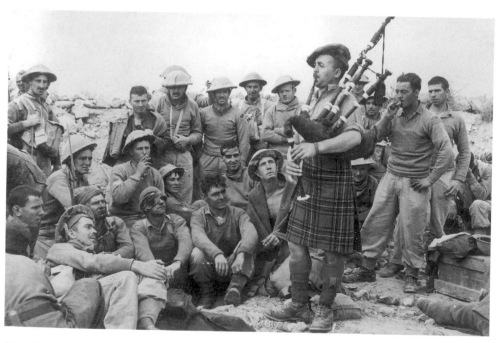

Men of the Black Watch relax and listen to a piper in North Africa. (Museum of the Black Watch, Royal Highland Regiment of Canada)

8

THE FAR EAST

If the war had started badly in France in 1940, it did not go terribly well elsewhere in 1941 and 1942. In North Africa the pendulum swung to and fro until El Alamein, but in Asia the initiative lay firmly with the Japanese. Almost without exception, British military and political authorities had failed dismally to make any kind of realistic appraisal of Japanese strength on land or sea. To some extent this had been fostered by the utter defeat that the Japanese had suffered at the hands of the Russians and their failure to conquer China in a war that had already dragged on intermittently for a decade. The British failed to appreciate the sheer scale of the war in China – though by late 1941 Japanese forces could be seen across the border of the New Territories. They also failed to appreciate that the Russians had fielded a powerful army of well-trained troops with excellent tanks and air support and had still had a hard time beating the Japanese. There was also a considerable element of ridiculous racist propaganda. Japanese troops were said to be unfit; Japanese pilots were allegedly incapable of night flying because they could not see in the dark. To make matters worse there was a good deal of British wishful thinking – the Brewster Buffalo fighter issued to RAF fighter squadrons in Malaya was the equal of the Japanese Zero; the Japanese would never invade Malaya, but if they did they would not be able to use tanks because the 'jungle was impenetrable'. None of this was even vaguely close to the truth – it seems not to have occurred to anyone that the Japanese might drive their tanks along the roads that ran the length of the Malayan peninsula from Singapore to the Thai border. When the blow fell, it fell all around the Pacific; only a few hours separated the attacks in Malaya, Hong Kong and Pearl Harbor.

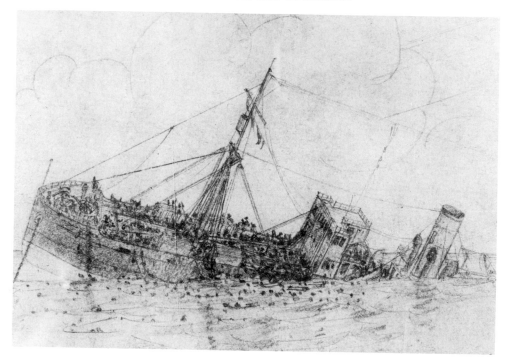

The sinking of the Lisbon Maru *in the China Sea, 20 October 1942. (Courtesy of Tony Banham)*

The Shin Mun Redoubt, Hong Kong. (Royal Scots Museum)

The Royal Scots in Hong Kong

The 2nd Battalion of the Royal Scots had been posted to Hong Kong in 1938, where they were one of the four regular battalions that constituted the colony garrison. The Japanese had already been fighting for some years in China and were now very close to the mainland portion of the colony, known as the New Territories. The general plan was that in the event of an attack four battalions of the garrison would hold the Japanese along a position known as the Gin Drinker's Line, though a pre-war report by Sir Robert Brooke-Popham had concluded that at least two divisions (a minimum of twelve battalions and appropriate supporting troops) would be required to man the position properly, albeit he – and virtually everyone else in the British military and political hierarchy – held an unrealistically low opinion of the abilities of the Japanese Army. The garrison commander, General Maltby, was promised two further battalions from Canada, which improved the situation slightly, but the Canadians arrived with little training, without transport and, crucially, without the Bren Carriers that were a vital part of the British and Commonwealth approach to combat. There were other difficulties too. The climate was not conducive to keeping the soldiers fit and healthy,

The frontier between Japanese-occupied China and British Hong Kong before the outbreak of the Second World War. (Royal Scots Museum)

133

A map of the Shin Mun area, marking where the pillboxes were located. (Royal Scots Museum)

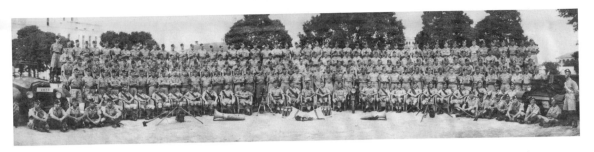

HQ Company, 2nd Battalion the Royal Scots, Murray Barracks, Hong Kong 1941. (Collection of Malayan Volunteers Group)

and training suffered accordingly due to the large numbers of men who were absent through illness at any given time. There was not enough ammunition for training purposes and there was a shortage of the mule trains that would be required to move the battalions' mortar platoons around the rough hilly countryside that divides Hong Kong from mainland China. If all that was not bad enough, there was also a complete dearth of air support.

Unsurprisingly, when the attack came on the morning of 8 December 1941, the Japanese were able to make rapid progress despite a stout resistance from the platoon of the Royal Scots who held the vital Shing Mun Redoubt. By the morning of the 11th it had become clear that the Japanese had gained the upper hand and any further resistance on the mainland would mean fighting in the streets of Kowloon, where it would be difficult to maintain control over the troops, impossible to apply the very limited artillery support available and where the superior numbers of Japanese would allow them to outflank and surround Allied units more or less at will. At half past seven that evening, having suffered heavy casualties from their near-continuous contact with the enemy, the Royal Scots were withdrawn to Hong Kong Island, where they now became the garrison reserve. Although there was absolutely no prospect of relief, the Hong Kong garrison conducted the defence with exceptional skill and zeal, with the Royal Scots regularly in the thick of the fighting. By dawn on the 24th they had been reduced to only 175 all ranks, but still managed to mount a ferocious local counterattack that afternoon. According to the official history of the South-east Asia campaigns, the loss of Hong Kong 'after only eighteen days fighting' came as a shock, though it is hard to see why. With no armour, no air cover, no adequate anti-tank weapons, shortages of transport, food, water and ammunition, and attacked by an experienced, well-led enemy in overwhelming numbers, the defence of Hong Kong should be seen as an exceptional feat of arms. The same cannot be said of the defence of Malaya or Burma.

The Argylls in Malaya

Very little of a positive nature can be said about the Malaya campaign of 1941–42, but one of the few brighter aspects is the conduct of the Argyll and Sutherland Highlanders. In August 1939, on the eve of the war, the 2nd Battalion disembarked in Singapore. The posting was doubtless seen as a disaster to some. There can have been little doubt that there would be war with Germany and the battalion was on the wrong side of the world. For professional soldiers the prospects were poor. If the war went on for any great length of time their comrades in Europe were likely to make significant career advances while the 2nd Battalion kicked its heels in a military backwater. Few people believed that Japan would enter the war at all, and even fewer had any regard for the quality of the Japanese armed services. Since Japan had been fighting in China for some years it seemed to many observers that the emperor's

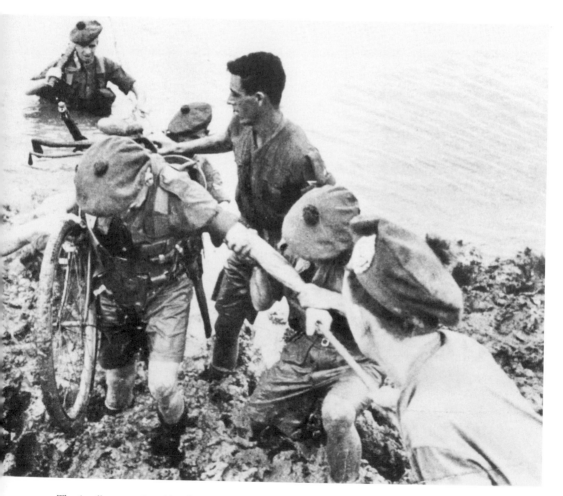

The Argylls cross a river. (Argyll and Sutherland Highlanders Museum)

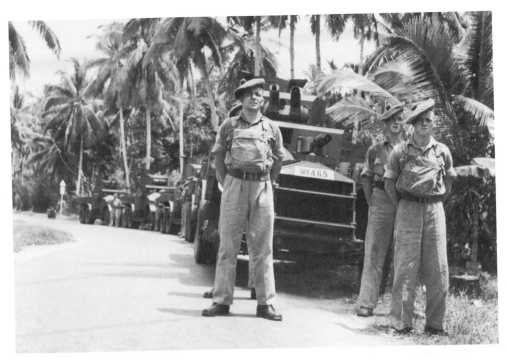

Men of the Argyll and Sutherland Highlanders in Malaya with their troop of obsolete Crossland armoured cars. The Crosslands were severely outmatched by the Japanese Chi-Ha and Kyu-Go tanks. (Argyll and Sutherland Highlanders Museum)

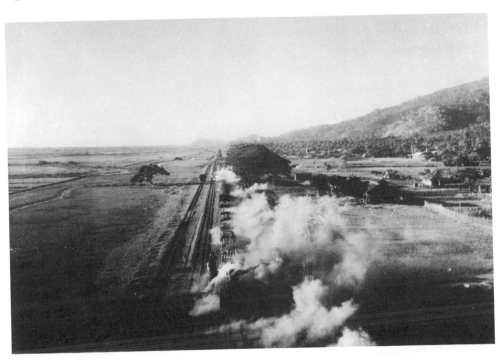

Air strike on Japanese communications. (Author's collection)

forces already had as much on their plate as they could deal with. Moreover, the war in China was a very long way from Malaya, any Japanese invasion force would be destroyed by the Royal Navy as soon as it approached British-held waters and Britain had a very strong Army and RAF presence throughout the length and breadth of Malaya, as well as an allegedly 'impregnable fortress' in the shape of Singapore Island itself, where a massive naval base had been constructed at enormous cost over the preceding twenty years. On top of all that, any Japanese expansion would also be opposed by France, who had colonies in Laos and Vietnam (French Indo-China) and the Netherlands, with their extensive holdings in Indonesia (Netherlands East Indies) and Britain would also expect the assistance of the powerful United States Pacific Fleet based at Hawaii.

All of these factors were negated by the events of 1940. The defeat of the French destroyed any prospect of French assistance since the Vichy authorities in Indo-China had to make terms with Japan, and although the administration of the Netherlands East Indies survived the fall of Holland intact and the forces there were extensive, they were poorly armed and trained. Since the Japanese had acquired virtually complete freedom of action in Indo-China they could build air bases within striking range of all of the Malayan Peninsula and, unlike the British, they had a large and modern air force.

The Japanese attacks on Malaya and Hong Kong coincided with the raid on Pearl Harbor, which put a large portion of the US fleet out of action for the foreseeable future, and it rapidly became apparent that all of the other assumptions that the British had made about the defence of the Far East were at best optimistic and at worst downright foolish.

Almost alone among the British battalion commanders, Colonel Stewart of the Argylls had put his men through a strenuous and effective course of training for jungle warfare. The men knew what to do and were fit for the task. Little more than a week after the landings they were putting their skills to the test. One rifle company and a section of the battalion's armoured cars were in action north of the town of Grik on 16 December, and the rest of the battalion had what the official history calls 'a spirited action' at Titi Karangan on the morning of the 17th.

As one of the few competent and reliable units available, the Argylls were in action almost constantly throughout the long retreat south, temporarily losing Colonel Stewart, who took over command of the brigade on Christmas Eve. The battalion was in action at Kampar, Trolak and at the Slim River before withdrawing to Singapore, where they fought on until the Army surrendered on 15 February. Of the 900-odd men who served in the battalion more than 240 were killed in battle and nearly 200 more would die of neglect, starvation and cruelty in Japanese prisoner-of-war camps.

The Gordon Highlanders in Singapore

The Gordons moved into Singapore's Selarang Barracks in 1937 and became part of the 'fortress' garrison. Casual use of the term 'fortress' would lead to a ridiculous level of overconfidence among the troops and civilians in Singapore and among the politicians and populace at home. In British military usage of the day, a 'fortress' was nothing more than a location where there were a great many troops. It was really nothing more than an administrative term to define the role of the senior officer on the ground with responsibility for supplies, discipline and general operating policy in the area, who would be known as the 'Fortress Commander' to distinguish his role from that of other senior officers whose troops happened to be in the vicinity. The term 'fortress' did not imply any level of preparedness or fortification. Although it is easy to see why politicians and civilians might fail to understand the difference, in Singapore and Malaya – and more widely for that matter – the distinction appears to have been lost on all but a few of the military men.

In the campaign of 1941–42 and in the barbaric captivity that followed, nearly 400 men of the Gordon Highlanders would lose their lives. The unit conducted exercises in the Kuala Lumpur, Muar and Mersing areas, but training was compromised by severe restrictions on the expenditure of ammunition and fuel for the Bren Carriers, which were such an important part of battalion tactics. Through the first weeks of the campaign the battalion was stationed in Johore, the most southerly state on the Malayan Peninsula, and for a few days in Singapore before moving to join the 27th Australian Brigade on the main highway south of Ayer Itam. The battalion came under attack early on 26 January, suffering around fifty casualties before retiring through the Australians, where they were briefly out of contact with the enemy, but were back in the thick of the fighting on the 28th. Early on the 31st the battalion crossed the causeway to Singapore to the accompaniment of two Argyll pipers playing the regimental march of *Blue Bonnets o'er the Border*.

Far from being a fortress, Singapore was extremely vulnerable and the defence of the island was very poorly managed. The Gordons were in action several times in the week of hard fighting that took place between the Japanese landings and the capitulation, engaging with the enemy at several locations and suffering from Japanese air strikes and artillery bombardments. However, like most of the other units, the Gordons suffered greater losses under the shameful conditions of their captivity than they had during the campaign.

Burma

No Scottish division served in Burma, but large numbers of Scots served in the various corps and departments of the British Army and a great many more in the Royal

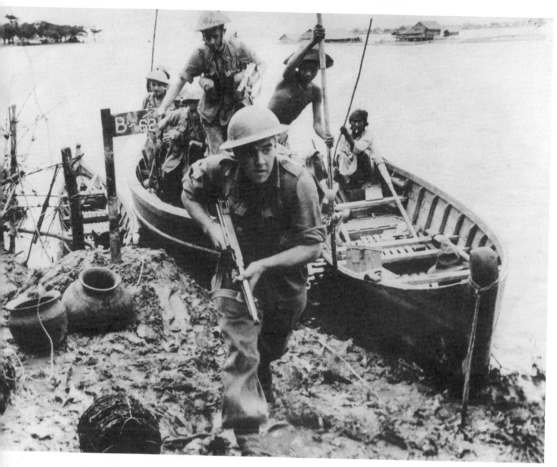

The 1st Battalion in Burma. (Royal Scots Museum)

Navy and RAF, both of which deployed large numbers of men in support of the land campaign. Several Scottish battalions served during the Burma campaign in different divisions of the British and Indian armies, as did at least one artillery regiment (100th Anti-tank), which had been raised originally as the 8th Battalion of the Gordon Highlanders before being converted to gunners. The Scottish battalions included the 1st Royal Scots and 1st Queen's Own Cameron Highlanders and 100th Anti-tank regiment in 2nd Division, 2nd Highland Light Infantry in 5th Indian Division, 2nd King's Own Scottish Borderers in 7th Indian Division, 1st Seaforths in 23rd Indian Division and, in 29th Independent Brigade, 1st Royal Scots Fusiliers and 1st Cameronians, as well as 116th Regiment of the Royal Armoured Corps, which had originally been formed as 9th Battalion the Gordon Highlanders, who were amalgamated with 5th Battalion and served in the famous 255th Indian Tank Brigade.

The presence of British and consequently Scottish battalions in Indian divisions was perfectly normal. All Indian divisions had British battalions as a matter of policy,

though this was not the practice in any of the African divisions that served in the Burma campaign. This may have been because the political authorities were confident that the African divisions could not be suborned by Japanese propaganda since the troops would be aware that they would find it virtually impossible to return to Gambia, Nigeria and Kenya save in a British troopship.

The Burma campaign was seen – and still is to a great degree – as something of a backwater compared to the much more well-publicised struggles in North Africa, Italy and northern Europe. The troops saw themselves, with some justification, as the 'Forgotten Army'. Under the leadership of their brilliant and charismatic commander, William Slim, Fourteenth Army achieved victory despite the dreadful environment, the determination of the Japanese and being very much at the end of the queue when it came to the allocation of the vital resources of modern war. Broadly speaking, troops in the Fourteenth Army spent a greater proportion of their days in close contact with the enemy than those in other theatres, and when they were notionally out of the frontline there was very often nowhere for them to go and nothing for them to do. When they were away from the frontline they were seldom able to get away from being in camp. General (later Field Marshal) Slim did his utmost to counter the boredom of the camps by encouraging as wide a range of social and educational facilities as he could. In an effort to give the troops some

A Naga village where some of the bloodiest fighting of Kohima took place. (Royal Scots Museum)

Dedication of 1st Battalion Memorial, Aradura Spur, Imphal, 25 November 1944.

semblance of the liberty of being away from the Army during leave periods, he tried to set up 'non-saluting' areas, but was prevented from doing so by the conservatism of the military and political establishments.

All of General Slim's efforts would have been in vain without the skills and commitment of the officers who led the men in battle; men like Colonel John Gunn of the Seaforths, whose obituary appeared in the *Daily Telegraph* in December 2005:

He (Colonel Gunn) accompanied 1 Seaforth to Burma and, after a period of rigorous training in jungle warfare, he was put in command of the long-range penetration patrol.

In June 1943, in the Chin Hills of northern Burma, Gunn led a patrol of 12 men in an attack on a Japanese garrison of some 80 men. The monsoon had broken, with its attendant horrors of mud and disease.

As they worked their way through the dense jungle, the patrol heard hideous noises ahead and thought that they might have run into the Japanese. It turned out to be a troop of monkeys.

A frontal assault was made by a company of 4/5th Mahratta Light Infantry. When the Seaforths heard the Mahrattas open fire, they climbed through the wire in the rear of the enemy position and slipped into their trenches.

A Japanese sentry spotted them but he was quickly silenced and surprise maintained.

Gunn and a comrade went to investigate some straw huts and were on the point of capturing an enemy officer when one of the patrol gave an ill-advised shout.

The officer heard this and ran for his hut. He was shot but he fell on one of his grenades which exploded and killed him.

Gunn grabbed the man's map case, which subsequently proved to be of great value; but the alarm had been raised. The attack by the Mahrattas did not seem to have been pressed, and the Japanese turned their attention to Gunn and his men.

The enemy counter-attacked three times with a bayonet charge. Each assault was heralded by much shouting and waving of drawn swords on the part of the officers; each was stopped at 10 to 15 yards distance and driven off.

When the Japanese began to infiltrate from the rear, the patrol fought their way out. Enemy mortars forced them to make a wide detour, but they returned to base after a long

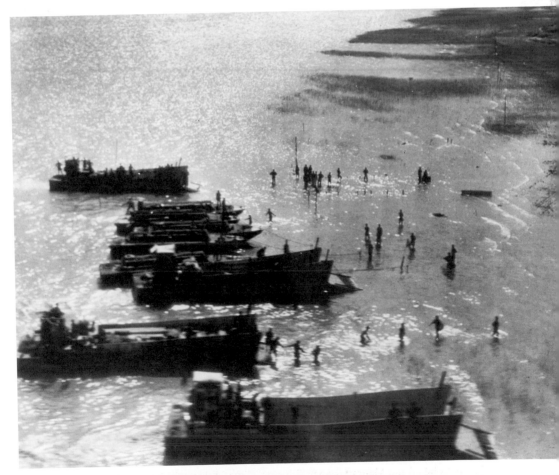

Akyab, Burma, was seized in Operation Talon on 3rd January 1945, as the tide of the Burma campaign turned against the Japanese (Author's collection)

trek and an absence of 36 hours. Some 47 enemy soldiers were accounted for; two Seaforths were killed and two wounded. Gunn was awarded the MC and decorated in the field by Lord Louis Mountbatten.

In May the following year Gunn was in action at Scraggy Hill, a 5,000-ft high feature in the mountains to the south-east of the Imphal Plain. The Japanese were just the other side of the hill, and no more than 20 yards away from the forward posts of one of the Seaforth's platoons.

Every attempt made by Gunn's company to erect wire to strengthen their position was met by a hail of accurately thrown grenades. Most of these fell on his forward platoon, and three times in an hour all the men in the trench nearest the Japanese were hit and had to be replaced.

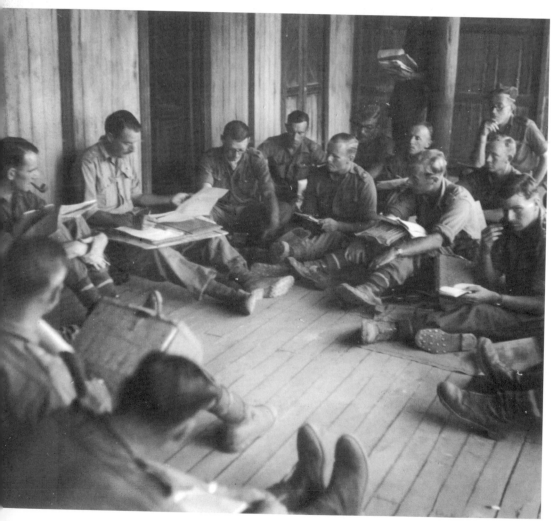

An 'O' group before the Battle of Ywathitgyi, 29 January 1945. (Royal Scots Museum)

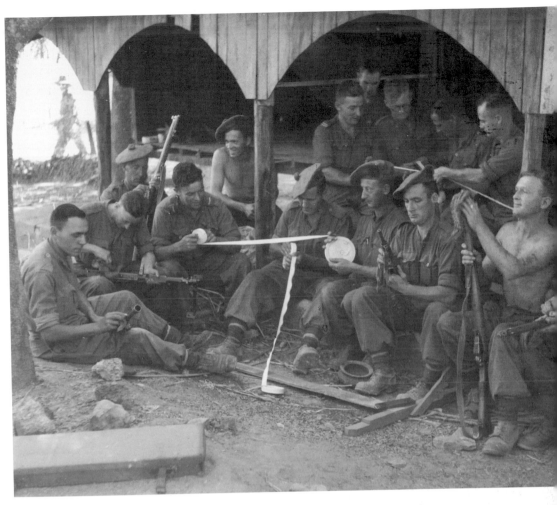

An assault platoon prepares the weapons prior to the Battle of Ywathitgyi. (Royal Scots Museum)

Gunn kept the situation under control, hurling grenades himself and, on one occasion, fending off with his arm a grenade that would have fallen into a trench full of his men. Eventually, he was hit in the stomach by a grenade and fell, severely wounded for the fifth time.

In an engagement lasting more than an hour, three Seaforths had been killed and 27 wounded. Gunn had been given up for dead when a small movement from him was spotted.

A brother officer, 2nd Lieutenant Iain Mathieson, went up the hill, put Gunn on his back and brought him down to the American Field Service, which had come forward under fire to evacuate the wounded.

The Jocks, in awe of Gunn's seemingly limitless courage, called out to Mathieson: 'Don't bring him back here, sir. He'll get us all killed!'

Several senior officers in the Burma campaign were Scots, including General Sir Philip Christison, commander of XV Indian Corps and Brigadier M.R.J. Hope-Thompson, who commanded the 50th Indian Parachute Brigade. The parachute brigade was hugely outnumbered and surrounded for nearly a week at the battle of Sangshak. Hope-Thompson's conduct during and after the battle was the subject of a malicious rumour campaign by a very senior British officer; however, Sangshak produced more decorations for courage under fire than any other single action in the history of the Indian Army.

Essentially, the men of Fourteenth Army learnt to treat the innumerable Japanese bunkers little differently to approaching an immobile tank, with the difference that as a general rule the crew of a disabled tank will abandon their vehicle as quickly as possible since it is such an easily identifiable target. A heavily camouflaged bunker, on the other hand, is a very hard target to approach and Japanese soldiers were seldom inclined to abandon a bunker regardless of the odds or the weight of fire. The PIAT was clearly a reasonably effective weapon, but it might actually take several rounds to inflict any real damage on a bunker, during which time the man firing the PIAT was very vulnerable. The anti-tank gun, though obviously a more powerful piece of hardware, could often only be brought through the jungle and into a firing position with great difficulty, and although the shield of the gun was allegedly bullet-proof, the crew would be exposed to mortar fire or, at close range, grenades.

One of the things that the soldiers in Burma, like troops everywhere, had to learn was to avoid giving away their presence to the enemy by thoughtless actions. Private Hazelhurst committed just such a transgression near the banks of the Sittang River when he served in the Border Regiment alongside a famous Scottish novelist:

George MacDonald Fraser was my section commander. I shot a vulture out of a tree there, because I was bored stiff. I looked at the vulture and thought 'I bet you think you are going to eat me later. You're not mate.' Fraser said 'You could have alerted the Japanese for miles around'. [Forgotten Voices]

Chindits

The term Chindit is a corruption of the Burmese word Chinthay or Chinthé, a creature of Burmese mythology and the model for statues that protect the entrances to many Burmese temples. The Chindit units were formed by Brigadier Orde Wingate in the summer of 1942, when Japanese success was at its height, to operate behind Japanese lines, disrupting their supply routes and diverting resources from the front. Several Scottish regiments provided Chindit troops, who, though specially trained, were not in any sense volunteers, but conventional infantry units assigned to the

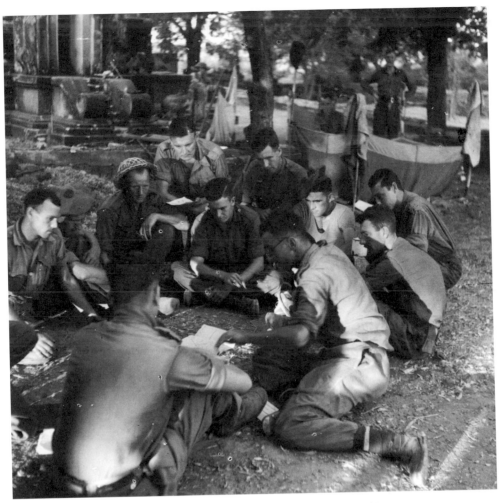

The Signals Officer, Captain Fenton, briefing his section leaders at Ywathitgyi, February 1945. (Royal Scots Museum)

Chindit project. The battalions spent a period in intensive training and were then deployed in half-battalion 'columns' to spend lengthy periods in the field. Numbers 42 and 73 Columns were from 2nd Battalion the Black Watch, 26 and 90 columns from 1st Battalion the Cameronians. In 1944 a little-known, though remarkable, Scottish soldier, Brigadier Bernard Fergusson (who would go on to be Chancellor of St Andrews University and the last British-born Governor General of New Zealand), led 16th Brigade on a seven-week operation behind Japanese lines over some of the most challenging terrain in the world.

Opinion was and is deeply divided about the value of the Chindit operations, not least among the men who took part. The initial role of conducting mobile operations was replaced in 1944 by a more ambitious target of seizing specified points and building major strongpoints from which columns could operate over several weeks

or even months. Morale among the original Chindit troops had been sapped by the knowledge that if they were wounded they would have to be left behind to become prisoners – though more realistically to be executed – by the Japanese. The new plan involved building airstrips so that supplies and replacements could be flown in and wounded men flown out. The theory was that the Japanese would be forced to mount costly attacks on these bases, which would cost them heavily in men and material. Regardless of the military value of the operations, there was certainly a propaganda element that was good for the morale of British and Commonwealth troops in Burma and good for Britain's image as a power that could protect India from a Japanese invasion; the fact that the battle was being carried to the enemy helped to undermine the idea that the Japanese Army was invincible.

Not all of the men who served in Scottish battalions were necessarily Scots. When the Battle of Kohima broke out, Second Lieutenant Gordon Graham of 1st Battalion the Queen's Own Cameron Highlanders was recently married and attending a combined operations (operations involving, as the term suggests, more than one arm of service) at Calcutta and had to make his way across India to rejoin his unit:

> The men in my platoon were a mixture of Yorkshiremen from the mining towns of South Yorkshire and Highlanders, the original Camerons from northern Scotland round Inverness and Skye, so you had a mixture of crofters and miners; they got on wonderfully. They were people of sterling qualities and used to the hard life, took their hardships stoically. The camaraderie between officers and men that already existed in the battalion was essential for survival in the jungle. Most of the senior NCOs were regular soldiers. [Forgotten Voices]

Jungle combat tends to be conducted at very close quarters; the range of the weapons is inevitably much greater than the extent of visibility. Combatants might only be 50 yards apart and be totally unaware of one another. As the troops on both sides became more familiar with the conditions and with one another, the ability to identify the presence of the enemy became more developed. Commonwealth and Imperial Japanese troops ate different rations, smoked different tobacco, used different soap, so the sense of smell became an important factor in locating and identifying the enemy. Although there was a great deal of fighting at very close ranges, it was often the case that the enemy had to be found before he could be fought and offensive patrolling was, perhaps, an even more significant part of the process of battle than it would have been in Europe.

Lieutenant Graham had this to say about it:

> The patrols were mainly quite long range, you went out with one NCO and five or six privates, your duty was to locate the Japanese and report back, because the command in the jungle is actually blind, you can't see what the hell is going on and life is full of surprises. That is one of the democratising elements of jungle warfare. The brigade command is just as

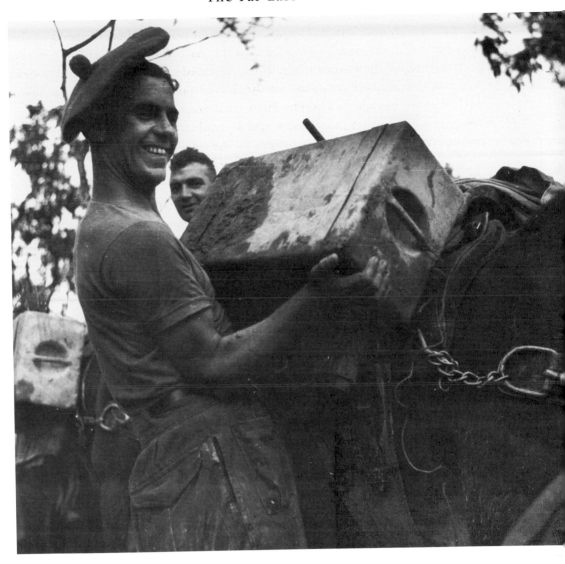

The water and ammunition supplies being delivered by mule, Kohima 1944. (Royal Scots Museum)

vulnerable as the humblest private soldier. They were just as much exposed as anyone else, so they were always anxious for information. [ibid]

If the chief function of patrolling was to find the Japanese, the counterpart was that the Japanese were also anxious to find the patrols. In part, patrol work was simply a matter of locating the enemy and destroying him, but it was also a matter of understanding his deployment and, perhaps most importantly, of trying to persuade him that he was less competent than his adversaries and therefore at greater risk of being killed.

Lieutenant Graham described one particular patrolling incident:

… we spotted some Japanese and took a note of where they were. They didn't see us. On the way back we found the corpses of a previous British patrol that had been wiped out and I said to one of the Jocks we'd better cut off their identity discs so we can report who they are. While he was doing this a Japanese patrol opened up on us, but we got back with only one wounded. But again, that was a piece of vital information. [ibid]

Graham's patrol had not caused any casualties among the Japanese, but it had done more than identify the remains of British soldiers. His report would indicate areas where the Japanese were actively patrolling and therefore, by the process of elimination, areas where they might not be present and where it might be possible for the British to advance in relative safety.

The defeat of the Commonwealth forces in Burma made it imperative that more troops be committed to stem the Japanese advance before it reached India. The Royal Scots Fusiliers had a long journey to get there; Colonel Kemp describes the journey:

December 2 [1942] the Scots Fusiliers moved to Durban where they remained occupied in platoon training until January 1943, when they embarked in the *City of London*, bound for Bombay. It is recorded that one day during the hot voyage the ship was making so much smoke as to cause concern to its escort, H.M.S. *Hawkins*, which signalled a message of protest: 'From H.M.S. Hawkins – Revelations XVIII, verses 17 and 18.' Recourse to the Bible deciphered the signal thus: 'For in one hour so great riches is come to nought. And every shipmaster, all the company in ships, and sailors, and as many as trade by sea, stood afar off And cried when they saw the smoke of the burning, saying What city is like unto this great city!' To which the *City of London* replied: 'Regret necessity for Revelations – but Job XXX, verses 29 and 30'; which read:

'I am a brother to dragons, and a companion to owls. My skin is black upon me, and my bones are burned with heat.'

The Fusiliers sailed from Calcutta and arrived at Chittagong on February 10. The Division, according to plan, was assigned reserve and defensive duties in the neighbourhood of the Mayu passes of Goppe and Ngakyedauk ('Okey-doke' to the troops). After a day spent in reorganisation, the Scots Fusiliers moved by train as far as Dohazari, and by motor transport to Chiringa, before taking up positions on February 13 along a perimeter on a bull-dozed track east of Bawli as Brigade mobile reserve. Its role was that of a striking force to drive any intruding enemy formations on to the other two Battalion areas. The Battalion reached full strength with the arrival of the carrier platoon, which had travelled separately across India. [Hist. RSF]

Getting to India was only part of the process. Once the battalion had arrived it had to adjust to the climates and train for a very different combat environment before the troops could be taken into battle.

Training in the new tactics began almost immediately after arrival at Bawli. All heavy and unnecessary kit was sent to a Battalion dump. A share in the extensive process of clearing up, after the damage caused by Tanahashi, [a Japanese force named after its commander] was given to the 36th Division, which played its part in the extrication of the entrapped formations and the general task of reorganisation. On the last day of the month the Scots Fusiliers relieved the 1/7th Dogras among the Mayu features.

Each company formed its own perimeter, except one company which was given a counter-attack role. Once established, the companies began forward patrolling, first only as far as the Rekhit Chaung, but later into close contact with the Japanese. There was a series of sorties and skirmishes by the companies on features named to express the character of the territory: the Col, Star Hill, Three Knobs and Three Pimples. The patrolling was of two kinds; the reconnaissance patrol, which was usually given a route by Battalion or Company Headquarters leading through the area round the company base, to look for signs of Japanese in that vicinity; and the fighting patrol, the role for which was often to find out if the Japanese were still in possession of a certain feature. The fighting patrols had no easy task. The enemy position about which information was required was often some knoll on the top of a razor backed ridge, from which all cover had been blasted by artillery fire and aerial bombardment. The only approach to the Japanese bunker would be along the ridge, on which movement was only possible on a one-man front. The last few yards to the bunker would be commanded by a Japanese machine gun inside it. Great courage and skill were required to find out whether the Japanese were still in possession or not. If they were, and if the patrol suffered causalities, the difficulties of evacuating the wounded back to the company base can well be imagined. [ibid]

After a period of close contact with the enemy, the fusiliers were moved to a new part of the front. The challenge of fighting in the difficult environment of Burma was a stern one, but just relocating the unit was a major achievement in itself, even if the Japanese did not intervene, though naturally they did:

The Battalion was bound for Mogaung, which was then a sea of brown mud through which all guns and heavy equipment had to be manhandled. It was reached by the first flight rail convoy of the Battalion at about midday on August 8. The flight pushed on to Pahok, leaving baggage parties to trans-ship the stores. The causeways of the railway and houses perched on piles were the only objects visible about the levels of the monsoon floods. An intense humidity, which had followed the improving weather, caused causalities from heat exhaustion. In the 72nd Brigade, which was still in the lead, three men died of heatstroke. At about this time, however, greatly increased quantities of salt were distributed as a corrective. At one period a mug of salt and water was given to each man as he arrived for meals, while a cigarette tin filled with salt was emptied into the 250-gallon water cart.

The column was nearly through the village when a light machine gun opened fire and snipers became active. A Fusilier was killed at point blank range. The cover was too

thick among the trees for effective counter-fire, but 77 grenades were used. The area was searched, but the only trace of the enemy was a quantity of blood, and the advance was continued. Two more machine guns opened fire and 20 men of the second combat team were pinned down as well as advanced headquarters. The first combat team at once formed a firm base in expectation of counter-attack. All movement could be stopped by enemy fire from deep cover. The second combat team retaliated with Bren and grenades. The 77 grenades, invaluable for allowing small groups to withdraw even when completely surrounded, served their purpose, and another strongpoint was built. Two-inch mortar smoke was put down to screen the troops who were still in trouble and all, except for one killed, got back to the strongpoints; after which the enemy position in the woods was accurately engaged by mortar fire. [ibid]

The fusiliers – and the rest of their parent formation, 29th Brigade – continued their advance to Namma against stiff opposition:

During the planning stage the Brigadier offered rewards of 1,000 rupees for a Japanese officer prisoner, 500 for an ordinary soldier and 100 for an identification. On October 14 'D' Company sent out a fighting patrol to Nyaunggon, about four miles south of Namma,

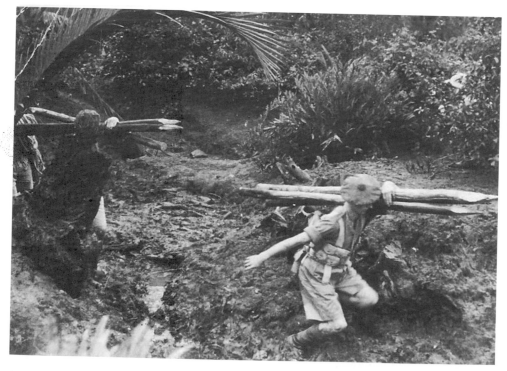

Men of the Argyll and Sutherland Highlanders in Burma carrying stakes to erect barbed wire entanglements. The environment in Burma was unforgiving at the best of times and most often a nightmare for all the troops stationed there. (Argyll and Sutherland Highlanders Museum)

which was believed to contain Japanese. The patrol located and shot up a post and withdrew. On returning they found traces of blood and a Japanese cap which one of the Fusiliers frivolously donned. Just then a Japanese came up the railway and seeing what he took to be one of his own comrades, he approached to within 300 yards before becoming suspicious. Sergeant McLean shot him dead and his identity disc showed that he belonged to the 34th Independent Mixed Brigade, the presence of which had been suspected but not confirmed. [ibid]

Although they had been forced on to the defensive and despite enormous losses, the Japanese were not yet defeated and the Fourteenth Army still had a lot of hard fighting ahead of them. One of the great problems was a general paucity of intelligence material. The huge cultural pressure on Japanese soldiers to fight to the bitter end meant that prisoners were very hard to come by. On the rare occasion that a prisoner was taken there was the problem of finding an interpreter; in those days very few Japanese people spoke English and even fewer British people spoke Japanese. On the other hand, since Japanese soldiers were expected to die rather than surrender, they had no training whatsoever in how to behave if they were captured and thus were often very co-operative subjects for interrogators. The offer of a cash reward for a prisoner was not unusual, but the reward might not actually be paid out; Colonel Kemp tells us why:

A resolute stand by the Japanese developed at about midday in a bunker visible from 200 yards down the track. The Scots Fusiliers' mortars and machine guns made no impression and flying splinters from grenades discharged by the enemy soon became a danger to the machine gunners. The full extent of the opposition was not known, but the noise and fire in the surrounding jungle seemed menacing, and here it was precarious to call down fire from the Chinese artillery because of the danger of tree bursts. The maze of jungle and lack of recognisable features ruled out the possibility of an air strike. Patrols failed to find the enemy's flanks in the dark and boggy forest despite continued and strenuous efforts, and at 3.30 p.m. it was decided to establish the Battalion in a perimeter for the night. Meanwhile the bunker was bombarded by 105 and 155 millimetre guns.

At 5.30 a.m. next morning the attack was resumed in the half light through a ground mist. It had been preceded by a heavy artillery concentration the previous evening, followed by harassing fire until 3 a.m. It was hoped that the Japanese, dazed by this violence, would be overwhelmed by the dawn attack; but no enemy was visible, except one very shell-shocked individual for whom the Brigadier refused to pay the rupee reward, when the assaulting companies went in on each side of the track [ibid].

The brigadier's refusal to pay was, perhaps, less than fair, but the value of the prisoner lay in what he could tell the intelligence staff about the nature, strength and position of his own and other units. Given that the man was 'very shell-shocked', he was

probably in no condition to tell anyone about anything and was therefore not a very useful acquisition.

Meiktila and Mandalay: the End of the Japanese Advance on India

A crucial part of the overall plan for the destruction of the Japanese forces in central Burma was that 7th Indian Division should capture and hold the Pakokku area in order to make a secure bridgehead before the Japanese could mount a properly co-ordinated counterattack. The opposition was provided by elements of 2nd Division of the Second Indian National Army (INA), under Shah Nawaz Khan. The Indian National Army, known to the British as the JIFs (Japanese Indian Force), was raised primarily from Indian prisoners of war who had been captured by the Japanese in Malaya and Singapore. Khan, who had volunteered for the Indian Army in 1940, did not join the INA when it was first raised, but after a period as a prisoner of war of the Japanese he decided that his future would be brighter on the battle-field than in a prison camp. Despite the fact they were ill equipped, badly treated and poorly supported by the Japanese, the INA put up a stiff fight and the Indian 7th Division, which included 2nd Battalion King's Own Scottish Borderers, suffered heavy casualties during the crossing. Eventually support from the Sherman tanks of 116th Regiment Royal Armoured Corps (a unit formed from an amalgamation of 5th and 9th battalions of the Gordon Highlanders) firing across the river forced the defenders to surrender.

In the later stages of the campaign it became increasingly easy to persuade the soldiers of the INA to surrender; most of them had been motivated to join the Japanese war effort as an alternative to being prisoners of war rather than by either a strong sympathy with the Japanese or a strong antipathy to the British – though many, understandably, did feel that the British had failed to provide them with proper training before going into action or with adequate leadership in battle. For the most part Japanese soldiers continued to fight to the death, as Colonel Kemp describes:

> The battle for Pinwe began on Armistice Day [11 November]. For three weeks the Divisional infantry, supported by artillery barrages and air-strikes, prodded, probed and skirmished for the village. The gunners poured their shells into the woods to clear away the branches and leaves, trying to improve visibility. The Japanese dug into the ground, sited their automatics with characteristic cleverness and picked off men by the dozen. It became a war of nerves. The Japanese planted snipers in trees as outposts. In what was possibly the thickest jungle in Burma they were unseen and it was almost certain death for anyone who came within their vision. [Hist RSF]

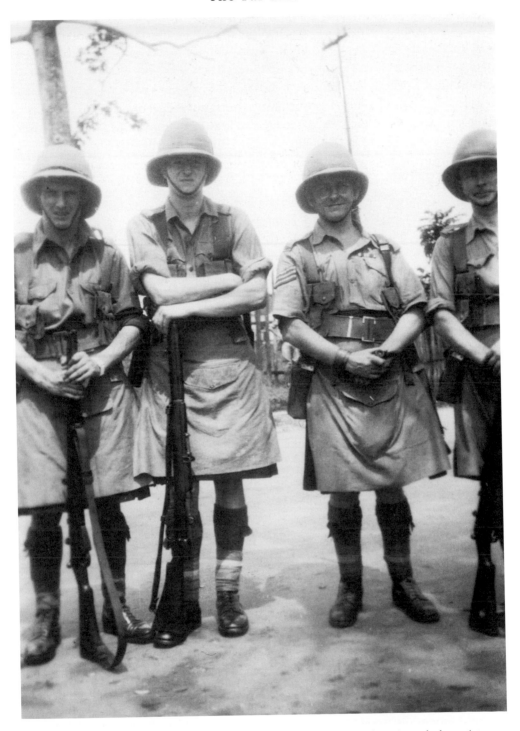

Men of the Scottish company of the Federated Malayan States Volunteers. A Scottish contingent had come into existence in the Singapore volunteers unit by the early 1930s. (Collection of Malayan Volunteers Group)

The constricted nature of the terrain forced both sides to rely on a very small number of very poor roads and tracks. It was often virtually impossible to concentrate a force for an attack on any scale greater than a company or even a platoon, so a handful of Japanese soldiers, or even just a solitary sniper with a strong and well-concealed position, could impose a delay on an advance out of all proportion to their numbers. When progress was made, the advancing unit would inevitably have made the enemy aware of their exact position and would therefore be very vulnerable to counterattacks and to enemy shelling:

> A mass assault on Pinwe was impossible … Platoons of men did creep over the stream by night but when daylight came they found themselves ringed by fire and pinned to the holes they had scraped out of the ground. Over 3,000 shells were one day poured into the woods in half an hour – a record barrage for North Burma at that time.

By January 1945 the Indian National Army had virtually ceased to exist and the Japanese Army in Burma had been rolled back for hundreds of miles to the Irrawaddy River. The men of the Fourteenth Army had suffered from weather, disease, shortages of food and often second-rate equipment that had already outlived its usefulness in North Africa and was considered inadequate for the European theatres. Mail from home was slow and the food was, at best, basic, though by the end of 1944 the efforts of General Slim and his staff had improved matters considerably. The troops themselves could do nothing about the mail, but from time to time it was possible to supplement rations from local sources:

> The year 1945 began with the first 12-mile stage of a two-day march to Tagaung. The Scots Fusiliers had arranged to camp on the banks of a chosen lake, which they fished with a few hand grenades. Fish was a welcome variant from the ration, which was adequate in quantity but had become monotonous and untempting. Improvement had begun however, and there were increasing issues of the British Service 14-men ration pack in place of its Indian Service equivalent. It was also intensely gratifying to everyone that the 'Mother Bird', as air supply was affectionately called, was now occasionally bringing in fresh meat and vegetables, and sometimes eggs. Villages liberated by the advancing Allies occasionally produced a variation of diet, but they were more often deserted, the Japanese having plundered them and dispersed their inhabitants to live as best they could in the surrounding jungle. [ibid]

In spite of the conditions of weather and terrain, and in spite of the immensely gruelling business of fighting such a determined enemy, Colonel Kemp was impressed by the ability of the fusiliers to cope with everything that was thrown at them:

> The outstanding characteristic of the troops was their cheerful acceptance of all conditions and situations which they were called upon to meet. On the move, a Fusilier's load in

This note on the back of a photograph is a touching reminder of how men were able to keep record of their experiences and the comradeship that was formed. (KOSB Museum)

those days was massive, consisting of the old 1914/1918 rifle with long bayonet, 100 rounds of .303 ammunition, two grenades, two Bren gun magazines, two or three days' rations, P.T. shoes and some spare clothing, mosquito net, shovel, steel helmet (on occasions) a machete and perhaps an item of platoon or company stores, all made up into a bundle of great weight, which the average man carried in his usual stolid manner through monsoon or hot weather for some nine months. Most men in the Battalion covered the greater part of the distance from Mogaung to Maymyo, about 300 miles, on foot with this load on their backs.

In action in the jungle the Fusilier's chance of survival depended for the most part on three factors: first, the marksmanship of the Japanese who opened fire on him, as often as not unexpectedly and from very close range; secondly, if still unhit, on his own speed in carrying out the prescribed drill of 'down, crawl, observe, fire'; thirdly, on the speed with which his comrades in his section reacted. The normal role of the leading section was to locate the enemy position and to try to find a way round a flank. With the loads the men carried and under the varying weather conditions which prevailed, this type of fighting called for an extremely high standard of individual training in the man himself and an even higher standard of leadership in his officers and non-commissioned officers. When not on the move there was little chance of rest, because of the normal duties of the company or Battalion base,

including sentry duty, local patrols, strengthening the perimeter defences, fatigues, duties on the dropping zone and so on [ibid].

A great deal of resupply in Burma was carried out by parachute drops. One of the strengths of the Fourteenth Army was their ability to adapt to local circumstances and to use local resources; in the absence of normal army-issue parachutes, the technicians of the Fourteenth Army turned to the only material that could be obtained locally and cheaply: jute. The 'parajutes' were not safe for use by personnel, but were perfectly adequate for dropping supplies to units which could not be reached by road or river transport. In addition to the many duties mentioned above, the soldier had to look after himself and his personal equipment and cope with the climate:

> … during these periods the Fusilier must also take the opportunity to get himself, his kit and his equipment cleaned up in preparation for the next move. During the closing weeks of the campaign the contrast between the cold of Maymyo and the heat of the Mandalay and Meiktila plain was very marked, with consequent uncomfortable effects on the troops. There was also the threat of an outbreak of epidemic cholera. All water, which was obtainable only from filthy green pools, had to be boiled before use. [ibid]

In the last phase of the Burma campaign, the Commonwealth forces made rapid advances and killed huge numbers of the enemy. To a considerable extent this was because the British, Indian, Nepalese and African soldiers who formed the bulk of the infantry had become superb jungle soldiers. Like the Japanese, very few indeed had even seen a jungle before they went to Burma, let alone tried to live and fight in one. The Commonwealth forces had also come to enjoy a physical superiority, not only in manpower, but in military technology that their comrades in the desert or Europe would never experience. The Grant and Sherman tanks that were so outclassed by the more advanced German models like the Panther and Tiger were much better vehicles than anything the Japanese could put in the field. The Zero fighter, which had gained control of the skies with graceful ease against the Buffalos of 1940–42, was no match for the later models of Spitfire, let alone the Tempests, Mustangs, Thunderbolts and Typhoons of 1944–45.

Additionally, the Imperial Japanese Army was a shadow of its former self. Losses in battle had depleted the infantry formations, and the high incidence of disease, the poorer medical facilities of the Japanese Army and, increasingly, malnutrition had further reduced their ranks. Before the close of 1944 a larger and larger proportion of the ranks of Japanese infantry regiments were filled by men who had trained and served as drivers, clerks, cooks and mechanics; men who, in the past, would not have been accepted for intense infantry training. All the same, most of these men fought with exceptional courage. By early 1945 the morale of the Japanese Army had clearly started to unravel, but on the whole there was still a lot of fight in Emperor

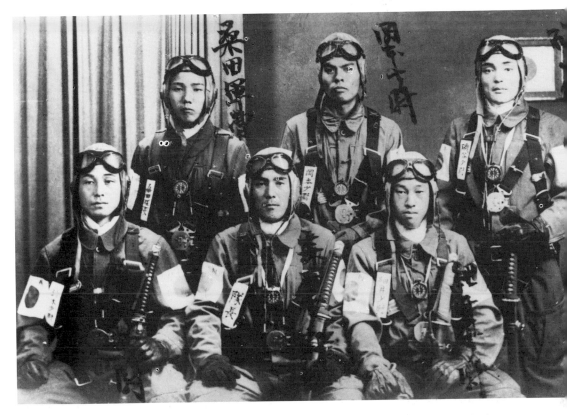

Japanese fighter pilots. Although British propaganda derided the Japanese Army and Navy fliers, they proved to be a skilled and tenacious enemy. (Scotsman Publications)

Hirohito's soldiers. Lieutenant Graham of the Queen's Own Cameron Highlanders was thoroughly impressed by their skill and determination:

> I immediately formed a very high opinion of the Japanese as soldiers, as it seemed they were enormously self-contained. They had this mythical reputation of invincibility because we didn't know what to expect. But they also intrigued me, because they didn't react as we did. They didn't seem to be afraid of dying.
>
> Some of the troops shot the Japanese as they lay sick on the ground, until I stopped them. There was one incident when one of the Jocks was knocking a Japanese prisoner about, and a medical officer said 'Stop that. We've got to live with these people after the war.' So there were interludes of humanity. Mostly it was just hate and destruction. There was no chivalry involved in this war. There was a clarity about it. No one had any doubts. The Japanese had a terrible reputation of cruelty to prisoners. It sharpened the hatred and determination of those fighting against them. It became counter-productive and, in the campaign in the early months of 1945, the Japanese were ruthlessly exterminated by thousands and tens of thousands, and nobody gave it a second thought. [Forgotten Voices]

The Royal Scots Memorial, Burma. (Royal Scots Museum)

The Burma war was more brutal than any other theatre in which Scottish service people were deployed. To a degree, this was simply a product of the environment, but it was also a product of the military ethos of the Japanese Army, which treated its own personnel with an oppressive approach to discipline that can only be described as cruelty. One uses the term 'Japanese Army' deliberately. Neither the Japanese Navy, nor the Army and Navy Air Forces seem to have been imbued with the same disregard for human life. The experience of battle means different things to different people. To Lieutenant Graham it was a character-forming process:

> … there was this thrill, that sense of reality, that here you are facing death in conditions of extreme risk and it was not all a negative experience. I guess that each person engaged in the sharp end of warfare is brought to confront himself, either consciously or subconsciously; you get almost in touch with a sense of reality that can be gained in no other way. One's senses become sharpened. And even if there is nothing pleasant or constructive about it, it is still a trial of the human spirit which has got a positive outcome for those who are ready to acknowledge it.

I don't regret any part of fighting in the war with the Cameron Highlanders. When one considers one's experiences against the background of the history of these times I felt that was the right place to be. I said to myself, aged nineteen, if there is to be a war the place to be is in the infantry, in the front, that is what wars are about. That may have been an innocent, misguided attitude, but looking back on it, I think I was right. There is a sense of satisfaction of having been at the sharp end. There is also a sense of conscience about having survived. You feel very bad about your contemporaries whom have not survived. Why were they killed and I was not? These are questions that lead one into all kinds of philosophical and quasi-spiritual reflections which I think become an asset in one's subsequent life when one is no longer dedicated to destruction. I was not wounded. My batman was wounded next to me, twice. [ibid]

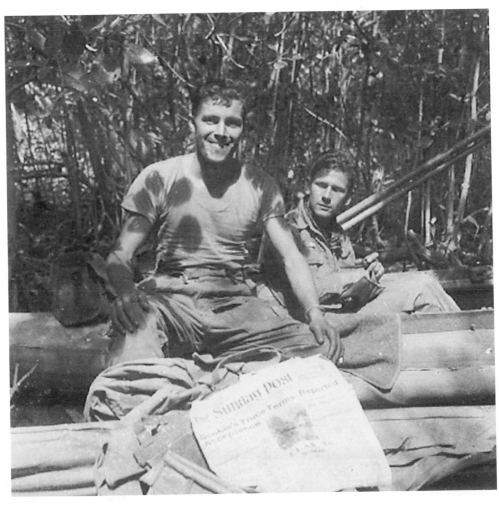

Men of No 2 Squadron, Special Boat Service reading The Sunday Post, *February 1945. (Collection of Bill Best/ Courtesy of the Commando Veterans Association)*

The British had not been popular in Burma before the war – their presence was much less acceptable to the local community than in Malaya or in India – and they were certainly not especially popular after the war, but within a few weeks of the Japanese invasion they were definitely seen as preferable to the new arrivals. In part this was simply because it was a very obvious imperialist regime. Burma had had almost complete political autonomy under the British since 1937, but that was clearly not going to be the case under the Japanese. It was also a very brutal regime. The Japanese would not stand for any form of opposition at any level, and were incredibly exploitative. Burmese people went hungry while the rice that they grew was taken away to feed Japanese soldiers; timber was requisitioned for the Japanese war effort. Worst of all, young women were forcibly dragged off to serve in Japanese military brothels.

However much they might have been resented in the years before the war, it was possible to have a more equitable relationship with the British:

> ... some discreet fraternisation was possible, and on one occasion, while General Festing was touring the area, a lengthy visit was paid to a most amiable Chinese family of three generations. The fact that neither party spoke the other's language proved no obstacle; tea was sipped, cigarettes and cheroots exchanged, and eventually the British departed with two large ducks and three pineapples at a cost of about 150 salt tablets. 'Generally', says Colonel Ritchie, 'we got on very well with the neighbouring villagers, who offered us chickens and eggs in exchange for salt, sardines, bully and, occasionally, parachutes. Such barter was later forbidden. When we arrived I had paid a ceremonial visit to the local headman complete with the Pipe-Major, who provided incidental music – which went down well. This resulted in a request for permission to hold a "party" for the harvest festival (coinciding with the Hindu Dusehra) to which the whole Battalion was invited'. [Hist. RSF]

9

INTO THE BAG

Scottish Prisoners of War and Prisoners of War in Scotland

Surrender is a difficult process, both emotionally and physically. The acceptance that there is no better course of action available is very often challenging in itself, but the practicalities of offering to surrender can be a problem. The enemy may well be suspicious that a ruse is in progress or he may just be unwilling to accept the burden of having prisoners to deal with. In the heat and aftermath of battle, he may not be inclined to accept surrender at all, especially if his own losses have been heavy. When large bodies of troops surrender this is generally less of an issue. There will usually have been a clear decision on the battlefield: the defeated force will obviously have had no other realistic choice and there will almost inevitably have been a process of negotiation to ensure an efficient transit from combatant to prisoner. When General Percival surrendered in Singapore the terms were ostensibly unconditional, but in practice he was allowed to retain a substantial number of men under arms for a short period in an attempt to impose a degree of law and order.

The captors and the captured may, unsurprisingly, have rather different views about the progress and nature of the action that brought about surrender. For the captor it may have been the result of a bold and decisive attack, while for the captive it was the inevitable consequence of a long, hard fight when all hope of relief or escape had evaporated. Colonel Tod of the Royal Scots Fusiliers spent five years as a prisoner of war of the Germans after being captured in France in 1940 and later described two conflicting views of the surrender of his battalion to Colonel Kemp:

> At first light on May 27 I extended what was left of the Battalion and advanced from the farmstead, sending Ian Thomson and his carriers to try and contact the unit on our left. No sooner had we taken up a position on the edge of a wood than the German attack began.

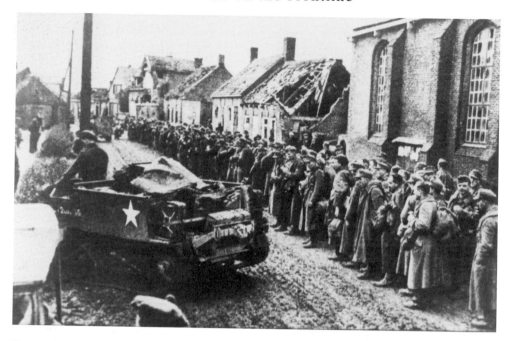

German Prisoners of War wait in line to be moved to temporary camps. (Royal Scots Museum)

Very soon they had broken through our thinly-held position and, at the same time, had come round both flanks and were behind us. It was at this time that Peter Green, bringing me news of the situation on the left, was badly wounded, but nonetheless, delivered his message; his leg was amputated later in a German hospital. I then decided that our only hope was to fall back on the farmstead again. There at least we could put up some sort of all-round defence. This was done, and on the way back I was hit and knocked into a stream.

We held the farmstead for some time, both sides lobbing bombs at each other. It was during this fight that a bomb was thrown at Arkwright. His servant, Leyden, tried to catch it but it exploded in his face. We thought Leyden was killed. His face was smashed but I met him later as a prisoner, the face beautifully patched up but with a rather Jewish nose. Arkwright got some of the bomb but was only badly bruised. The situation soon became quite hopeless. The Germans were still around, the barn was full of wounded and our ammunition was all but expended. Rightly or wrongly, I then surrendered. The time was about 11a.m.

After I had been a prisoner for more than a year someone brought me a cutting from a German newspaper. It contained an account of a deed for which a German captain had been decorated. The gist of it was that on May 28 near Voormezelle he had destroyed the tanks of a famous regiment of Scotland. There can be no doubt that this referred to Ian Thomson, and the tanks were his wretched carriers that were not even bullet-proof. That they were not bullet-proof I know, because early in May one of the Fusiliers let off his rifle by mistake and the bullet went slap through a carrier parked nearby. [Hist. RSF]

Prisoner-of-war camp, Mittelstrasse. (Scotsman Publications)

The prospect of captivity is particularly bleak for the professional soldier; there may be serious career implications, especially when the period of captivity may be prolonged. Again, captors and captives may have very different views about how long that period is going to be. For the captor the enemy has been defeated and must surely now make terms to bring the war to a formal conclusion. For the captive, defeat may be no more than a temporary setback that will be remedied in due course. Colonel Tod foresaw (correctly) a lengthy spell in German hands:

> On the day after we were taken prisoner we reached a sort of P.O.W. collecting place. As soon as we arrived a car appeared and a German officer came to me, saluted and told me in English that General von Richenau wanted to see me. Von Richenau was commanding

either a corps or an army. He was the general who commanded the IV Army Group that marched into Austria in 1938 and who, later, commanded an Army in Russia; he ended his days with a so-called heart attack in the train taking him back to Germany from Russia.

I was taken into his room and, when I appeared, he got up from his chair, bowed and said in perfect English, 'I wish to congratulate you. I am told your troops fought magnificently. I hope you will have lunch with me.' He then said he realised what my feelings must be at being a prisoner but added it would not be for long. 'I promise you', he said, 'that you will be home with your family by Christmas.'

Just then the telephone rang, and after he had talked for a bit he turned to me and said: 'You will be interested to hear that we have just taken Kemmel Hill. It was giving us a little trouble.'

I said 'I am sorry to hear that; it now means we are in for a long war' – not a very scintillating remark but I was not feeling very scintillating and it certainly annoyed his staff.

Von Richenau then told me to go in to lunch and he would follow. We had just started lunch – waiters with white coats and all that and me unshaved, muddy and covered with blood – when von Richenau appeared in his hat and coat and told me he had to go up to the front immediately. Neither von Richenau nor his staff asked me any questions about the situation or about units of the B.E.F. [ibid]

Colonel Tod was something of a thorn in the flesh of his captors and in due course was moved to the post of Senior British Officer at the famous Colditz prisoner-of-war camp, where the Germans concentrated a considerable number of British, French, Dutch and Russian officers who made persistent attempts to escape.

Many thousands of British service personnel became prisoners of war, but surprisingly few recorded their experiences. Some, particularly career soldiers, possibly saw capture as a stain on their record, others that the whole episode was best put behind them and forgotten about. For many, especially those in the hands of the Japanese, the experience scarred them for life and they really did not want to be reminded of any part of it. Compared to the number of men who became prisoners, the number of prisoner-of-war accounts, published or otherwise, is not great, and most of them are from the hands of officers. This account from the online museum of 51st Highland Division is a rare example of the recollections of a private soldier who was taken prisoner in 1940 and wrote home about his experiences:

I am so glad to hear that you are alright and are being treated the same … I know just how you feel about it all, but we all have to do those things in life we do not like, and to leave ones home for so long is about the worst of them all, but like all bad things, it will come to an end, and then you can tell us all about it, and what a big and great chap you will be to all at home.

I was taken prisoner with most of my Division (51st Highland) on 12th June 1940, by Rommel, later known as the Desert Fox. We were force-marched through France; in fact it

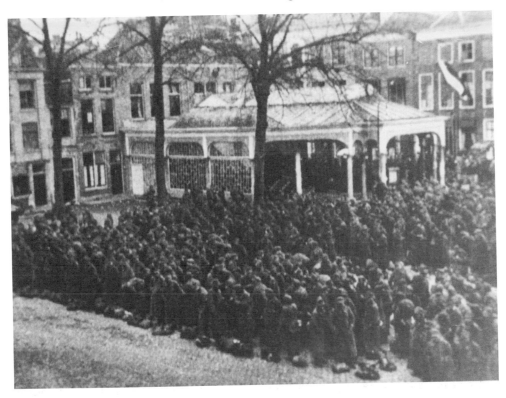

Prisoners of war in Dam Square, Middleburg. (Royal Scots Museum)

would be fairer to say they made us run through France, as it was obvious that they feared that another landing of British troops might take place to rescue us. We were beaten with rifle butts, kicked and abused to keep us moving, anyone falling out of the column ran the risk of being shot (as many were), although in some instances, men were picked up by motorcyclists and taken away, as happened to my fitter sergeant Ian Macmillan. Much later, we found out he had died.

I remember that we were held overnight at Arras racecourse, British and French together, when it was announced that an Armistice had been signed. The French were delighted, as they thought that they would now go home. Friction broke out between the British and French, which seemed to be encouraged by the German guards. The next day the French were still marched out with us, much to their distaste.

The march got worse, there was very little food. A mouldy loaf of black bread between six men, and a meagre ration of ersatz coffee for those who had a tin or a dixie, was supplied at Arras, after we had queued for about five hours. The coffee was soon lost, as we had to run, being helped on our way by kicks and oaths.

The weather was extremely hot. We marched on without any water, which was worse than the lack of food, and out of desperation, we drank anything from pools made by rain, or out of cattle troughs. Consequently we suffered from stomach ailments and dysentery.

I must mention that the French women were marvellous. They would leave buckets of water and containers of boiled potatoes at the roadside, which invariably were kicked over by our guards. These ladies took considerable risks, and were often roughed up. Their efforts helped us to survive and we owe them our grateful thanks. [www.51HD.co.uk]

One of the many worries for a prisoner of war was that his family might not be aware that he had been captured and that he might be listed as 'missing, presumed dead'. A number of men returned from captivity in the Far East to discover that their wives had been notified that their husbands had been killed and had remarried. For a fortunate few, the issue was dealt with by courageous and conscientious individuals before the British authorities were able to ascertain who, exactly, had become a prisoner and who had been killed. Henry Owen was one of these:

One lady pushed a napkin into my hand. Inside was a note telling of the news from the BBC, such as reports of the bombing of the Italian ports, and such like. The note also asked me to write the name and address of my next of kin so that they could be informed that I was a prisoner. I was to hand the note, with the address, to another lady, about a kilometer further on; this lady would be holding a napkin for identification.

I wrote down my mother's name and address, and duly passed it on to the lady with the napkin, although I had little hope my mother would receive it. As it turned out, this was the first news my mother had that I was alive; in fact she had to inform Army Records! The Comité de Béthune Red Cross Women's Section, sent the note, and I am eternally grateful to them. They added the word 'prisoner' to the note, and forwarded it to my mother at Anti-Tank Regiment, 201 Battery, 51st Division based at Bordon in Hampshire, as they were short of gun fitters.

As dysentery took hold, we had to stop more and more to relieve ourselves. We used to dash into the fields and take our trousers down, until the Germans started to use us as target practice (a soldier next to me was shot), and we all raced out of the field trying to pull our trousers up. After that, we soiled our trousers rather than go into the fields.

Eventually, after marching through France and Belgium, we were bundled, or should I say stacked, into open railway trucks in Holland, and taken on a journey to the Rhine at Wesel. There we were given a loaf of mouldy black bread, and pushed down a ladder into the bowels of a filthy coal barge. It was pitch dark and airless, and was more terrifying than the march. The stench was awful.

When the barge got under way, we were allowed to take turns to come on deck, and a makeshift toilet was rigged up, with just a pole to hang on to whilst you relieved yourself. Needless to say, the death toll started to mount. We endured this for about three days until we reached Germany proper, after a short rail journey to Dortmund, where the Nazi flags were flying to celebrate their great victory.

We were shoved into cattle trucks, which bore a notice saying eight horses or forty men. Between sixty and seventy of us were loaded, and the doors were locked. We only had a little

grill at the top to let the air in. There was not enough room on the floor to sit down, so those who were fittest stood. We had no food or water, no toilet facilities; the stench once again was awful, as there was no means of getting rid of the human waste. We used our dixies (if we had any) to urinate in, and then tried to pour it out of the grill. Those who had no dixie either borrowed one, or used their boots for the same purpose.

This journey was simply horrific, and I do not use the word lightly. It lasted between three and four days, until we eventually arrived at our destination – Torun (Thorn) in Poland, and we marched, in a pitiful condition, to a balloon hangar for processing, and to be photographed and provided with a new identity tag. My number was 14704. I was issued with a thin Polish uniform to replace my tattered British one, which stank after the ordeal that we had endured. [ibid]

Other men made their escape before they reached a formal prisoner-of-war 'cage'. Colonel Kemp seems to have thought this example of soldierly humour was almost as significant as the subject's actions:

An incident which occurred during an inspection of the Battalion by His Majesty King George VI deserves mention. While passing down the ranks the King paused to speak to a Fusilier wearing a Military Medal, which he had won with the Battalion in France in 1940. Expecting to be informed of the engagement for which the decoration had been awarded, the King inquired: 'Where did you get this?' To His Majesty's evident surprise the answer was: 'From yourself Sir, at Buckingham Palace.' The Fusilier had been one of those captured with the remnant of the Battalion in Belgium, but had escaped during the march to a prison camp in Germany. He reached Marseilles where, working as a waiter in a German mess, he contrived to set up an organisation to assist British prisoners to escape. Finally he himself returned to the United Kingdom, to be awarded the Military Medal. [Hist. RSF]

The German attitude to prisoners of war varied a good deal from one place to another. The majority of other ranks were obliged to carry out useful work for the German state. This was permissible under the terms of the Geneva conventions. Such work was not, in theory, to be of value to the war effort of the captor nation, though all sides were less than scrupulous about this. Many German prisoners of war in Britain worked in agriculture, effectively providing foodstuffs for British troops or, at the very least, providing foodstuffs that would otherwise have to have been imported. Their work therefore reduced the strain on British shipping, which was desperately needed for the transport of munitions and personnel. Many British prisoners of war in German hands worked in coal mines and other industrial applications, directly contributing to the Reich's war economy.

The life of prisoners of war in Germany was largely filled with work for other ranks and tedium for officers, who were not obliged to provide labour. Mail from home was generally slow, and in the later stages of the war, as the transport infrastructure of

Jimmy Howe's dance band performing in Stalag VIIIB. (Royal Scots Museum)

Germany was increasingly compromised by Allied bombing, personal mail and the parcels of food and other supplies from the Red Cross dwindled even further. Men had time on their hands and some put their energy into such activities as the situation permitted, such as study, sports and games, and amateur dramatics, but for many their emotional and physical health suffered and readjustment to life outside the camps was a slow and painful business.

Prisoners of the Japanese suffered under a much harsher regime. They were employed as slave labour under atrocious conditions and with the constant threat of beatings, torture and murder. A soldier goes where he is sent and finding oneself in captivity in South Asia was something of a lottery. Robert Smith and Laindon Cornwell of Arran were both conscripted into the Scottish Horse immediately before the regiment had its horses removed. The unit was divided into two parts alphabetically and both the resulting units converted into artillery regiments. Robert Smith and his comrades now found themselves to be gunners in a 25 pounder field regiment and served in North Africa and Italy. His friend, Gunner Cornwell, was sent to Singapore with an anti-aircraft regiment. Letters were exchanged for a year and more, with Cornwell extolling the joys of swimming and tennis in a fine tropical location. The letters stopped at the end of 1941 with the Japanese invasion of Malaya and Gunner Smith never heard from his friend again. Gunner Cornwell and the majority of his party of 600 men of the Royal Artillery were murdered by the Japanese Army in May 1943 after building a military airfield on the island of Ballale in the Shortland Islands of the Solomons. Tragically, this was far from being an isolated incident. Thousands of Scots died in captivity or suffered for years after the war from the effects of malnutrition, disease and abuse. Civilians suffered terribly as well as

service personnel. The European Holocaust is familiar to everyone – as it should be – but the Asian Holocaust is almost entirely disregarded. Over the years of Japanese occupation in China, Malaya, Singapore, Indonesia, the Philippines and elsewhere, millions upon millions of people died through a mixture of wilful neglect or outright murder. For a variety of political and cultural reasons – essentially racism – the plight of the people who suffered under Japanese occupation has received shamefully little attention from historians. Although Red Cross parcels were supplied to the Japanese administration they seldom reached the prisoners and thousands lived – or died – in conditions of abject misery.

Escape was virtually impossible and would-be escapers took a terrible risk, as Ian Mackenzie of Gargunnoch recalled :

Escaping was something I never considered for two reasons. Firstly there was no place to go when you got outside, though getting outside was relatively simple for this was no Colditz. Secondly, if you got caught it meant instant execution Two Gordon Highlanders attempted to escape from Changi which was really rather foolhardy. They were caught on the beach trying to get hold of a boat. One was executed by sword on the spot and the other made a run for it. He sustained a bad sword slash across the shoulder but did make it back to Changi where he was hidden away until the wound had healed. [*Beyond the Bamboo Screen*, Tom McGowran, Cualann Press].

Prisoners often created small plays as a diversion from the misery of their daily lives in captivity. (Argyll and Sutherland Highlanders Museum)

Prisoners did not need to be engaged in trying to make an escape to find trouble. Being outside the camp for any purpose other than as a member of a work party was a danger in itself, as Mr MacKenzie discovered:

At one time I shared a corner of the one of the rooms with Corporal Hepburn, Gordon Highlanders. It so happened that Wee Heppie had a Chinese girlfriend who lived about three or four miles from our camp. He wanted to visit her and insisted that I accompany him. On reflection, I suppose it was rather silly but there were very few Japs about. For a part of the way we kept to the undergrowth and to the quiet roads. We finally arrived at Wee Heppie's girlfriend's place of residence. As we peered out from the undergrowth just across the road we could se a Jap staff car duly bedecked with a pennant parked right outside the house. From this we deduced that the young lady was otherwise engaged and that the only thing we could do was to retrace our steps.

We reached a point about half a mile from camp. As we walked along a quite road two Japanese soldiers came around the bend of the road on bikes. It was too late to dive into the

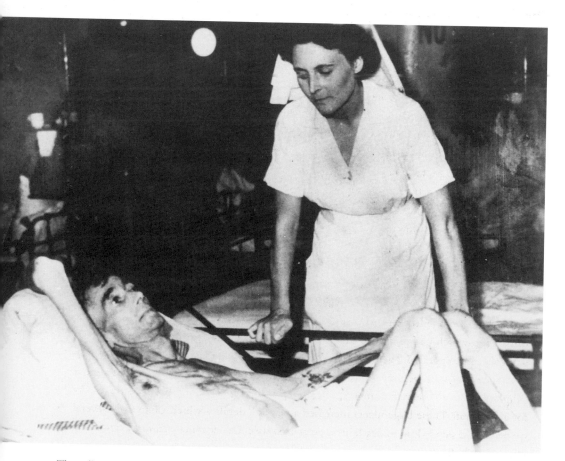

The suffering of POWs in Japanese captivity was largely ignored, even supressed, by the UK government after the war. (Argyll and Sutherland Highlanders Museum)

undergrowth so we thought the best thing we could do was to bluff it out as if we were sup-posed to be there and to give them a smart salute. Unfortunately this did not work and they took us along to the *Kempi,* the Japanese military police headquarters, in Orchard Road.

As the *Kempi* had a reputation that would make the Gestapo look like a group of Sunday school teachers, we were very concerned. They locked us up in a tennis court and mounted a machine gun outside the fence. I suppose when it was increasingly evident that we were not attempting to escape and were in fact making our way back, the Japanese dealt with us leni-ently by their standards and sentenced us to fourteen days in the 'No Good House'. This was to prove to be a masterpiece of understatement for Wee Heppie and I were locked in a very small lavatory and fed on rice and water once a day. It was a very small lavatory, just enough room for the pedestal and one person and no window – just a small grill very high up.

During the fourteen days we were not allowed out. I can still remember the utter bore-dom and the hunger but was thankful to be alive. [ibid]

The dreadful diet, extreme overwork, the beatings, the heat and the unsanitary con-ditions that prisoners of the infamous Burma railway had to contend with naturally brought on a wave of illnesses, as Dr George Graham of Kilconquar observed:

Amoebic and bacillary dysentery were endemic and there was no means of identifying the cause of blood and mucus in the stools; they were only distinguished by gross clinical fea-tures. Either alone or following upon malaria, either of these could well be fatal. I once passed a stool with blood and mucus and feared the worst, but next day all was well and there was no repetition. Diarrhoea was the rule (fortunately I was an exception) and prob-ably connected with our diet of rice and watery stews.

Beriberi, pellagra and other vitamin-deficiency diseases were a way of life. The main symptom of beriberi (vitamin B1 deficiency) was a swelling of the feet, ankles and lower leg, possibly going on to congestive heart failure. Dry beriberi produced polyneuritis and muscle weakness, then wasting. Pellagra (deficiency of vitamin niacin or nicotinic acid) pro-duced skin lesions, especially in parts exposed to the sun, progressing to nervous or mental disorder, quire commonly associated with an exuding dermatitis [the skin flaking off the body] of the scrotum and given by us the rather picturesque name of 'rice balls.'

Leg ulcers were very common and any cut or abrasion of the leg easily became septic and then a chronic ulcer ensued. A lot of trouble came from bamboo. There was one type of bamboo which had spike-like thorns, and with no covering for the legs, wounds and scratches easily appeared. These became very difficult to heal and with the body in a debili-tated state they soon became septic and an ulcer formed. Some of these got to enormous proportions, often encircling the whole calf, and under normal conditions would qualify for a skin graft. These large ulcers increased a person's debility which came from several causes, would slowly lead to death in an emaciated state. The death rate from all causes was over 30%. [ibid]

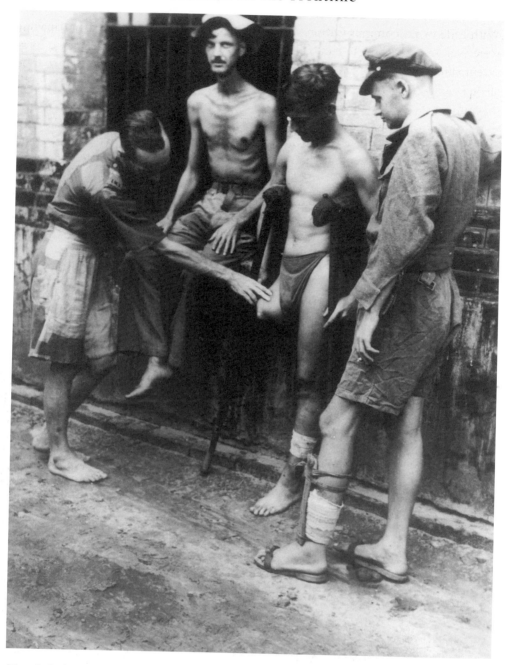

Men who had sustained wounds in battle faced starvation and cruelty as prisoners of Japan between 1942 and 1945. (Argyll and Sutherland Highlanders Museum)

Into the Bag

With little or no communication with the outside world, prisoners of the Japanese were even more in thrall to rumours than prisoners elsewhere. One of the more persistent rumours was that once the prisoners had outlived their usefulness they would all be killed. It is easy to dismiss that view as a product of the misery of camps and the despair that the conditions engendered. In fact, regardless of the root of the rumours, there was a firm foundation in Japanese policy. Once it became apparent that Japan was going to lose the war, the Japanese Government came to realise that they might well be held to account for the state of prisoner-of-war camps. The starvation, mistreatment and outright cruelty suffered by prisoners might not be ignored as part and parcel of the war. Plans were made and orders given to make sure that there would be no personal testimony from the survivors by the simplest method: killing them. This document was entered in the journal of the headquarters responsible for prisoners of war in Taiwan a week before the first atomic bomb was dropped on Hiroshima:

At such time as the situation became urgent and it be extremely important, the POWs will be concentrated and confined in their present location and under heavy guard the

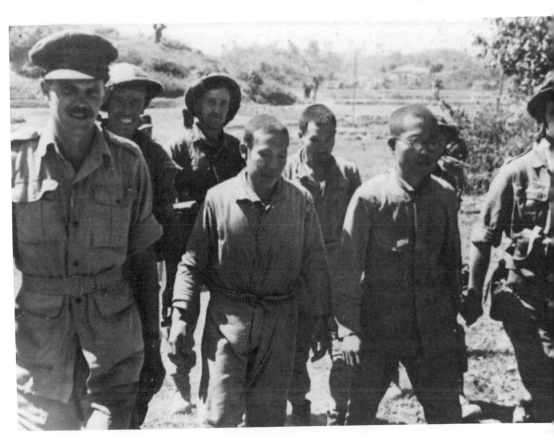

Japanese prisoners of war are escorted by soldiers of the Royal Scots. (Author's collection)

preparation for the final disposition will be made. The time and method of this disposition are as follow:

The Time. Although the basic aim is to act under superior orders, individual disposition may be made;

The Method. (a) Whether they are destroyed individually or in groups, or however it is done, with mass bombing, poisonous smoke, poisons, drowning, decapitation, or what, dispose of them and the situation dictates. (b) In any case it is the aim not to allow the escape of a single one, to annihilate them all, and not to leave any traces. [Imperial Japanese Army]

Worldwide revulsion at the revelation of concentration camps in Europe doubtless concentrated the minds of the men who were responsible for the situation in Asia. Clearly the Japanese Government was anxious to leave no trace of the prisoners. All of the methods outlined above and others – such as burying people alive by the hundreds and thousands – had, in fact, been employed in the past to dispose of large numbers of civilian and military personnel in China, Singapore and elsewhere. How the Japanese Government was going to explain the disappearance of hundreds of thousands of British, Indian, Dutch, Australian and American prisoners of war and civilian internees does not seem to have been considered.

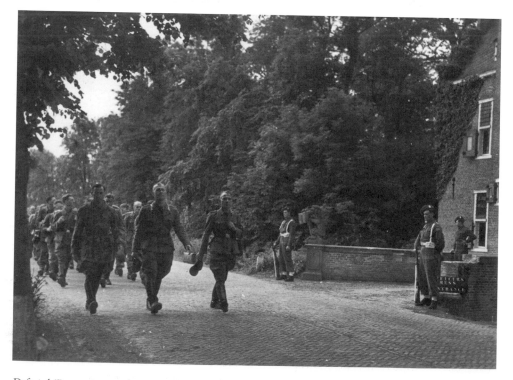

Defeated German personnel en route to Germany, June 1945. Battalion Headquarters, Castle Ayemode, Holland. (Museum of the Black Watch, Royal Highland Regiment of Canada)

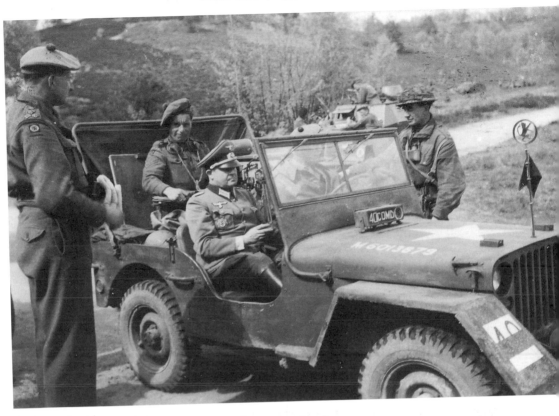

A German prisoner of war. (Argyll and Sutherland Highlanders Museum)

While Scots were spending time as prisoners abroad, German and Italian service-men were spending time as prisoners in Scotland. The Geneva Convention and other legislation governing the treatment of prisoners allowed for the deployment of rank-and-file troops as labour, though not their officers. Officers on both sides were considered to have a duty to attempt to escape and return to the fight. A substantial number of British officers — and of other ranks — did manage to escape, though the process was fraught with difficulties and danger. A man trying to escape had put himself into the category of active combatant and might well be shot and killed. Would-be escapers in German custody could try to make a break for Switzerland or Sweden, both of which were neutral. Those who got as far as France, the Netherlands or Belgium stood some chance of making contact with the resistance movements and being helped on their way. Escape from the Japanese in Singapore, Malaya, Hong Kong or Burma was virtually impossible due to the huge distances that would have to be travelled. Many prisoners of the Japanese were taken to Formosa (Taiwan), to Japan or to small islands in the South Pacific and had no prospect of escape at all. If they did attempt to escape the reprisals carried out against the other inmates of the camps were unutterably savage and escaping was discouraged accordingly.

German and Italian prisoners in Scotland were faced with a huge challenge if they chose to make a break. They had no real hope of finding a sympathetic helper once they had made their way out of the camp. Even if they made their way to the coast there was little prospect of getting transport across the Channel or the North Sea. Just as importantly, once it became apparent that the Axis forces had lost the war in the desert and were losing the war in eastern Europe, there was little incentive to make the attempt, and whether or not they believed the claims of the British that the conditions in a camp in England or Scotland were more comfortable than conditions at home in Germany, it is clear that most Axis prisoners of war were not prepared to take the risk of attempting to escape. A great many prisoners were relocated to Canada, so after the United States entered the war in 1941 there was no longer the possibility of being repatriated from a neutral America.

Guarding the prisoners was yet another draw on British military resources. To some extent the task of keeping watch on prisoner work parties could be entrusted to the Home Guard, but the Home Guard soldiers had work to go to and homes to tend, so the bulk of the work had to be done by the Army. Increasingly after 1943 – and before in some cases – the Axis officers (who were supposedly obliged to escape) and other ranks could give their parole and enjoy a considerable degree of liberty. The relationship between prisoners and the community at large could be difficult. From time to time civilians had to be dissuaded from throwing insults – or stones – at prisoners on their way to or from work. Such incidents were generally prompted by air raids or by bad news from the front, but were few and far between. It was more common for the prisoners to carry on with their assigned duties and for the civilians to accept their presence as just another peculiarity of the war.

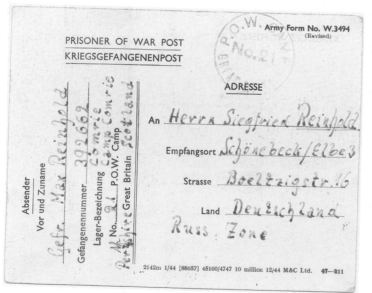

Prisoners of war in Scotland were allowed to write brief postcards home. (Courtesy of Trond Norboe of NF Stamps)

Axis POWs in Shetland. POWs were routinely assigned to a variety of labouring tasks. (Courtesy of the Shetland Museum)

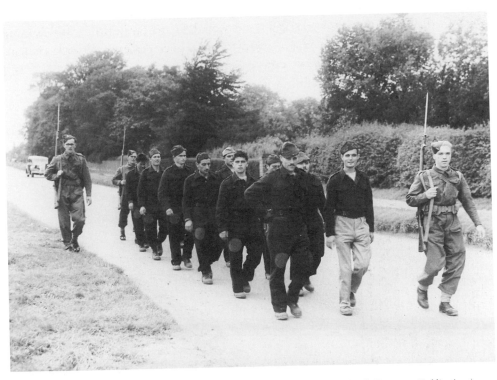

Axis POWs escorted by Home Guard soldiers at an undisclosed location in Scotland. (Scotsman Publications)

10

AFTER THE WAR

The end of hostilities did not really end the war in a more general, social sense. Conscription continued until the 1960s, and in 1945 it was still necessary if the government of the day was to fulfil its obligations. Plus it had the additional advantage of being a means of controlling unemployment to a certain degree. The jobs of those called up for the armed services were effectively taken up by men returning from war service. Willingly or otherwise, the wartime coalition had taken on a wide range of burdens in addition to those that had already existed in 1939 and these commitments were inherited by Clement Attlee's government after the General Election of 1945. Enormous forces were needed to restore or maintain order in territories all over the world; not least in India. The prospect of forming two countries – India and Pakistan – meant that large numbers of British troops would be required to keep the peace as far as possible in the run up to independence.

Much the same applied in British colonies across the rest of the globe. In part this was a consequence of the experience of the highly internationalised Commonwealth forces. Great numbers of men – and some women – had enlisted in the armed services of the British Commonwealth and had fought with great distinction around the globe. People from India, Nepal, Kenya, Uganda, Jamaica, Fiji and scores of other locations had served in Burma, Italy, Tunisia, Egypt and elsewhere. Some had served after the war over in Indonesia or the Middle East. Having fought to make other countries free from foreign occupation, it would have been curious if they had not been moved to try to secure the liberty of their own country. As they sat in a slit trench under Japanese fire, a British soldier asked an Indian soldier why he was fighting at all since he was under no obligation to do so – there was no conscription in India so all of the soldiers, sailors and airmen were either regulars or had volunteered for the duration of the war. The Indian soldier told him that since they were sharing a house (India) and the house was on fire (the war) it was only sensible that he, as an

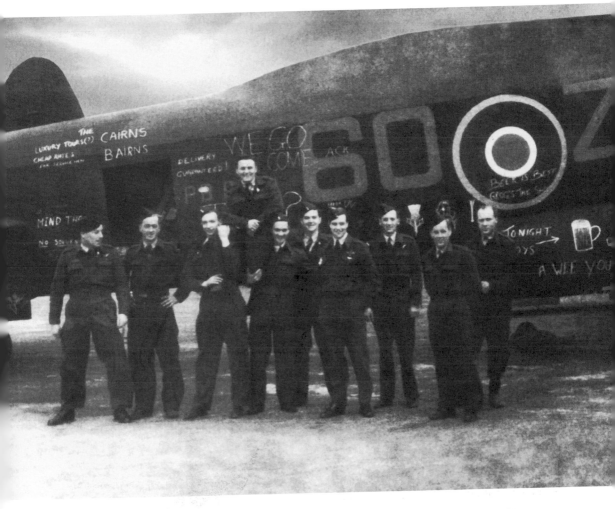

A bomber crew return after the war, note the graffiti on the plane, a typical example of soldierly humour. (603 Squadron RAFVR)

Indian, should help to put the fire out. Then he added that as soon as the war was over he would be more than happy to 'kick your arse out of my country'.

No doubt a similar sentiment could be found among the soldiers of most, if not all, of the different nations who fought against Hitler, Mussolini and Hirohito. Once the war was over many of them would be in the forefront of independence movements. Some would be treated very shabbily indeed. Career soldiers in the Indian Army, who had fought in Burma to protect India from a Japanese invasion that would have resulted in a regime infinitely more harsh and oppressive than anything that could ever have occurred in British India (and one should remember that even at the height of British Empire the overwhelming majority of India was not, in fact, 'British' at all), were denied the army pensions that they were due – though, perhaps unsurprisingly, civil servants still got theirs.

At the end of the war, in addition to the pre-war imperial commitments, Britain was deeply involved in many other conflict situations. These included suppressing insurgents in the Dutch East Indies, maintaining law and order in French Indo-China (Vietnam) pending the reinstatement of the French colonial administration, a thankless role in the Greek civil war and trying to prevent a general conflict in Palestine – a situation which included preventing thousands of Jews who had escaped the Holocaust in Europe and who now wanted to make a new home in an independent Jewish state.

It might seem almost an anomaly that there was no similar appetite for political reform in Scotland. Although the cause of 'home rule' had not been an issue of pressing political significance in the 1930s, it was part of the fabric of both the Labour and Liberal parties and some form of devolution had been a strong possibility in the years immediately prior to 1914. In fact, it could be argued that the process was only halted by the outbreak of the First World War and the calamitous depression years that followed. In reality the issue had not really gone away. Although devolution was almost conspicuous by its absence from the Labour election campaign of 1945, the party had been in favour of devolved government for Scotland for decades. While it is quite likely that many Scots still favoured some degree of autonomy, the issue was for a while lost among the many problems and challenges that arose after victory over Germany and Japan. Even so, in 1949 a body called the Scottish Convention

A group of liberated Dutch civilians. (Royal Scots Museum)

The Russians at Schwerin, June 1945. 8th Battalion the Royal Scots met the Russians at this time. (Royal Scots Museum)

organised a petition which attracted around 2 million signatures – well in excess of 50 per cent of the adult population of Scotland. The text of the petition ran thus:

> We, the people of Scotland who subscribe to this Engagement, declare our belief that reform in the constitution of our country is necessary to secure good government in accordance with our Scottish traditions and to promote the spiritual and economic welfare of our nation.
>
> We affirm that the desire for such reform is both deep and widespread through the whole community, transcending all political differences and sectional interests, and we undertake to continue united in purpose for its achievement.
>
> With that end in view we solemnly enter into this Covenant whereby we pledge ourselves, in all loyalty to the Crown and within the framework of the United Kingdom, to do everything in our power to secure for Scotland a Parliament with adequate legislative authority in Scottish affairs.

The Labour government refused to give any recognition to the petition, rejecting the principle of devolution and claiming that the issues at stake were 'much too complicated' to be put to the people in a plebiscite.

A surrendered German warship in the Firth of Forth. (Scotsman Publications)

The petition was unquestionably part of a long-term trend, but it would be difficult to argue that the war had not played a part in its popularity. On the other hand, despite the enormous majority won by Clement Attlee in 1945, by 1949 the Labour government had become exceptionally unpopular and was only able to secure a majority of five in the 1950 General Election. Another election followed eighteen months later and devolution would not re-emerge as a significant issue for nearly a quarter of a century.

Political issues aside, there were many other consequences of the war, some to be addressed, others to be ignored. The demand for soldiers, sailors and airmen to police the many territories for which Britain had responsibility could not be met by simply retaining men in the forces; their enlistments had been, in essence, 'for the duration' and even though fighting continued the war was over. Tens of thousands of service people, particularly in the Far East, had not been home in four years; they could not be forced to stay in service indefinitely.

When they came home they had to be reinstated in their previous occupations as far as possible. To a modest extent this was offset by the conscription process, but to a much greater extent it meant that women who had taken on roles in commerce and industry that had been denied to them in the past were laid off to make room for men returning from the front. For many women this was not an unhappy situation: some had detested their work, some wanted to resume their role as wife and mother. For others losing their jobs was poor reward for having taken up their posts in their country's hour of need. Many had enjoyed the activity and comradeship of the work-place or the prospect of making a good career, a great many would miss the money and personal independence.

For many service people returning to civilian life there were huge challenges to be met in readjusting to an existence without the stress, danger, comradeship, excite-ment, fear or adventure that had been their lot since 1939. There had been a great deal of social and economic change. The implementation of the Beveridge Report (the basis of the post-war Welfare State), nationalisation and many other factors had altered the relationship between the individual and the state. While the service people

The Scots Greys march out on parade. (The Guards Museum)

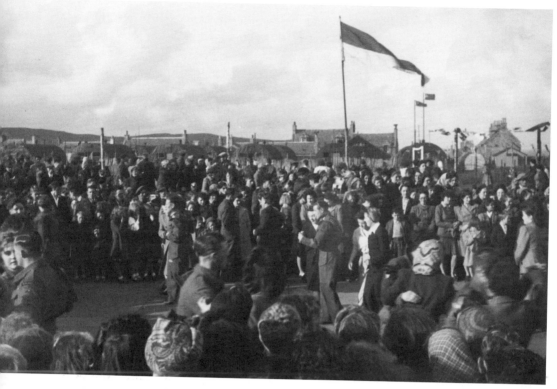

A brief celebration on homecoming, before the challenge of readjustment and starting a new life. (Courtesy of the Shetland Museum)

had been away, those who remained at home had had their own issues to deal with and were not always very sympathetic to the needs of the returning veterans.

The passage of large numbers of service personnel through the towns and villages of Scotland had left marks of various kinds, some of them exemplified by anecdotes like this one from *Tom Shields' Diary* (Mainstream Publishing, 1991):

> A Kilwinning man was having his parentage discussed. 'Naw, she's no his mither. She's his Auntie. She had him tae a sojer during the war.' (No, she is not his mother, she is his aunt. She had him by a soldier during the war.)

Government was not as helpful as it might have been and now that the war was over most politicians, regardless of party, wanted to put it behind them and pursue their own ideological agendas and political careers. The veterans of the First World War had been promised a land fit for heroes to live in and had been let down badly; veterans of the Second World War often fared little better.

FURTHER READING

In addition to the books and websites mentioned in the text, readers who wish to extend their knowledge of the Second World War might look to some of the volumes noted below. It is not my intention to provide a universal reading list for the entire war, simply to point to a handful of sources that are reasonably easily available from shops or libraries. Some of these volumes have been out of print for some considerable time, but can usually be provided through the inter-library loan scheme for a very tiny fee – or in some areas for free. The HMSO *Official History* series has, mostly, been reprinted in paperback in recent years, and, though sometimes very generous in its assessment of the conduct of particular senior officers, is still a good starting point for each of the campaigns of the Second World War. The maps alone are worth the price. The strategic and major tactical maps are second to none and most volumes contain more than one map illustrating the course of a relatively minor action; these repay careful study since they convey so well the nature of battle at unit level – a rare thing. There are many Osprey volumes relating to specific campaigns, battles, armies, navies and air forces of the Second World War. As a source of visual material or as a 'start line' for a particular event or formation they are generally of a high standard and very suitable for schools.

Chapman, S., *The Jungle is Neutral*, Chatto and Windus (1957)

Eisenhower, D., *Crusade in Europe*, William Heinemann Limited (1948)

Farrell, B., *Defence and fall of Singapore*, The History Press Ltd; (2005)

Fergusson, B., *The Black Watch: A Short History*, Collins (1955)

Grant, R., *The 51st Division at War*, Littlehampton Book Services Ltd (1976)

Guderian, H., *Panzer Leader*, Da Capo Press Inc (1996)

Innes, W., *St Valery, the Impossible Odds*, Birlinn Ltd (2004)

MacArthur, B., *Surviving the Sword*, Time Warner Paperbacks (2005)

Miles, W., *The Gordon Highlanders, 1919–45*, Gordon Highlanders RHQ (1961)

Montgomery, B., *Memoirs*, Collins (1958)

Moorehead, A., *The Desert War*, Penguin (2001)

Parkes, M., *A.A. Duncan is OK*, Kranji Publications (2003)

Royle, T., *The Royal Scots: A Concise History*, Mainstream Publishing (2006)

Slim, W., *Defeat into Victory*, Cooper Square Press (2000)

Terkel, S., *The Good War*, The New Press (1997)

Urquhart, R., *Arnhem*, Pen & Sword Military (2008)

White, P., *With the Jocks*, The History Press (2001)

Wilson, W., *The War Behind the Wire*, Pen & Sword Books Ltd (2000)

The internet is always a dubious place for history; there are literally thousands of sites constructed by people whose intentions are honourable (and quite a few constructed by others …), but whose knowledge and understanding is not as good as it might be. There are, however, quite a number of excellent web sources:

National Museums of Scotland
SCRAN
Library of Congress
The National Archives
Shetland Museum and Archive Service
Bayonet Strength

ATTRIBUTIONS FOR SOURCES IN TEXT:

History of the Royal Scots Fusiliers, Lt Col J.C. Kemp (Robert Maclehose (1963)), pp.15-19, 24-5, 27, 29-31, 35-6, 45, 53, 55-7, 60, 62, 64.

www.51HD.co.uk, pp.19, 34, 39, 62, 64.

Forgotten Voices of Burma, Brigadier J. Thompson (Ebury Press (2009)), pp.51, 52, 58, 59.

Beyond the Bamboo Screen, T. McGowran (Cualann Press (1999)), pp.65, 66, 67.

www.15threcce.org, pp.37, 38, 44, 45.

The Lion and The Eagle (ed.) Dr. D. Henderson (Cualann Press (2002)), pp.40-42.

The Daily Telegraph (December 2005), pp.49-50.

INDEX

Other titles published by The History Press

THE FLIGHT OF RUDOLF HESS: MYTHS AND REALITY
Roy Conyers Nesbit & Georges van Acker

On 10 May 1941, Rudolf Hess – Deputy Fuhrer of the Third Reich – embarked on his astonishing flight from Augsburg to Scotland. At dusk the same day, he parachuted on to a Scottish moor and was taken into custody. His arrival provoked widespread curiosity and speculation, which has continued to this day. This is one the most objective assessment of the Hess' story yet to be published.

9780750947572

FLYING FOR FREEDOM: THE ALLIED AIR FORCES IN THE RAF 1939-45
Alan Brown

During the Second World War, exiled airmen from six occupied countries in Europe flew from British soil, fighting in or alongside the squadrons of the RAF; each had a burning desire to strike back at the cruel regime that had so ruthlessly crushed his homeland. This book explores these courageous and often undervalued men who were caught up in a web of political argument.

9780752459981

BATTLE STORY: ARNHEM 1944
Chris Brown

The battle of Arnhem has acquired a near-legendary status in British military history as an audacious plan to land a paratroopers into the Netherlands and spearhead an attack against the German-held Ruhr, ended in disaster. If you want to understand what happened and why – read Battle Story.

9780752463117

THE HARD WAY: SURVIVING SHAMSHUIPO POW CAMP 1941-45
ed. Andrew Robertshaw

Major Vic Ebbage was a Colonel with the Royal Army Ordnance Corps, serving in Hong Kong in 1941, when his garrison was attacked by the Japanese Army. He was captured and taken prisoner to the notorious Hong Kong death camp, Shamshuipo. His story is an extraordinary one of survival against all the odds.

9780752460642

Visit our website and discover thousands of other History Press books.

www.thehistorypress.co.uk

The History Press